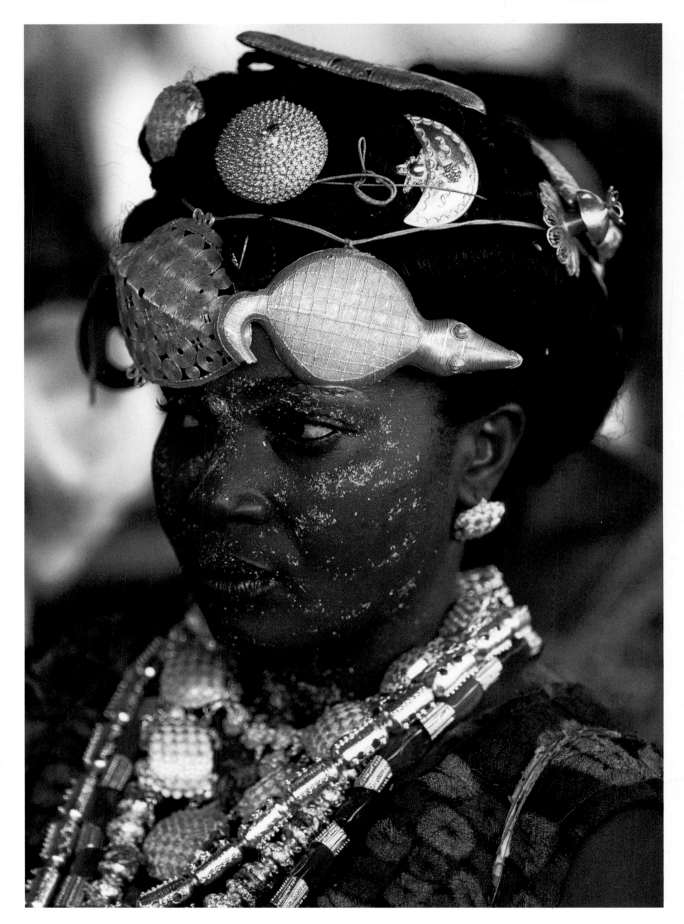

passages

photographs in africa by **carol beckwith** & **angela fisher**

HARRY N. ABRAMS, INC., PUBLISHERS

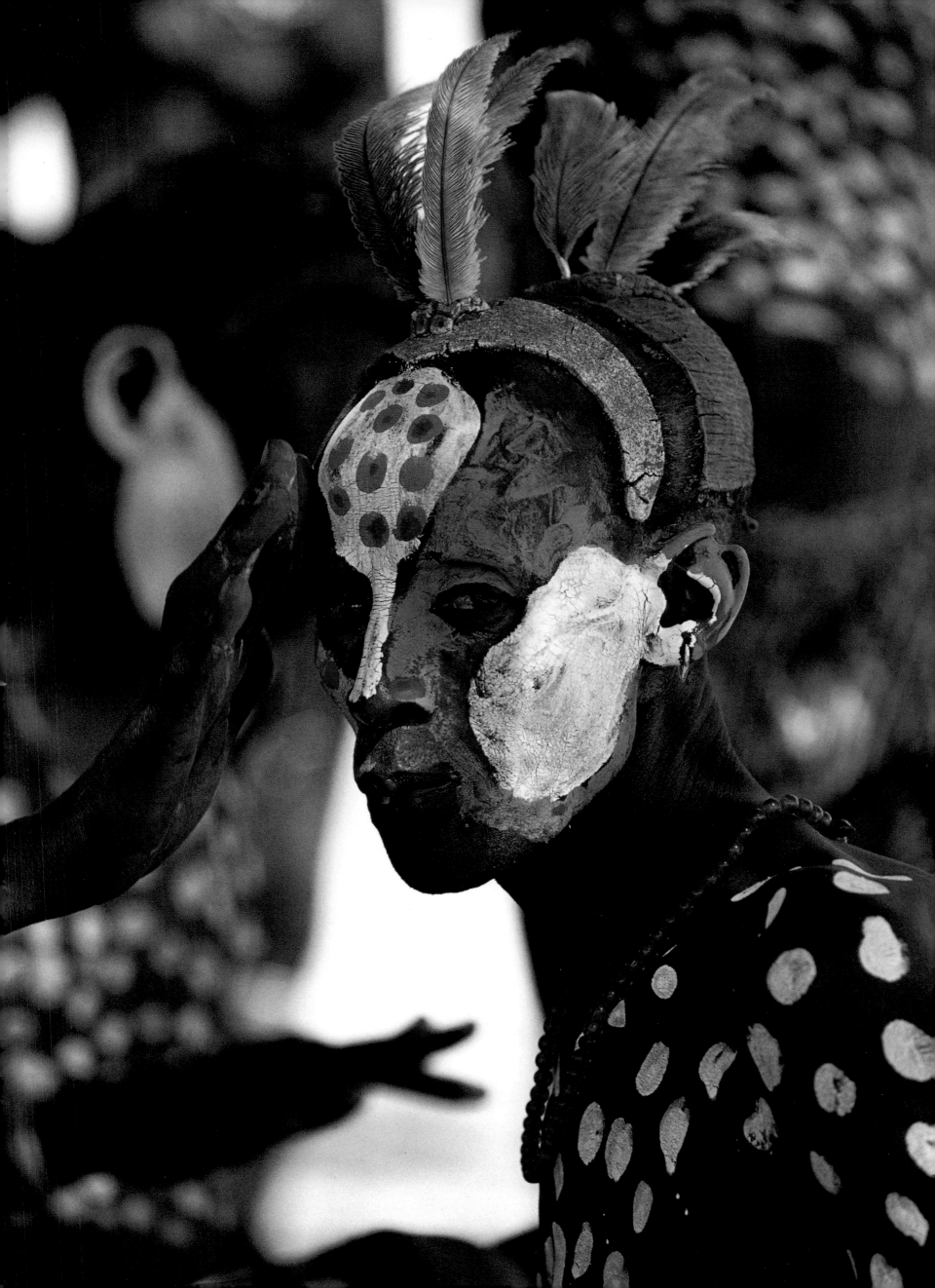

Introduction

For thousands of years, rites of passage have played vital roles in marking the progress of individuals and communities through life's inexorable cycle, from birth to death. Malidoma Patrice Somé, the West African shaman and teacher, calls such rituals and ceremonies "journeys of the spirit," for they truly enable people to rise above the mundane happenings of every day life and connect them with larger forces, higher powers. Nowhere in the world today has this been more true than in Africa. All over the continent, from the outskirts of major cities to the arid, near-desert lands south of the Sahara, thousands of boys and girls, men and women, gather together periodically to participate in ritual acts that enhance their lives, connecting them with one another, with their ancestral traditions, and with nature.

Carol Beckwith and Angela Fisher have traveled in Africa separately and together for some thirty years. They have lived among native peoples, sharing their daily lives, and recording with their cameras the rich panoply of their ceremonies—from the naming of babies and the courtship of young adults to communal rites of the seasons, displays of royal power and wealth, and practices devoted to healing, worship, and death. No artists of any era have captured so many images of authentic and ancient ritual practices.

Beckwith and Fisher know very well that much of Africa has come fully into the twenty-first century. But they have left the modern world to photojournalists. Their aim has been to document as fully and artistically as possible the traditional rituals that persist more or less unchanged, even in the modern world. It s fortunate indeed for us that they have done so, for many of these rites are dying out or becoming altered as Africa assimilates the habits and products of other parts of the world. One important ceremony they witnessed on the Kenya-Tanzania border, a week-long ritual in which 104 Maasai warriors celebrated their emergence as elders, had not happened for seven years and seems likely never to happen again, at least not on such a scale.

Recognition of the vital role these women have played in recording traditional ceremonies came to them in 1999 on publication of their monumental, two-volume book, *AFRICAN CEREMONIES*, containing 850 of their color photographs. Among much praise and excellent reviews, they received the Award of Excellence from the United Nations Society of Writers and Artists. U.N. Secretary General Kofi Annan sent a special envoy to convey the honor.

The work that Beckwith and Fisher have done in Africa was not achieved easily. Traveling on foot, by mule train, on camelback and on horses, in four-wheel-drive vehicles, and occasionally by boat, they traversed the continent, ultimately witnessing and picturing more than ninety distinctive ceremonies in twenty-six countries over the course of ten years. Moving through the desert with cattle-herding nomads, enduring daytime temperatures of 120 degrees, they subsisted only on milk for days on end and waited weeks for rains to come so that the group could settle down with their cattle and perform a long-awaited ceremony. Once, having spent eight weeks in southwestern Ethiopia photographing the Surma people's rites, they learned that they had deeply offended some 14,000 tribal members who felt that they had been excluded from the photographs. Threats of an ambush on their departure led their guide to hold a goat feast for the Surma chieftains at which he persuaded the leaders to escort the photographers' mule train through Surma land, which they did. On the way, armed men waiting in the trees fortunately respected the chiefs' presence and did not fire on the travelers.

But Beckwith and Fisher did more than endure hardships. They shared close and warm contact with dozens of men and women, some of whom have become lifelong friends, maintaining these relationships with care and concern from long distances. They have also done their best to give back to Africa, contributing some of the earnings of their seven books to a variety of needy projects, supporting the digging of wells in the arid Sahel and helping to build schools for Maasai and other youngsters. Perhaps their greatest gift to the future, however, will be the remarkable artistic document of their photographs, preserving the rich and varied ways of life that have sustained millions of people who live close to nature in communities whose shared values and common spirit could serve as models for all the world.

ROBERT MORTON, EDITOR

Coming of Age

ACROSS AFRICA, children are seen not only as members of an ances-
tral lineage and of a community but also as future custodians of the
culture of their people. From the outset, many different ceremonies are
performed to reinforce this connection.

Because infant mortality remains high in Africa, many cultures are
extremely superstitious during the first few years of a child's life and
carry out rituals to protect it from hazards. The Himba of Namibia never
leave a baby on its own or even put it down, lest the child be stolen
away by some malevolent spirit. The Wodaabe of Niger do not name a
child before its twelfth birthday, so it cannot be identified by the spirit
of death. For Maasai babies, however, village elders officially bestow a
name soon after birth.

RIGHT:

This Himba baby wears a leather talisman round her neck to dispel the
attentions of evil spirits. For beautification and protection from the sun,
Himba children are adorned with jewelry and smeared with a mixture
of red earth and animal fat when they are only a few days old.

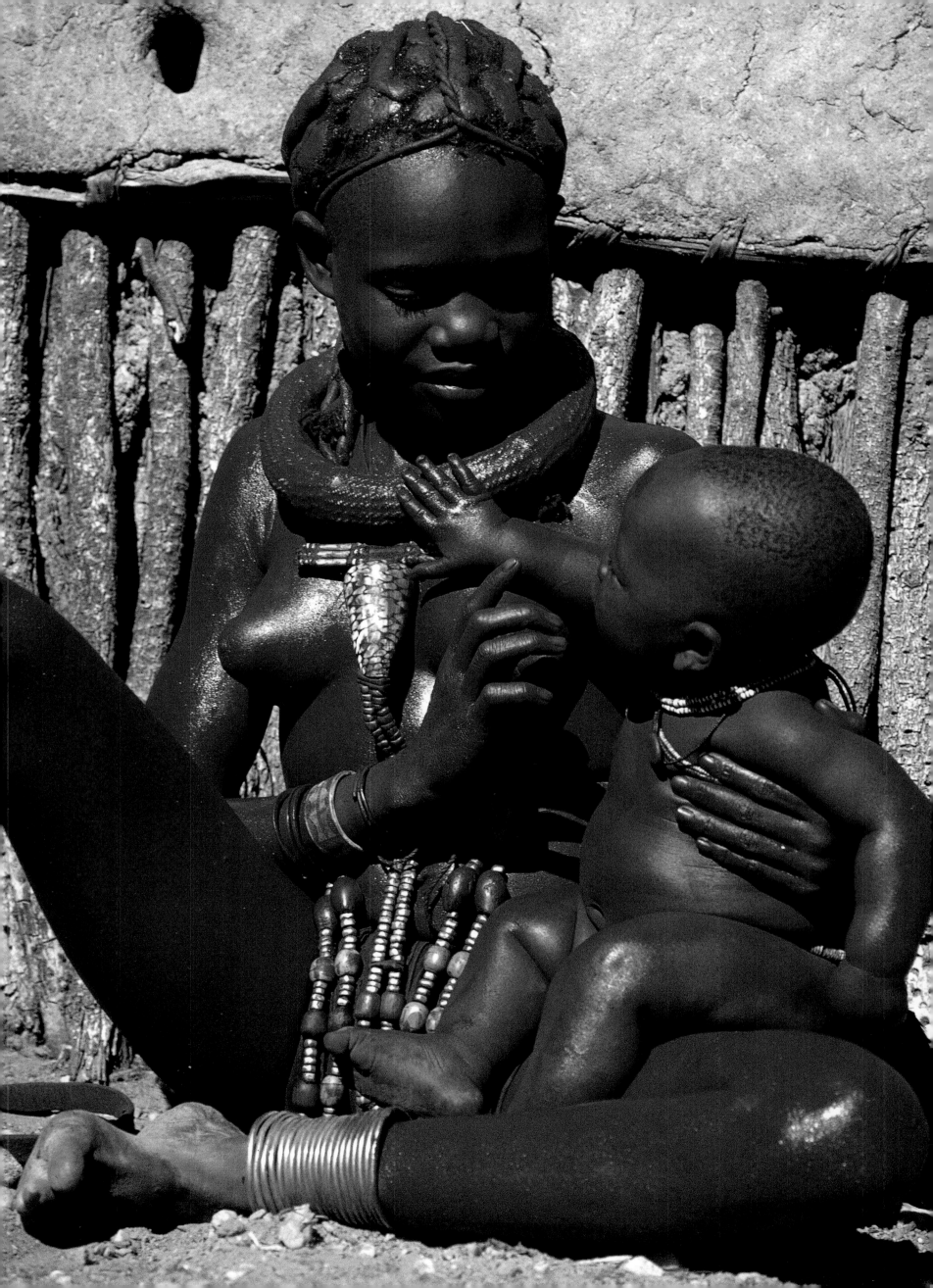

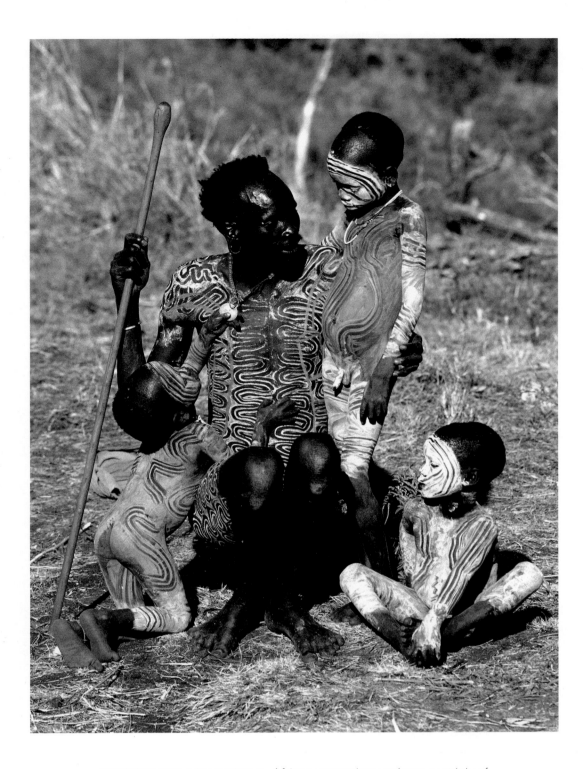

ENTERING THE ADULT WORLD, African youngsters undergo a variety of initiation rituals, beginning at about the age of ten. These rites provide individuals with instruction in what is expected of them during the next phase of their lives.

In all such ceremonies, a select group of elders takes charge of the sequence of ritual events, which invariably involves a ritual isolation of the male and female novices, separating them from the community to prepare them for their transformation. To begin their training they often enter a special place, a sacred forest or a ritually built house. It is there that initiates lose their childhood identities and gain their adult selves. After being isolated for a period of instruction, the initiates undergo an encounter or ordeal that marks the climax of their initiation and the beginning of their new lives.

ABOVE:
A Surma father from Ethiopia tenderly looks after his children.

RIGHT:
On special occasions, Surma children decorate their bodies with chalk and earth pigments to create a fantasia of patterns. Imitating their parents, the youngsters begin to learn the art of body painting at an early age. Possessing little in the way of material culture, Surma people paint themselves as their prime means of artistic expression.

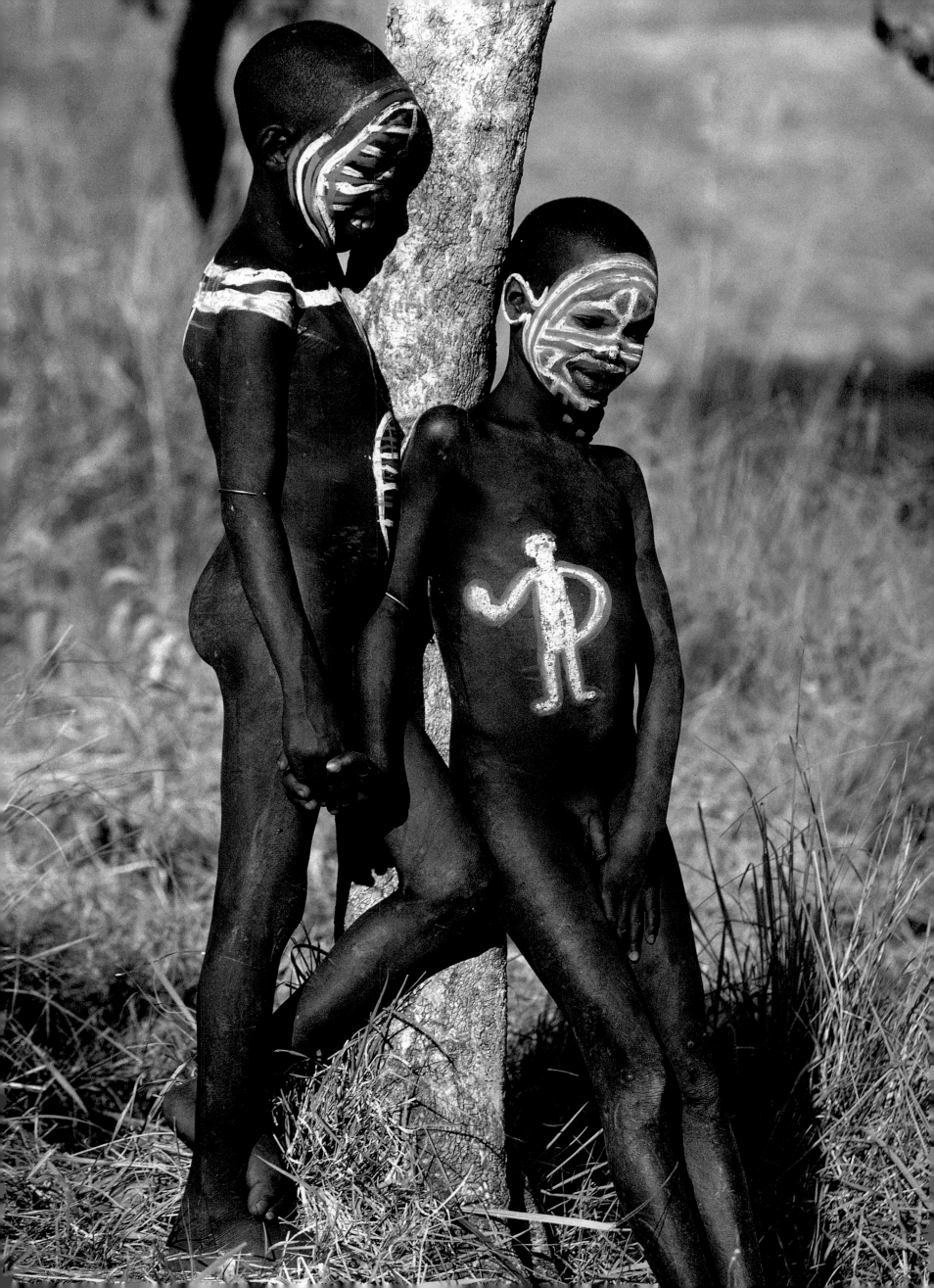

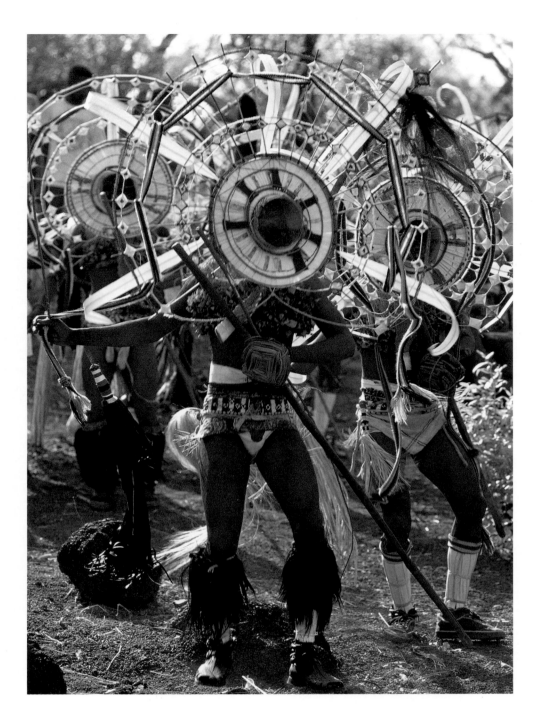

INITIATION INTO ADULTHOOD of the Bassari people of southern Senegal occurs for young men between fifteen and twenty years of age and takes place over several months. In the sacred forest the boys undergo the deaths of their childhood identities through a series of harsh rituals, and they emerge from the forest behaving like infants. During this limbo period, lasting for a week, the boys are unable to fend for themselves, and are cared for by guardians, who carry them, feed them, clean them, and even lay them down to sleep. This simulated regression recreates a state of purity, from which they will emerge as adults.

ABOVE:

Masked dancers called Lokuta emerge from the sacred forest to join the ritual celebration. Embodying the spirit of nature, they descend from the mountains at such times to oversee festivities and ensure that tribal traditions are being maintained.

RIGHT:

Wearing a headdress of feathers from a sacrificed chicken, a boy meditates silently.

>OVERLEAF:

A line of initiates leaves the sacred forest to reenter the village.

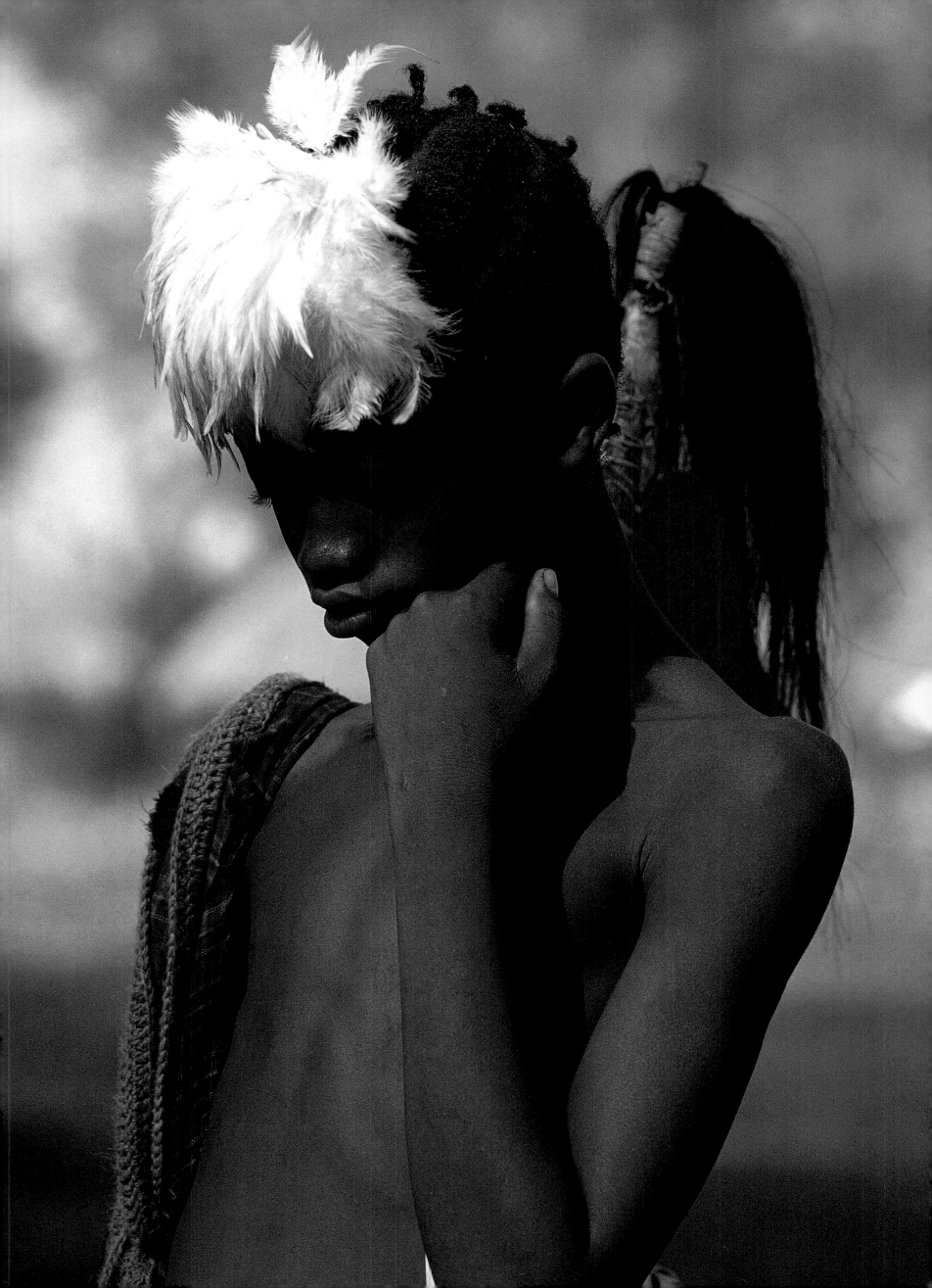

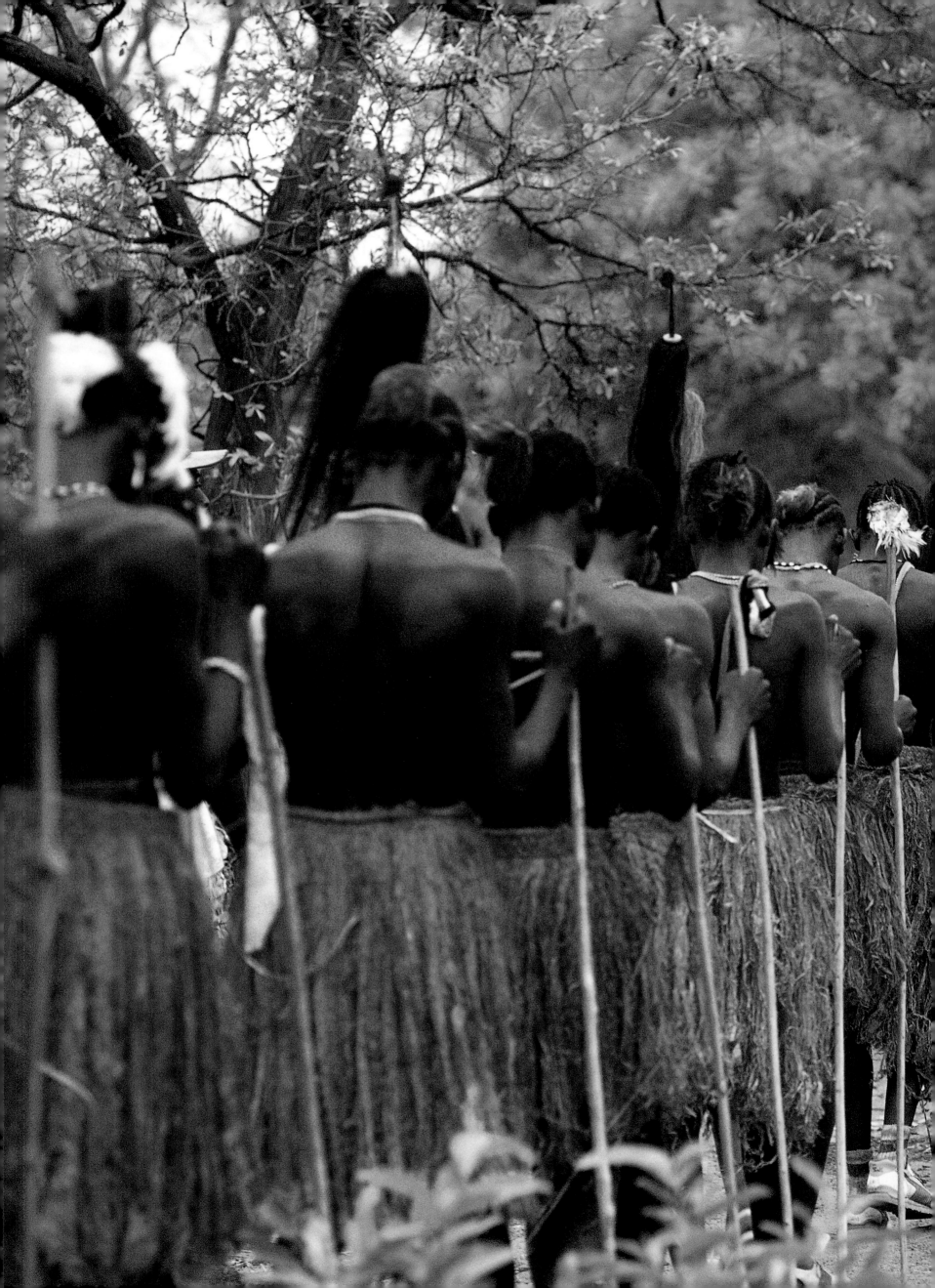

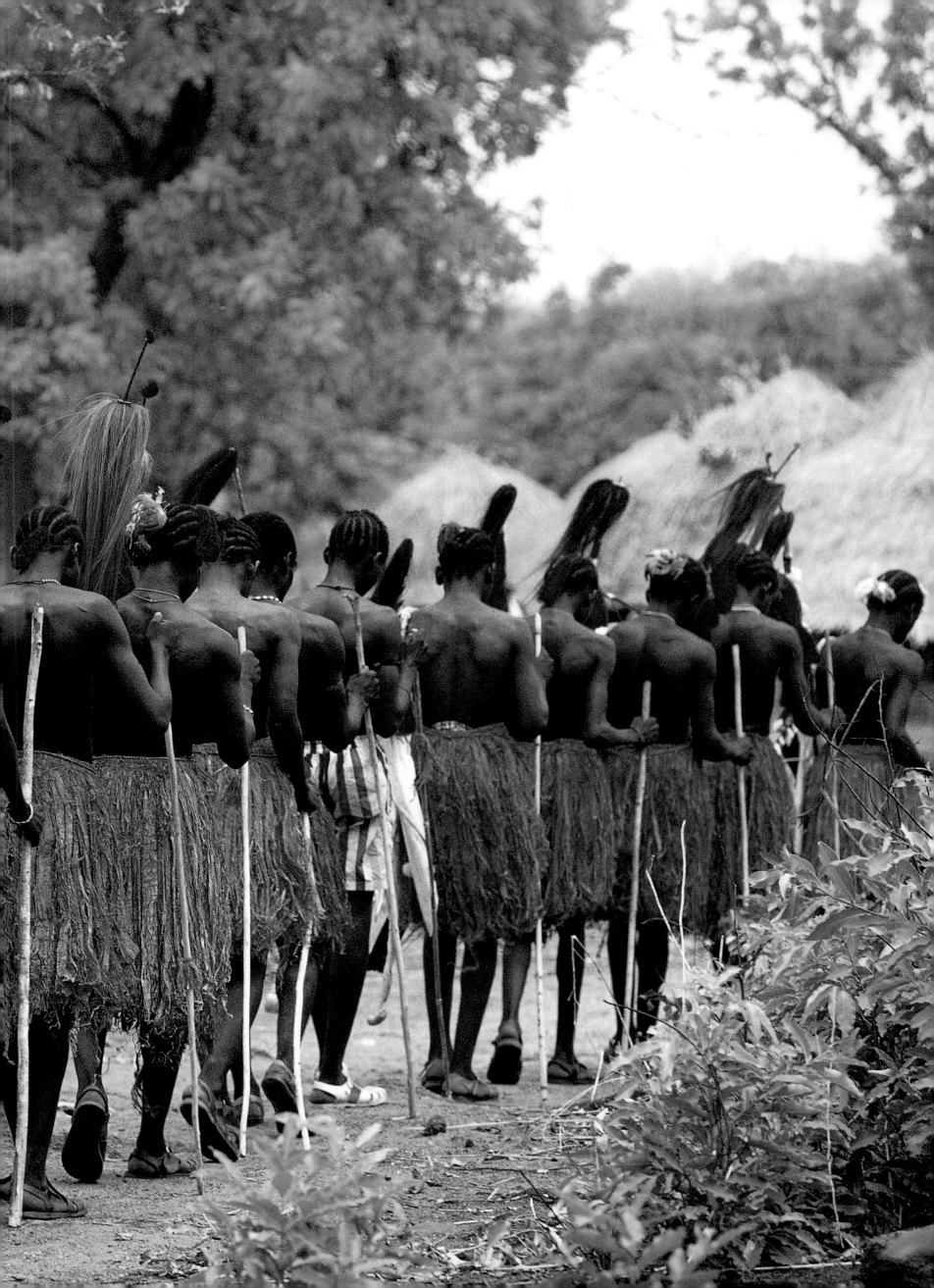

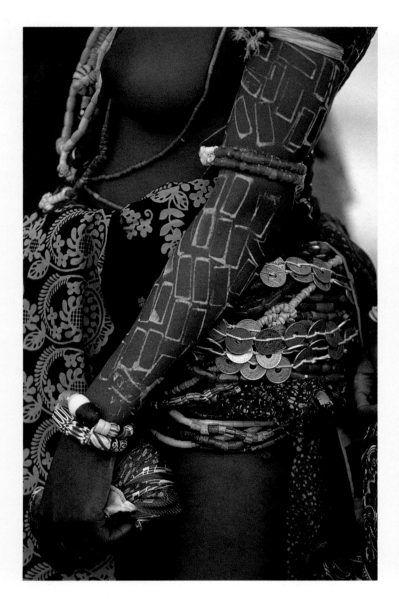

FEMALE INITIATION RITUALS, called Dipo among the Krobo people of eastern Ghana and their tribal cousins the Shai, celebrate femininity and fertility. The initiates enter a three-week period of seclusion, during which they learn the ways of adult women: personal grooming, female conduct, domesticity, and, finally, the arts of music and dance.

RIGHT:
Two Shai girls relax together before the final stage of their initiation. During their final week of Dipo instruction they will learn about the subtleties of seduction, including special techniques for making love. Shai initiates wear unique headdresses called *cheia*. Made of hoops of cane wrapped in blackened cord, the headdress is constructed on the girls' heads the day before the ceremony. It takes six hours to complete, and will remain in place for a week. The initiates wear strings of glass beads often weighing up to twenty-five pounds tied around their necks and hips. Of great value, the beads often have been passed down through many generations.

>FOLLOWING PAGES:
Krobo initiates, wearing distinctive *dipo pe* straw hats and white loincloths symbolizing purity, perform the traditional *klama* dance.

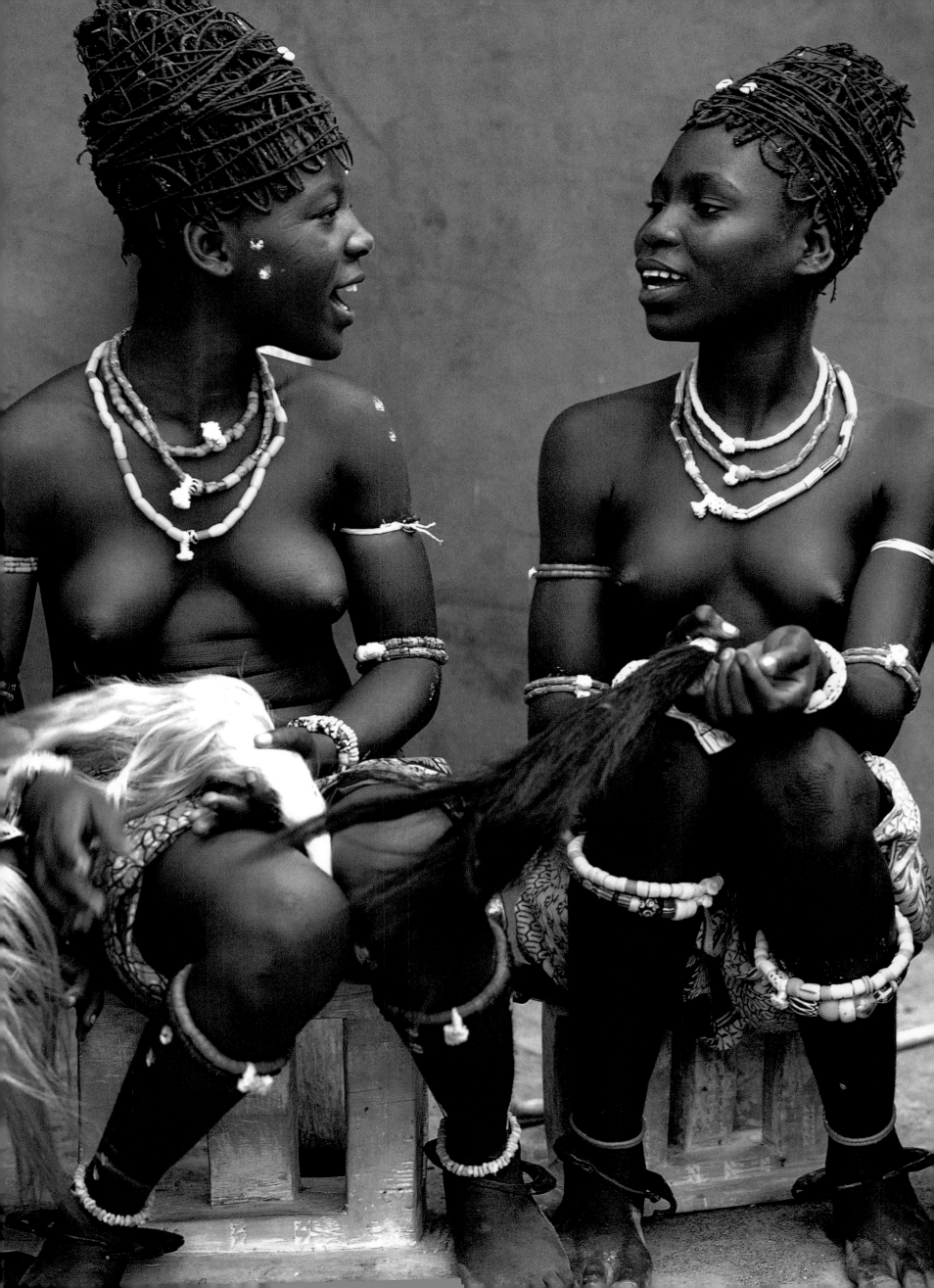

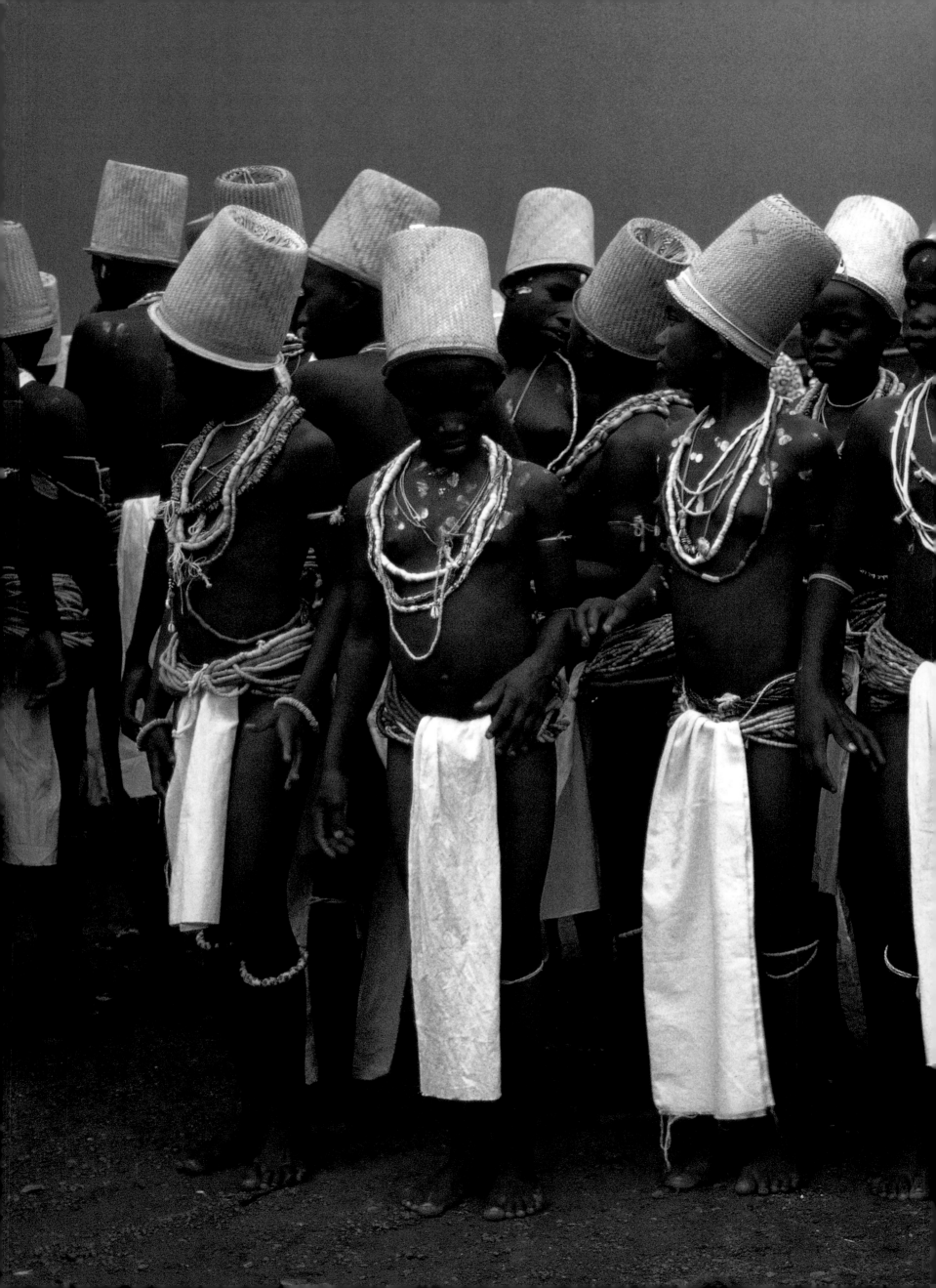

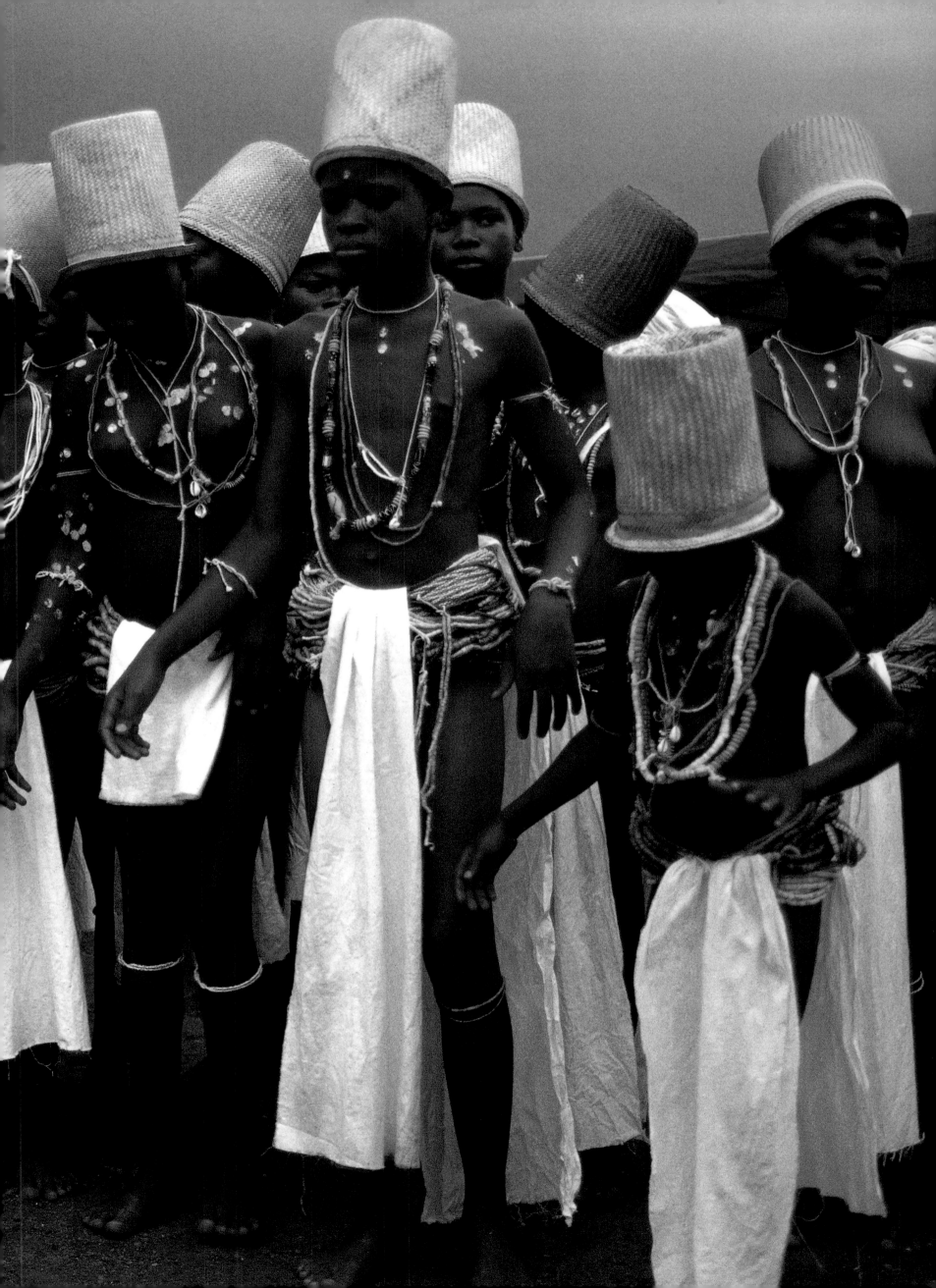

PASSING FROM WARRIORHOOD INTO ELDERHOOD, Maasai men of Kenya and Tanzania undergo a ritual called *eunoto,* performed roughly once every seven years at a place selected by the most revered holy man, or *laibon*. At this point in their lives, an entire age set moves from the freedom of youth, when they are warriors responsible for protecting the group's cattle, to the responsibilities of adulthood, beginning with marriage. At the chosen place, the mothers of the warriors build a ceremonial circle of forty-nine huts, a *manyatta,* including a large ritual house called *osingira*. There, and at sacred chalk banks nearby, the most important rituals of transformation take place.

During his warrior years, a Maasai may take girlfriends from the community of young, uncircumcised females. Although many of the girls are too young for the relationships to become sexual, the warriors establish intimacy with them in other ways.

RIGHT:
A Maasai warrior displays his beaded headdress with ostrich feathers.

>OVERLEAF:
Warriors charge about the *manyatta* blowing long horns and carrying buffalo hide shields. To carry such a shield a warrior must either have killed a buffalo for the hide, an extremely dangerous feat, or receive it as a gift from an older brother.

>>FOLLOWING PAGES:
Throughout the ceremony, young Maasai girls adoringly accompany their warrior boyfriends. The beaded collars and headbands the girls wear are designed to bounce rhythmically to enhance their bodily movements as they dance.

>>>NEXT FOLLOWING PAGES:
With their heads newly shaved and their bodies rubbed with glistening red ocher, the initiates gather to receive the final blessings of the elders. The elders walk among them, chanting prayers and spraying them with mouthfuls of milk and honey beer.

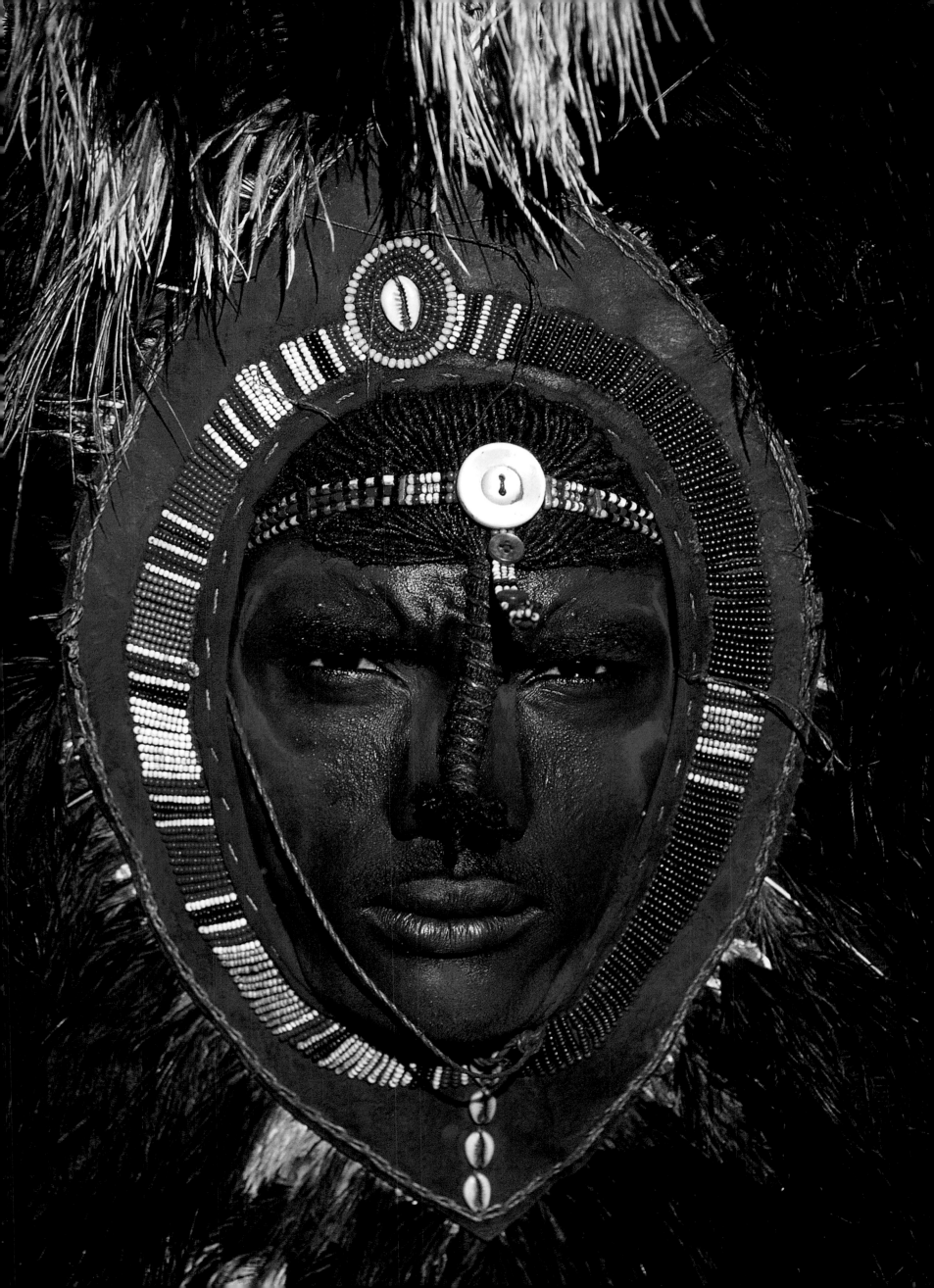

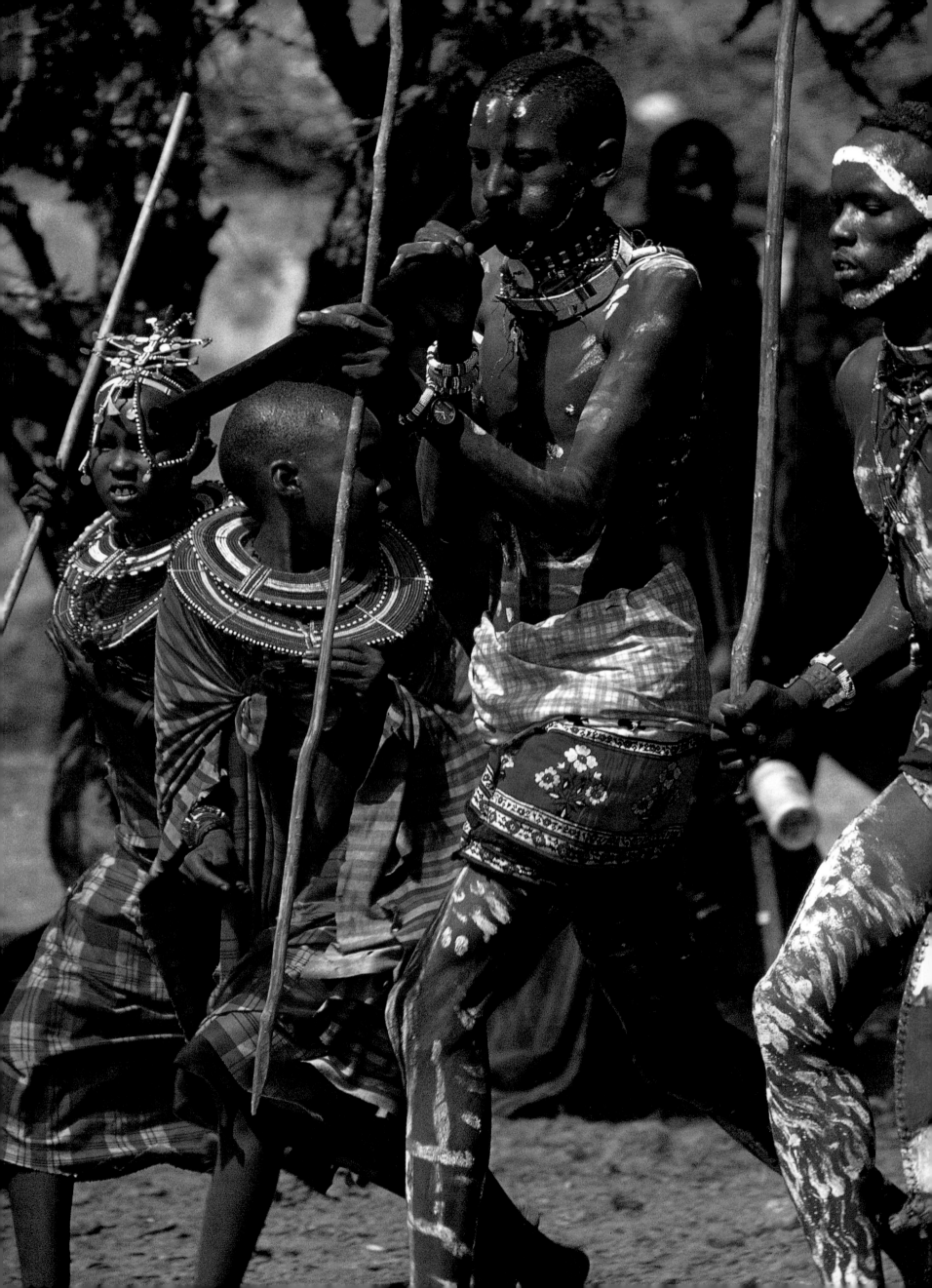

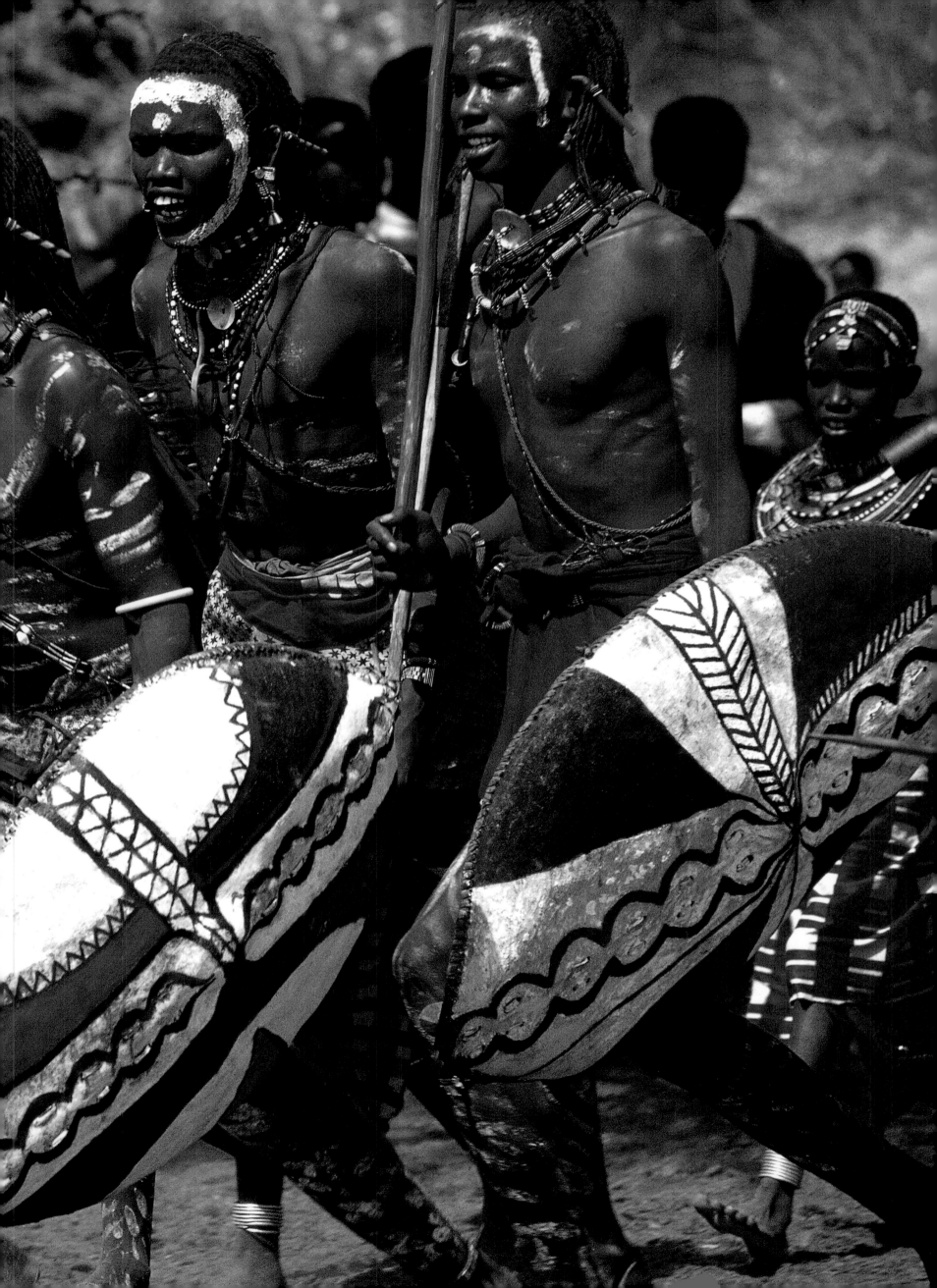

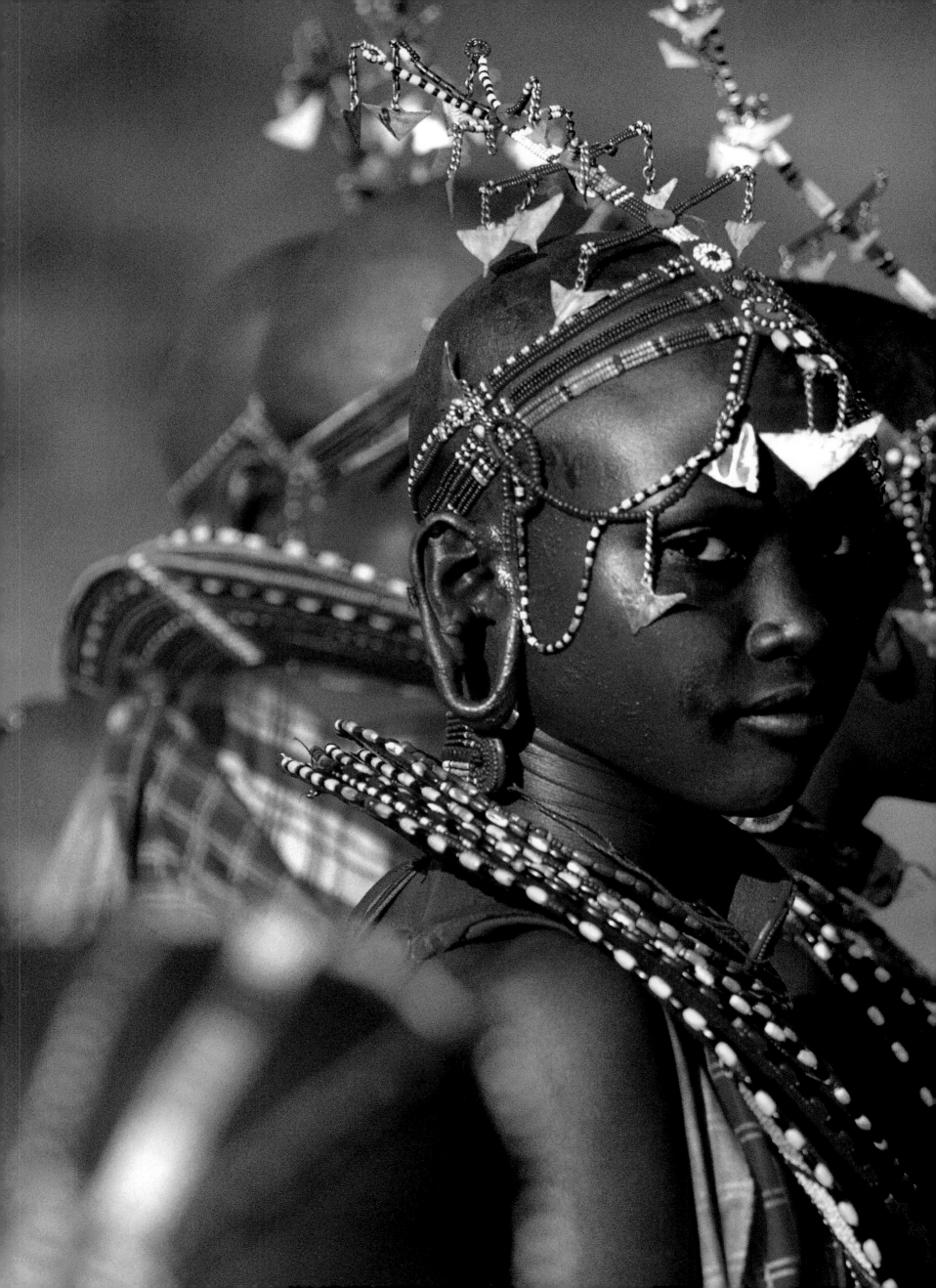

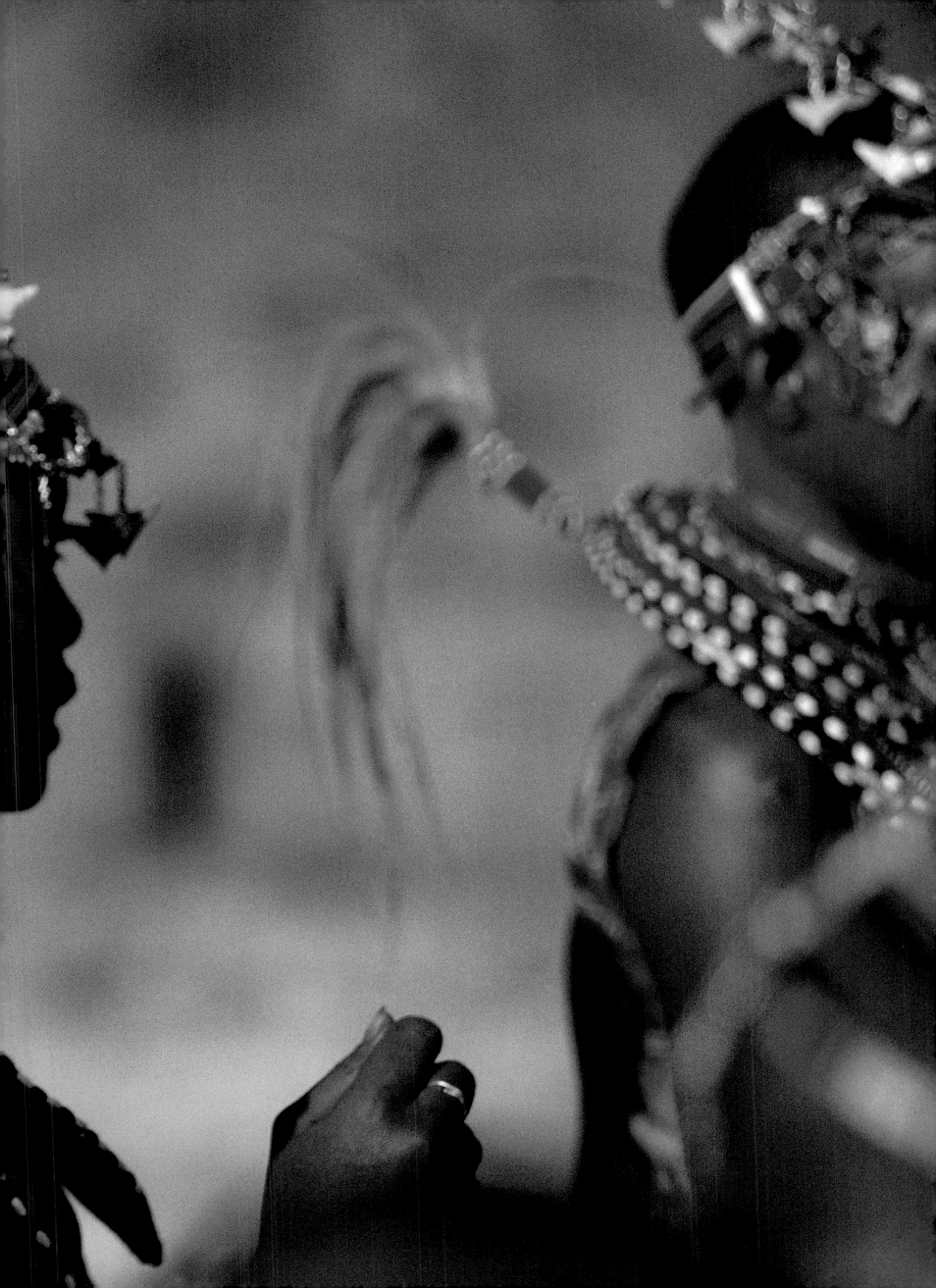

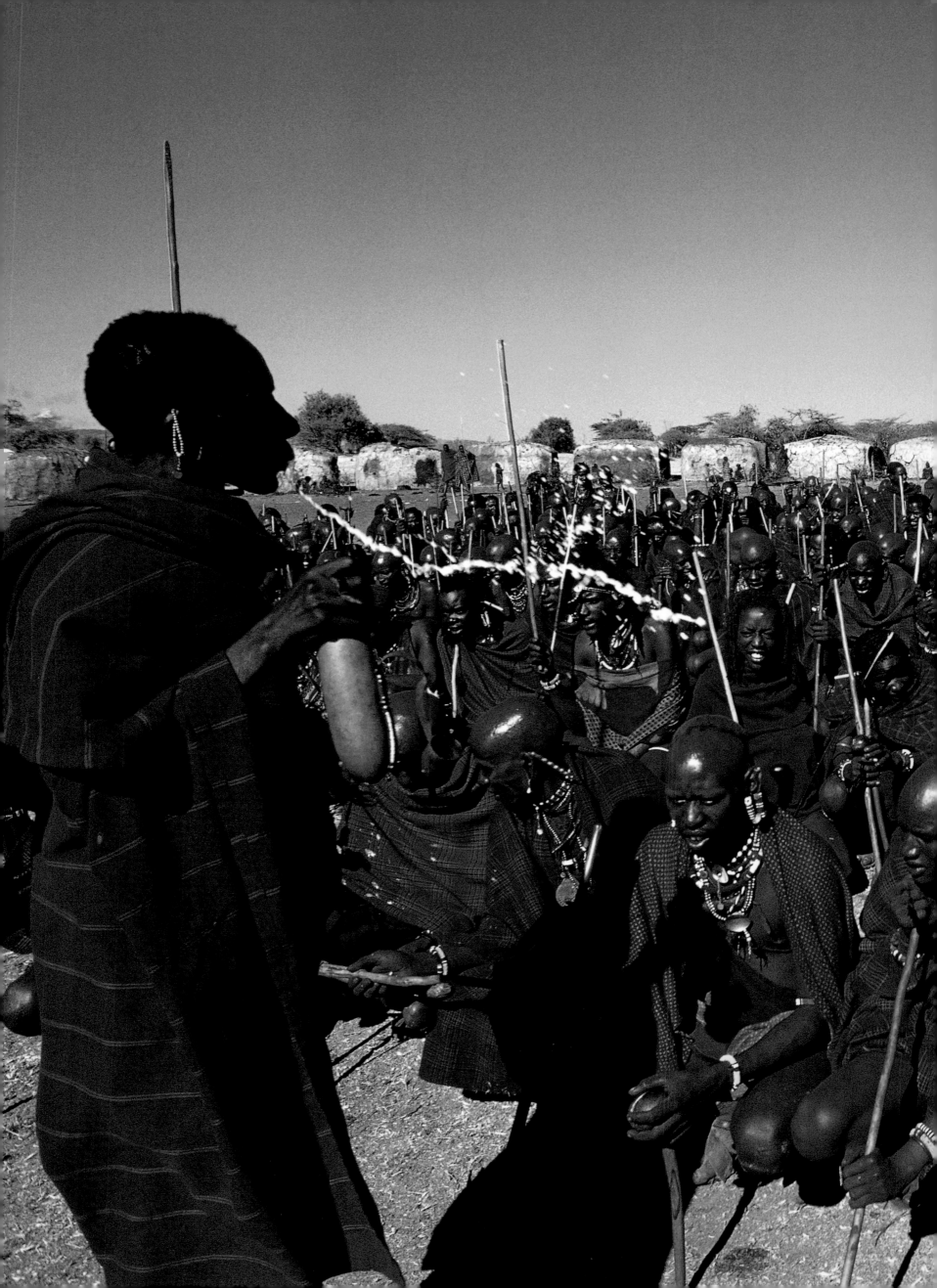

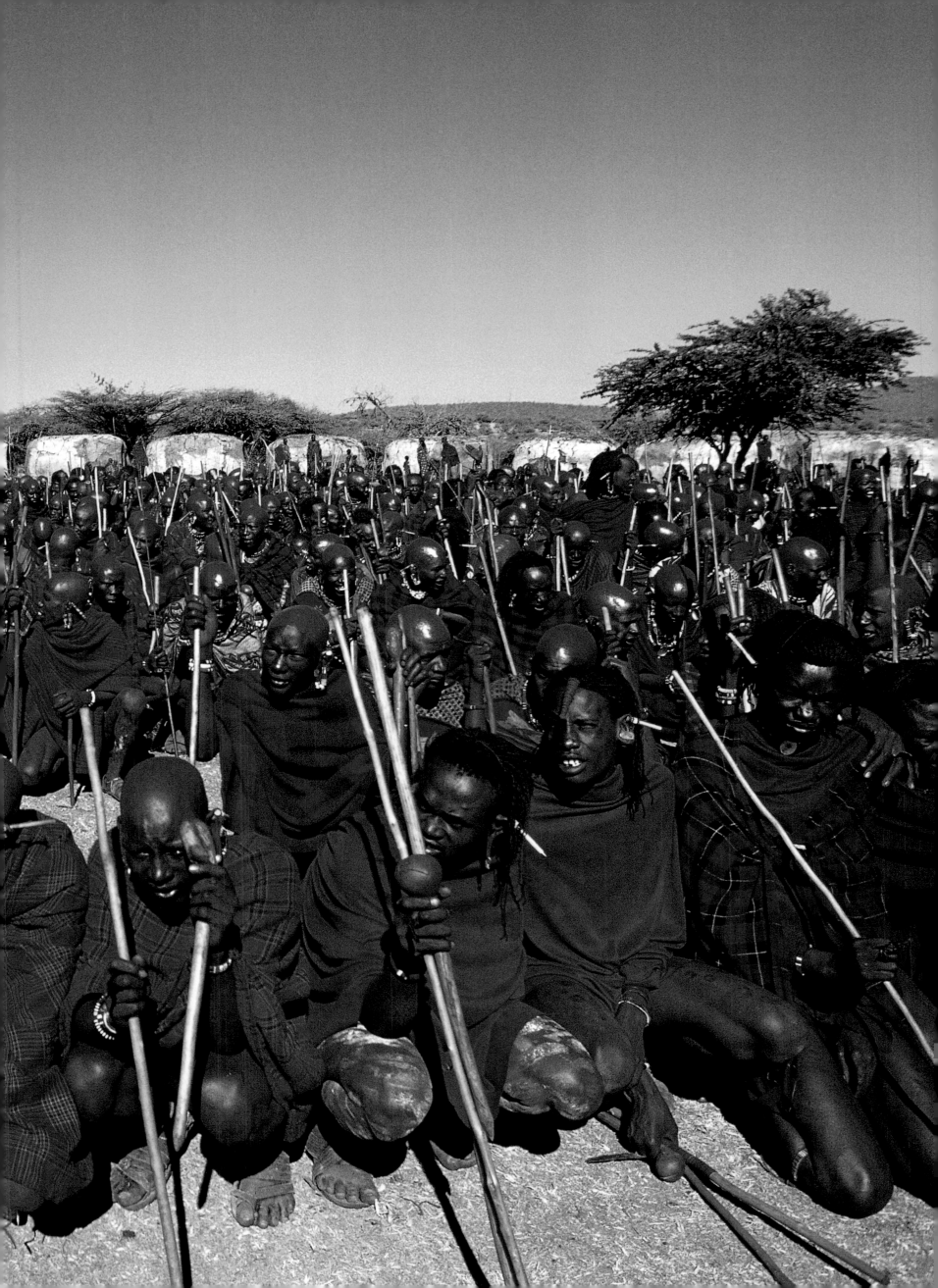

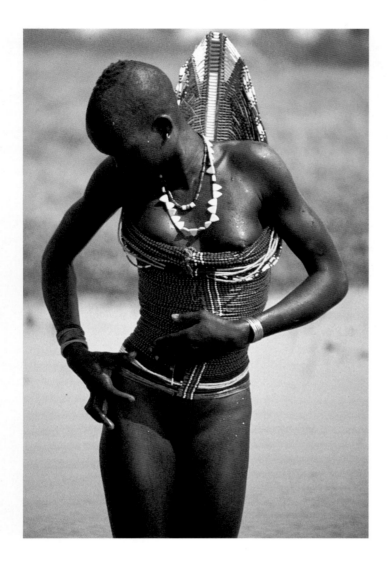 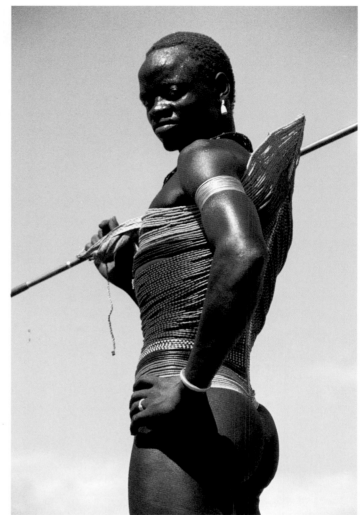

Courtship and Marriage

SEASONAL MEETINGS of young Dinka men and women take place during the dry season, when the vast plains of the southern Sudan become so dry that the herdsmen are forced to move to the swampy lands near the Nile, where water continues to support grazing for the animals.

Dinka dry season cattle camps are run mainly by the young men and girls, older people having been left behind in the highlands. During this favorite, leisurely time of the year, young people are surrounded by their animals and enjoy a convivial social life. A young man accompanied by his favorite ox makes a special point of visiting his girlfriend, and he will sing songs extolling the virtues of the magnificent beast and the beautiful girl he is courting. Dry season camps not only provide essential grazing for the animals but also many opportunities for marriages to be made.

ABOVE:

The corsets worn by this couple are unusual because of the height of the projections at the back, which indicates that the wearers come from families rich in cattle. The corsets are worn until marriage, when they are removed.

RIGHT:

Dinka herders in traditional beaded corsets walk among their cattle in their dry season camp. The tight beaded corsets indicate the men's position in the age-set system of the tribe. The corsets are first sewn in place at puberty and not removed until the wearer reaches a new age set. Each group wears a color-coded corset: a red and blue corset indicates a man between fifteen and twenty-five years of age; a yellow and blue one marks someone over thirty and ready for marriage.

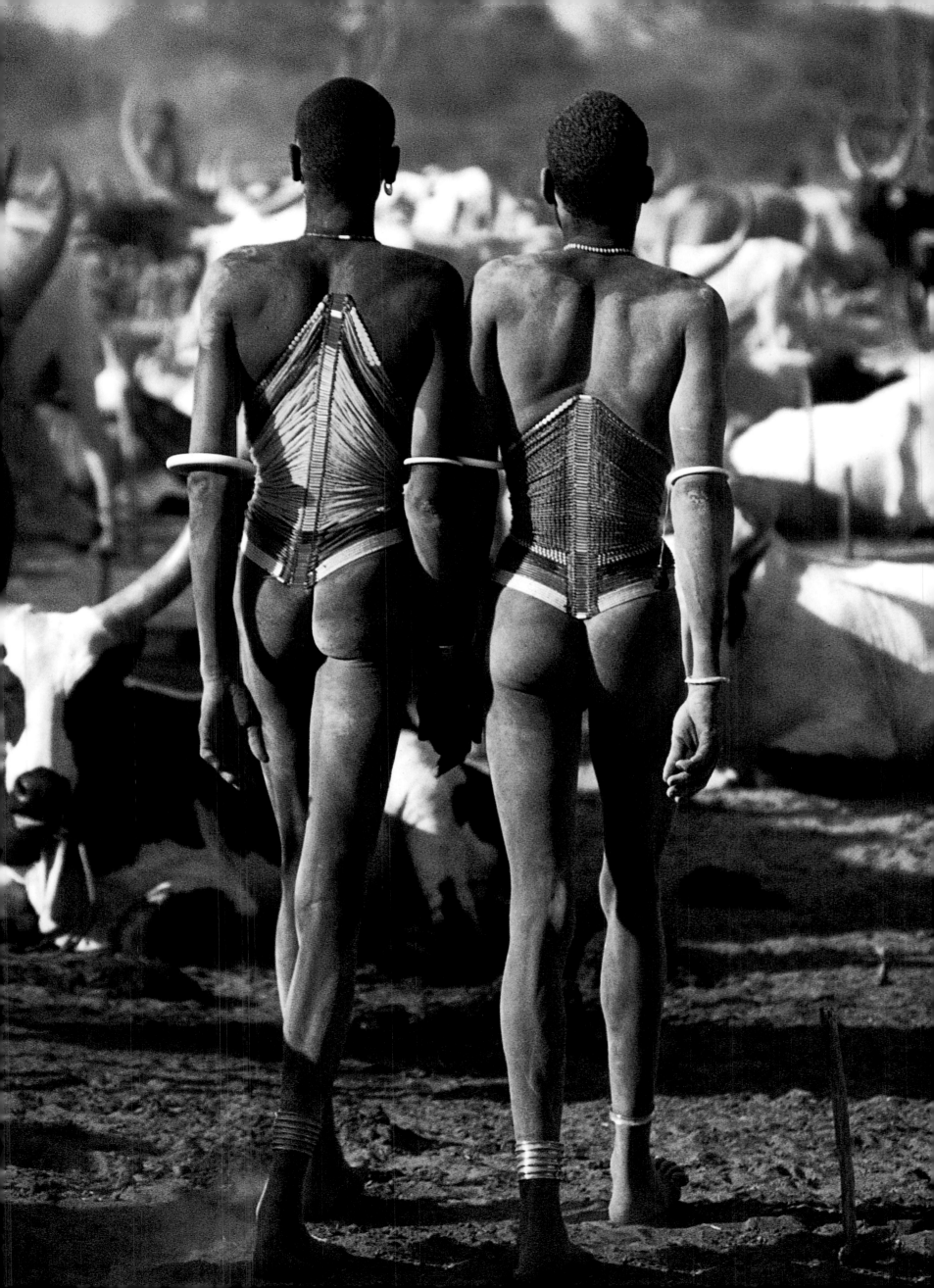

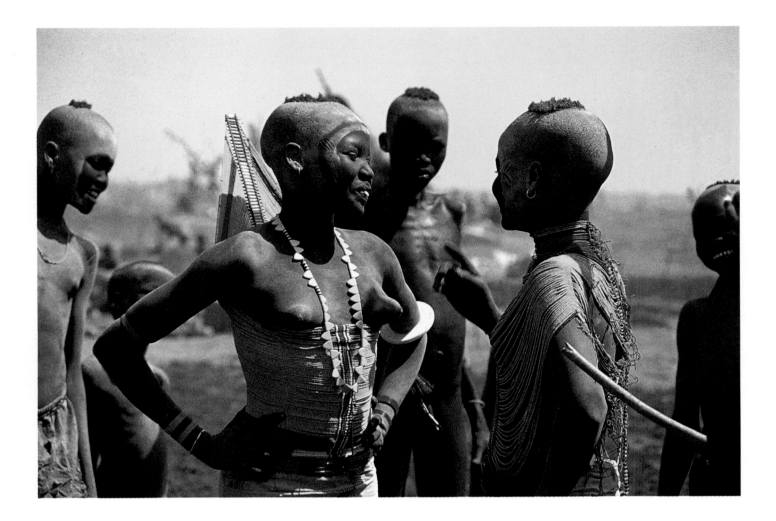

CELEBRATIONS OF COURTSHIP AND MARRIAGE for the Surma of southwestern Ethiopia take place after harvest season, when food is plentiful. During this time, young men and women spend considerable time painting their bodies and adorning themselves to attract the opposite sex. Marriage proposals are traditionally made among the Surma by a man selecting a bride and then negotiating with her father a dowry paid in cattle. A dramatic alternative exists, however, in which young women get to choose a husband after an extraordinary competition among the men called the Donga stick fight.

ABOVE:
Dressed to atract the attention of young men, Dinka girls wear lavishly beaded bodices and adorn their upper arms with flat ivory bracelets.

RIGHT, AND FOUR FOLLOWING PAGES:
During courtship season, the Surma decorate their bodies with chalk paint and pigments to attract the opposite sex.

>>>>NEXT FOLLOWING PAGES:
A test of nerves and brute strength, the Donga stick fight proves masculinity, settles personal vendettas, and, most importantly, wins wives. The fifty or more men who participate in each tournament represent different villages. The contestants fight in heats, with the winners going on to the next round until the competition narrows to two finalists. At the tournament's end, the winner is ceremonially lifted onto a platform of Donga sticks and presented to the young girls who have been watching from the sidelines. The girls decide among themselves who will choose the champion as her husband.

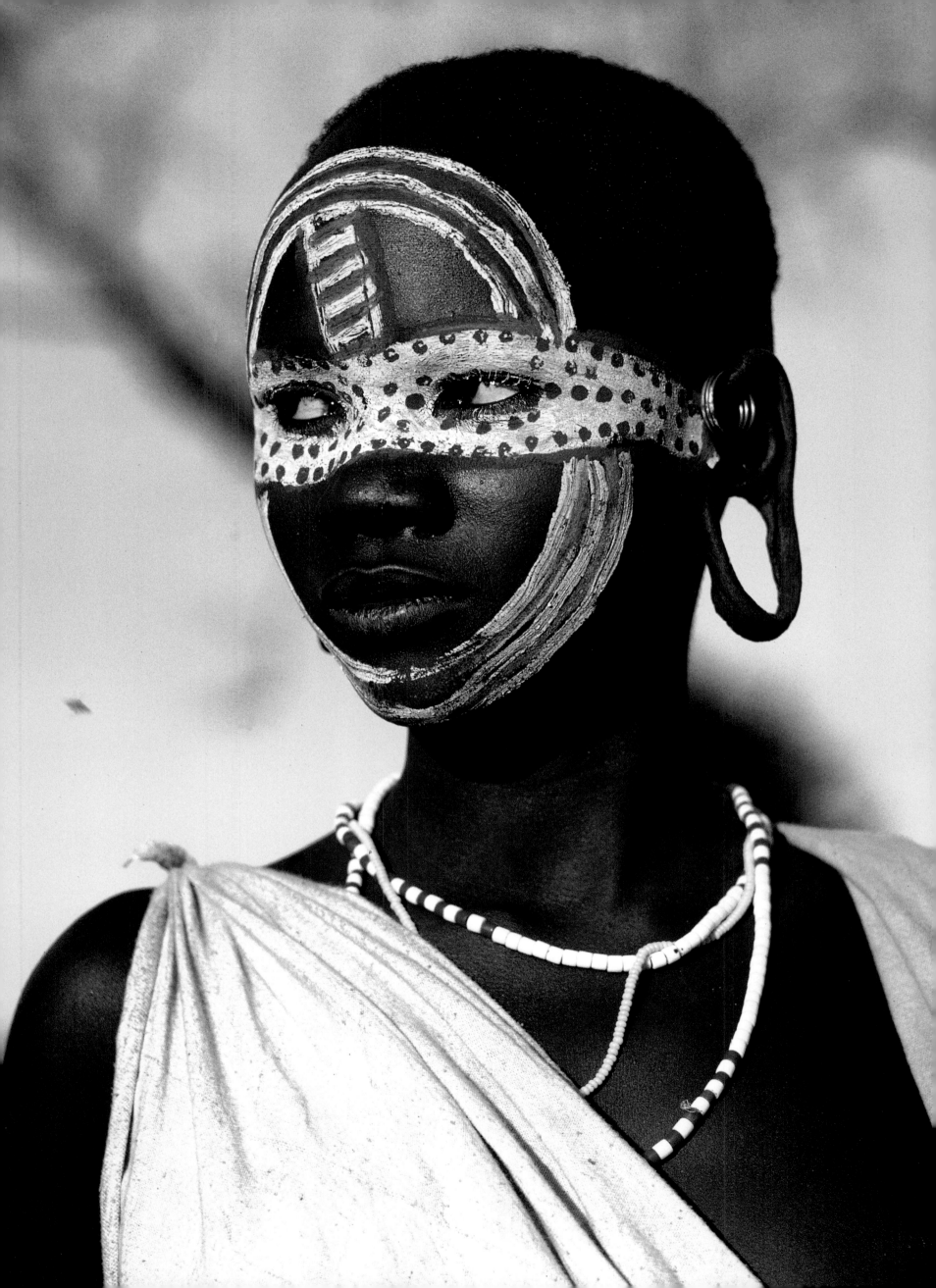

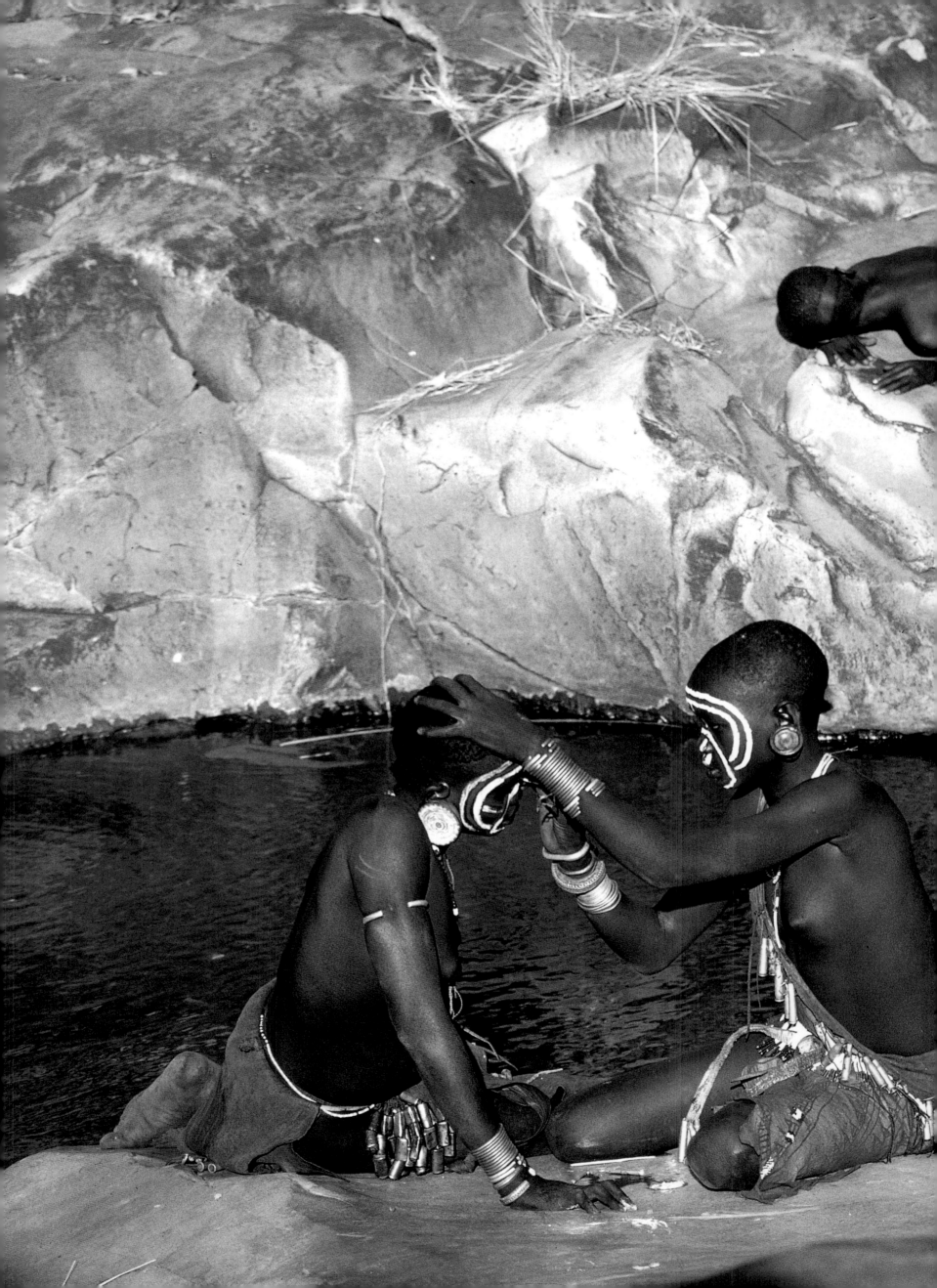

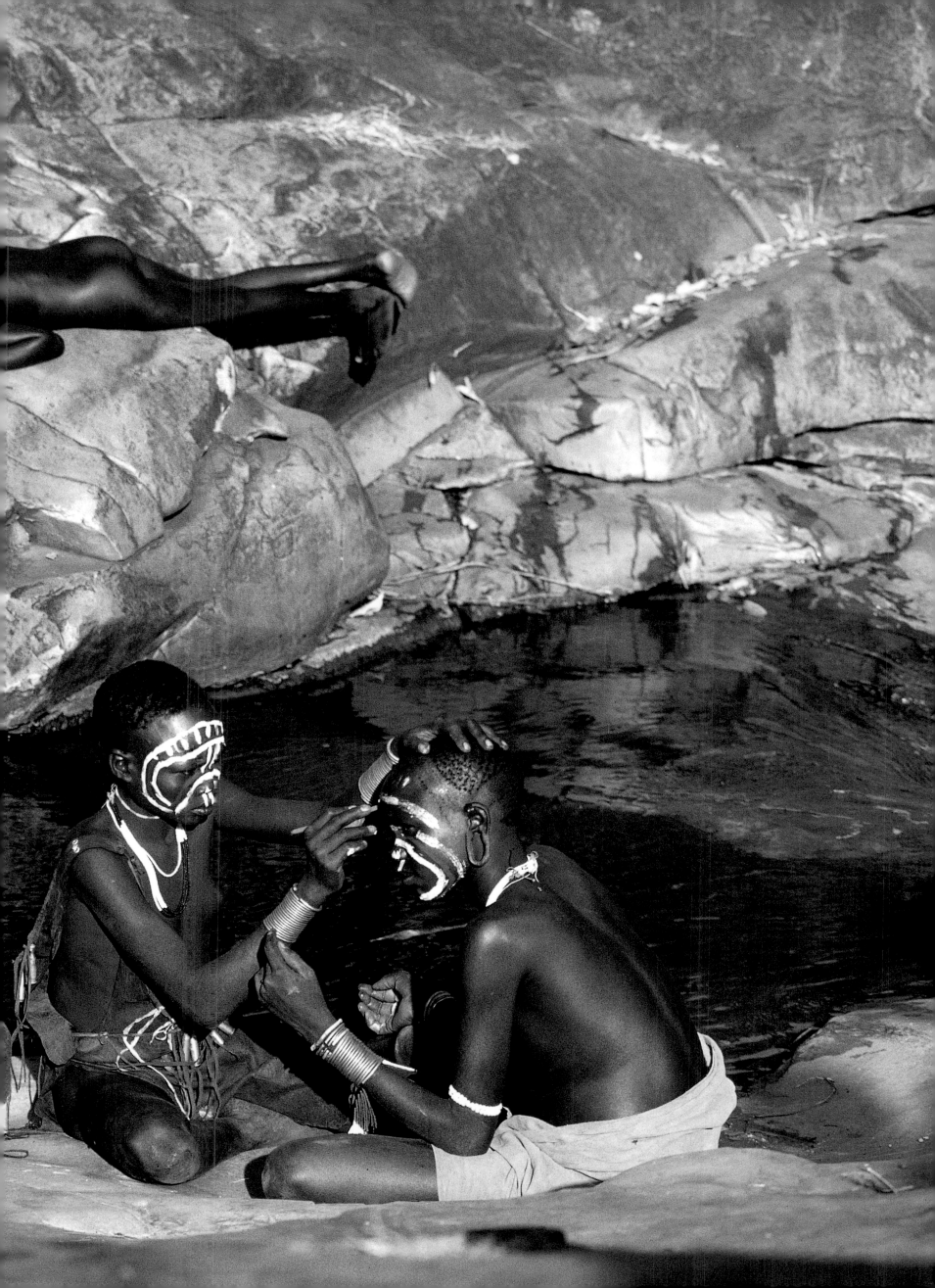

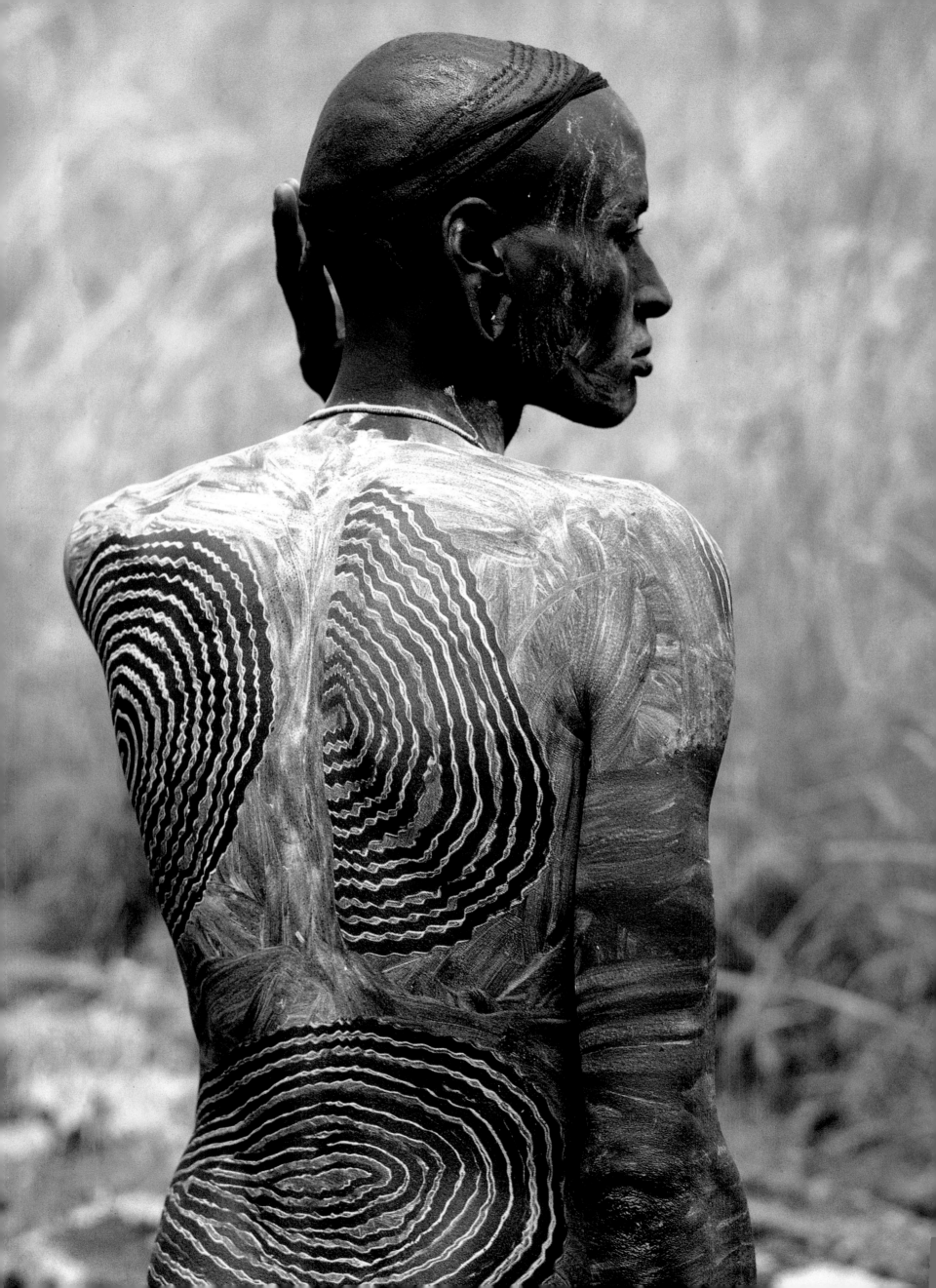

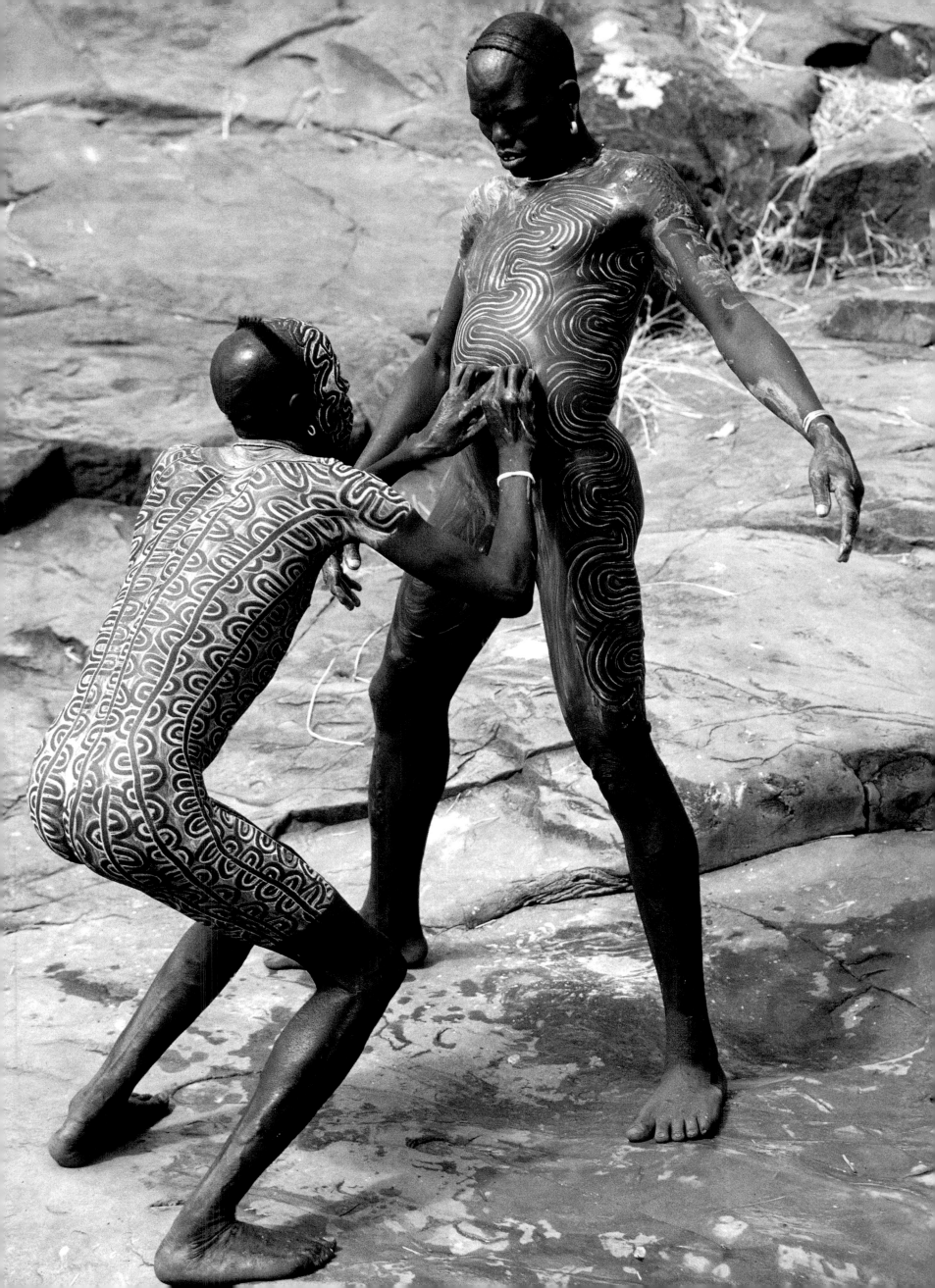

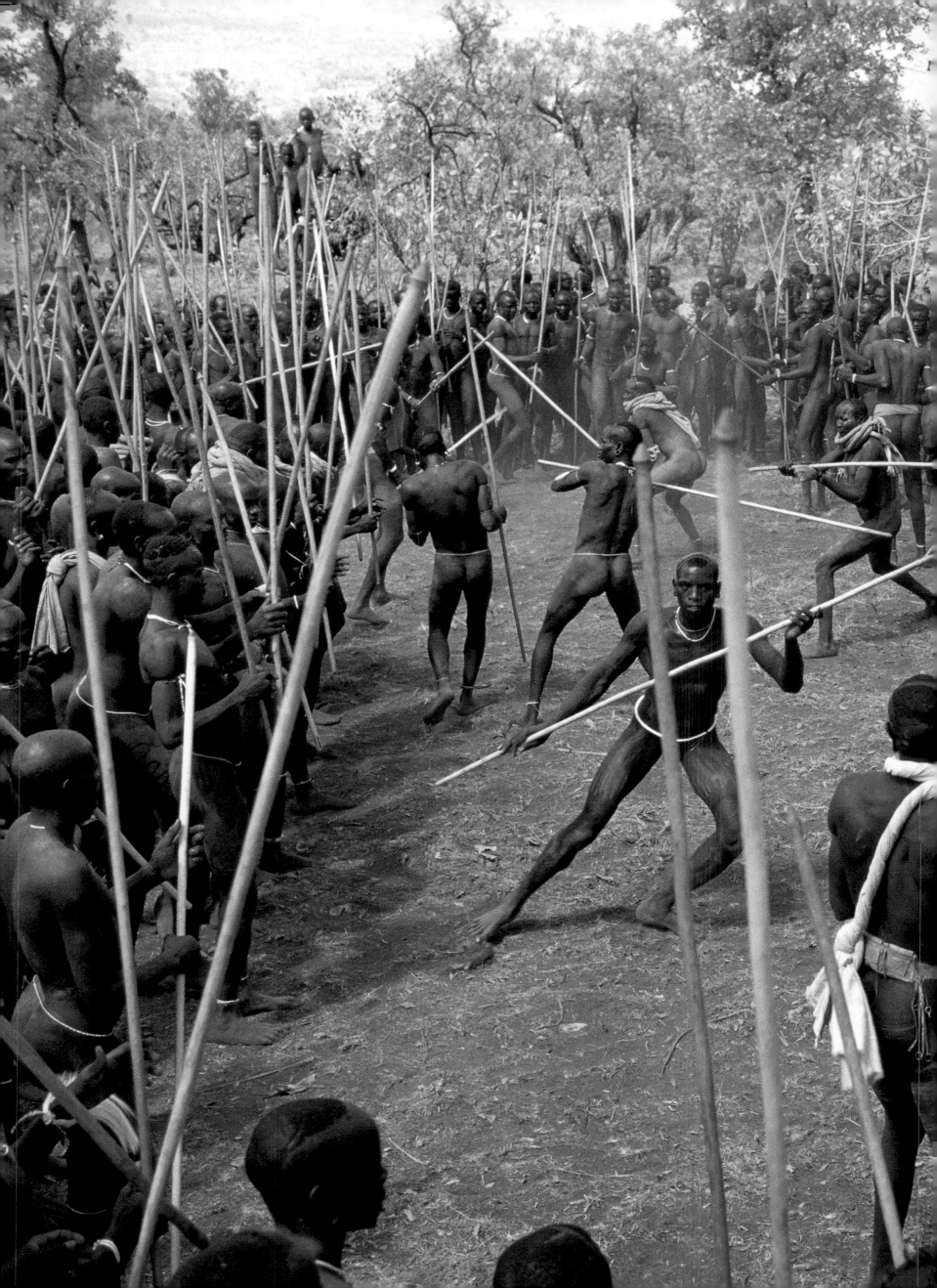

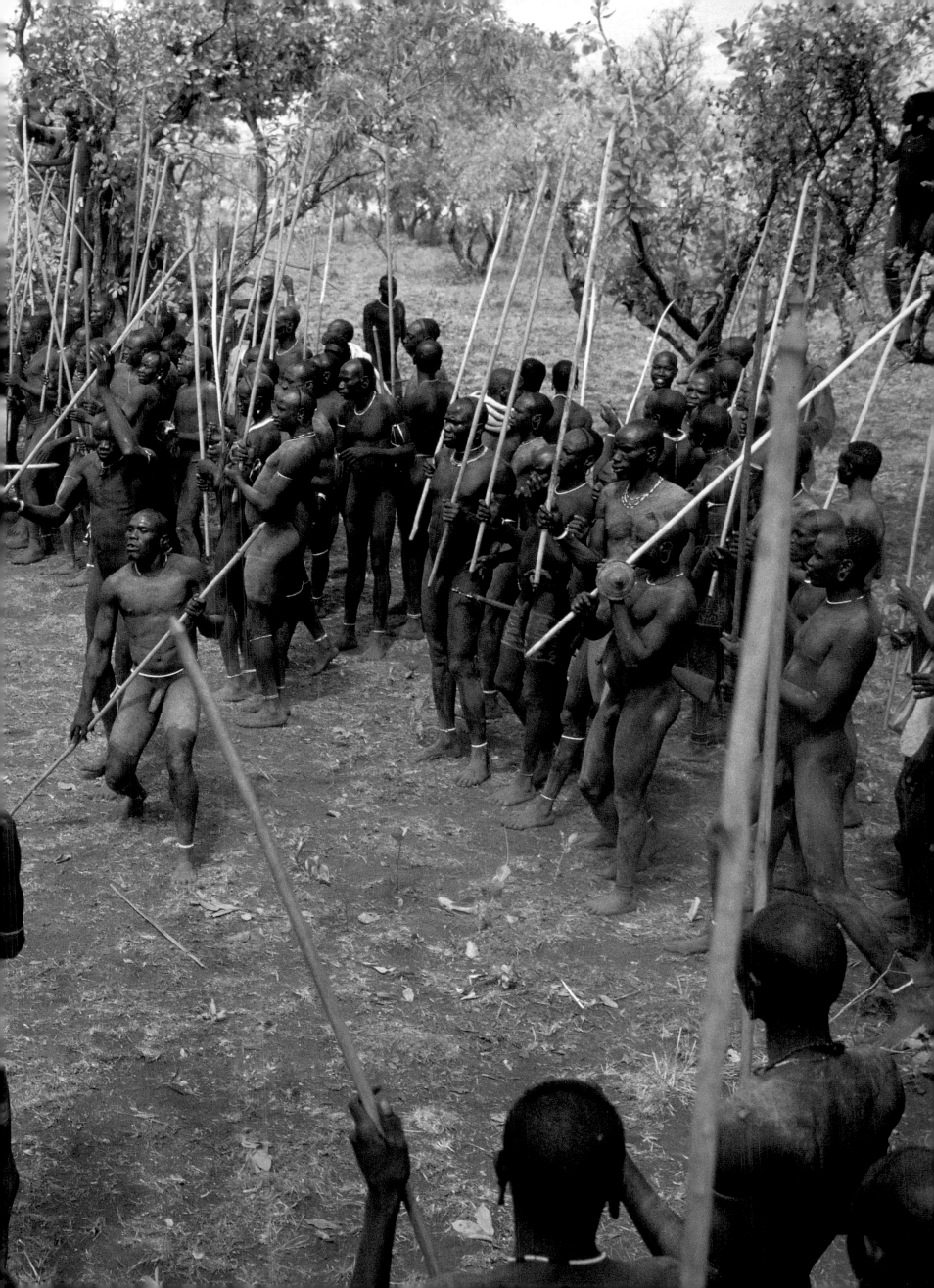

WODAABE CHARM DANCES take place at the end of the rainy season in the vast reaches of the Sahel, the "shores of the Sahara Desert" in central Niger. For seven days, up to 1,000 men participate in a series of dance competitions judged solely by women. During this week, women single out the most desirable men, choosing husbands and lovers: many romantic alliances flourish.

RIGHT:

A Wodaabe man wraps a twelve-foot-long turban in preparation for the Yaake dance, a competition of charm and personality.

>OVERLEAF:

Performing the Yaake, the male dancers stand shoulder to shoulder, quivering forward on tiptoe to accentuate their height, and launch into a series of wildly exaggerated facial expressions: eyes roll, teeth flash, lips purse, part, and tremble, and cheeks pout in short puffs of breath. A man who can hold one eye still and roll the other is considered particularly alluring to the judges. The Wodaabe say that it is through the strength of the eyes that marriages are made. At the height of their dancing, an elder woman dashes up and down the line of dancers to inspire greater performances.

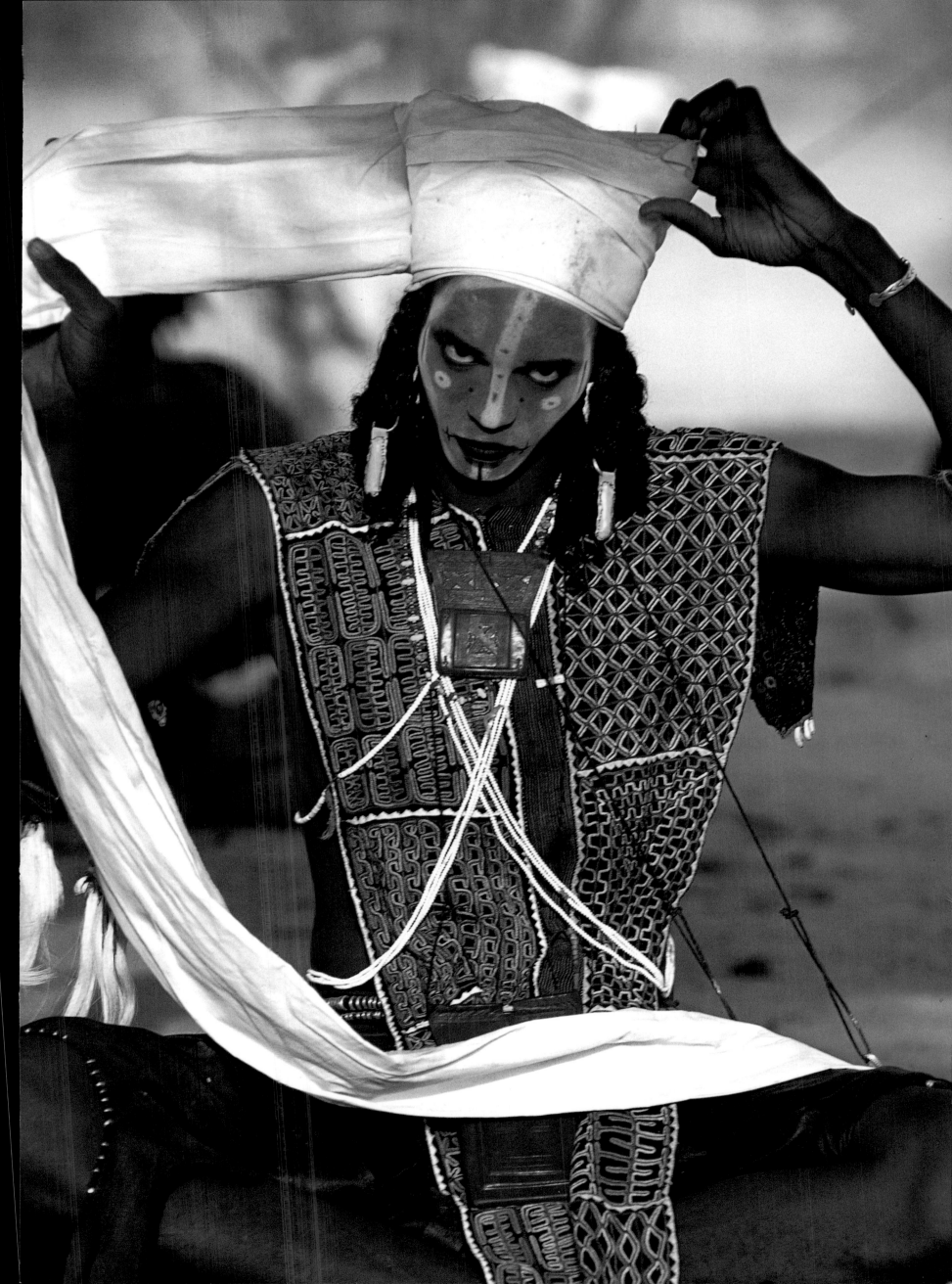

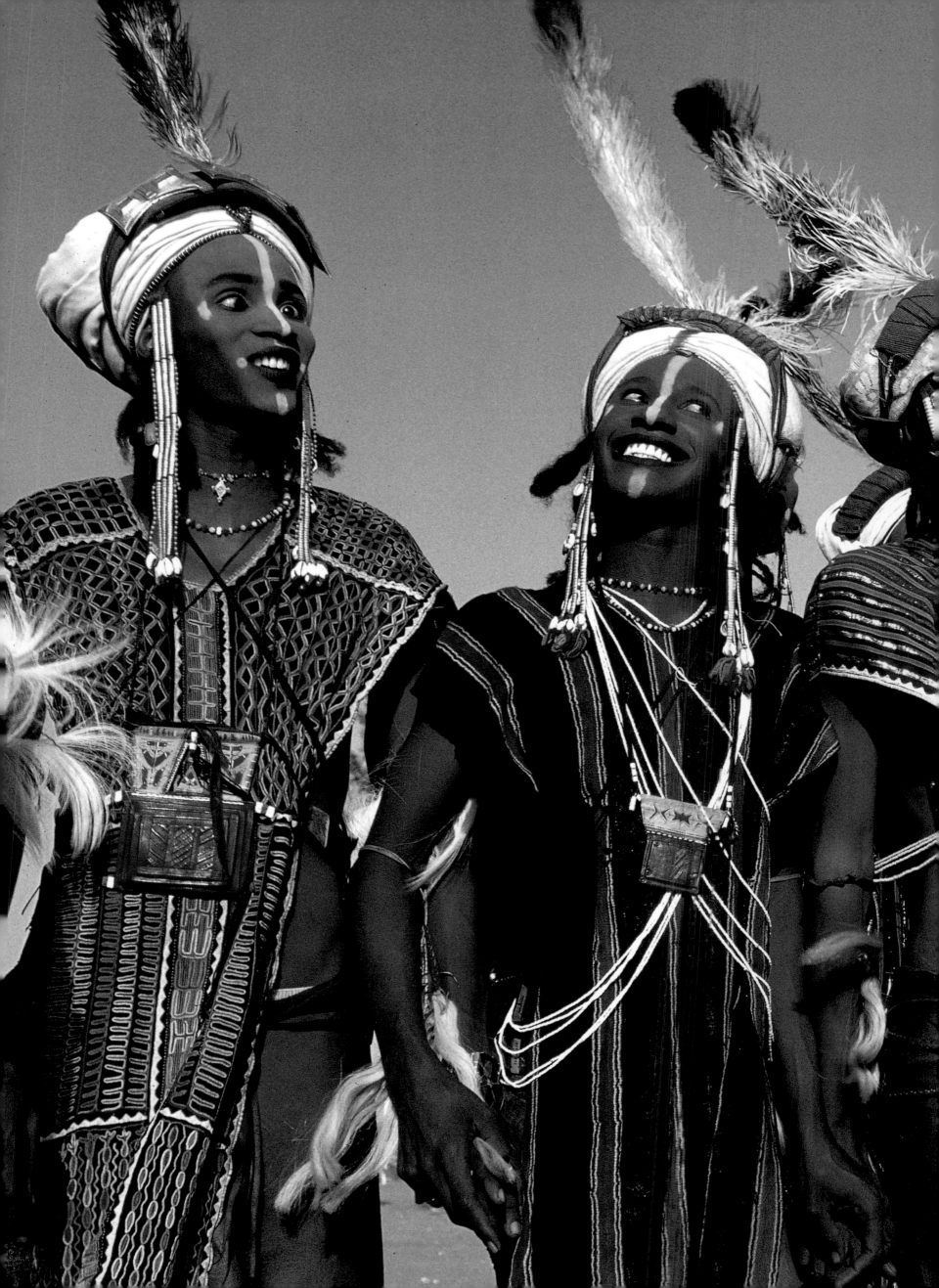

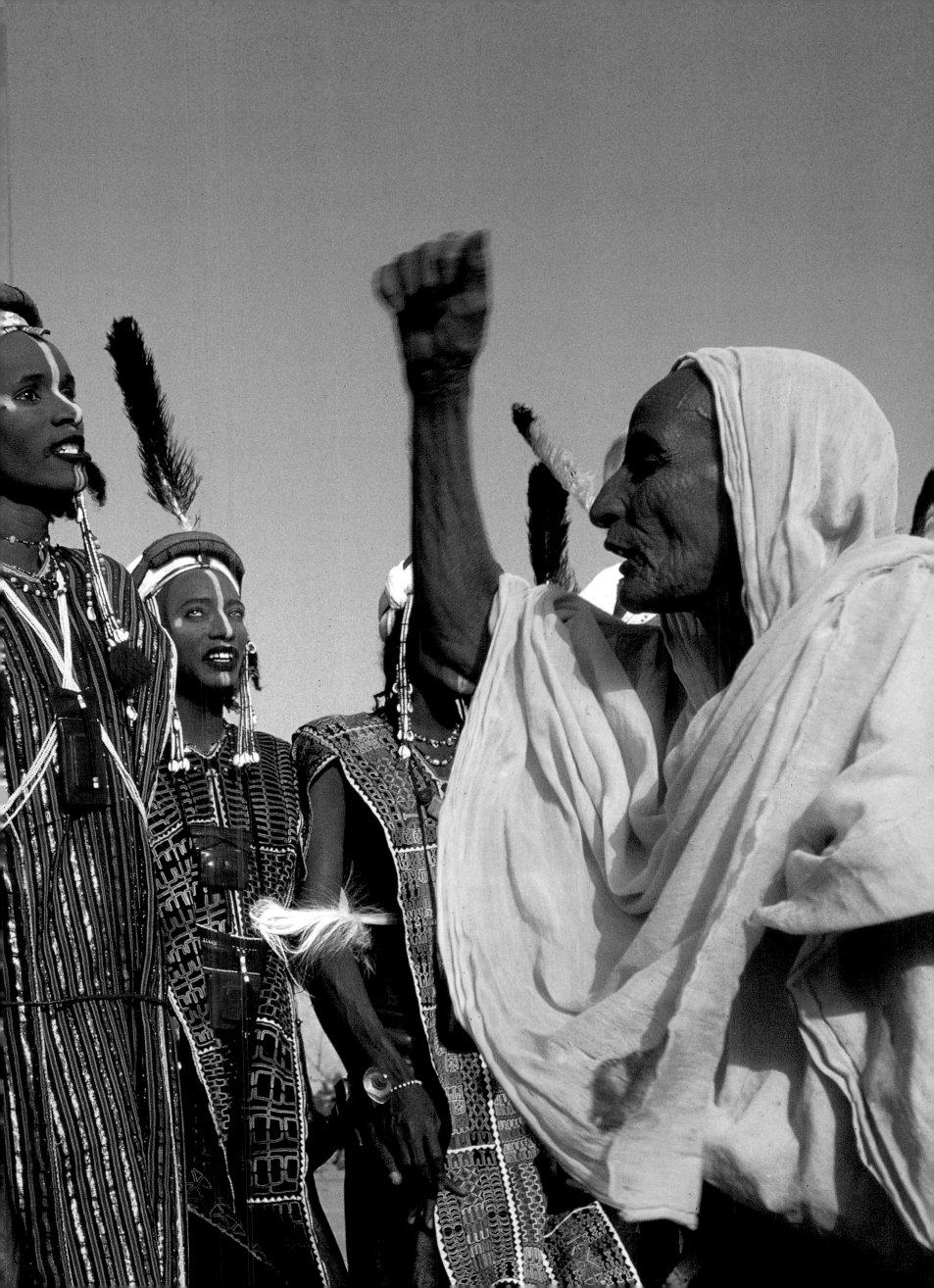

TRADITIONAL WEDDINGS OF THE TUAREG NOMADS of the Sahara Desert begin with the announcement of marriage by the local blacksmith, who is believed to possess special powers of sorcery.

RIGHT:

A distinguished guest at a Tuareg wedding, this nobleman has dressed in his finest, indigo-dyed robe and wears attached to his turban a cylindrical silver box containing verses from the Koran.

BELOW:

In the privacy of her mother's tent, a fifteen-year-old bride prepares for her wedding. Most important of all, the wife of the blacksmith plaits her hair. The Tuareg insist that a bride's hair must be dressed by a woman of the smith's family or else the girl's hair will fall out during the first two years of marriage. The grooming completed, the bride begins a ritual seclusion for a week before the wedding.

>OVERLEAF:

Dressed in their nuptial finery, women wedding guests arrive on donkeys heavily laden with intricately patterned leather cushions and blankets, the men towering high above them on camels.

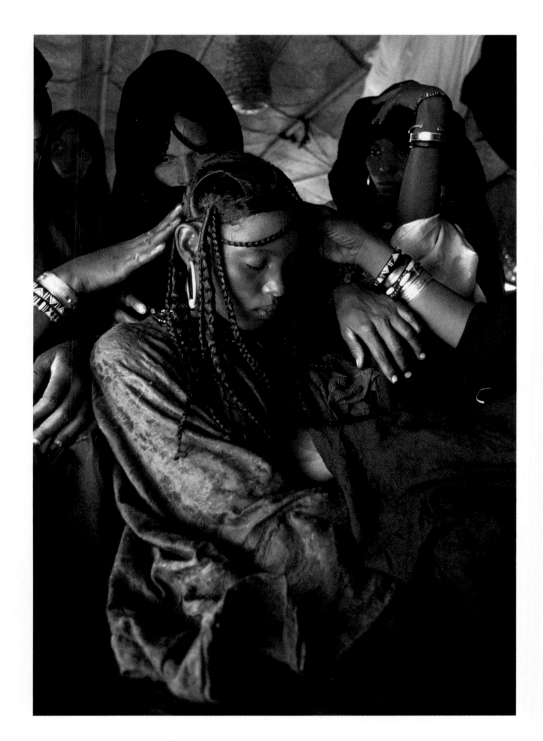

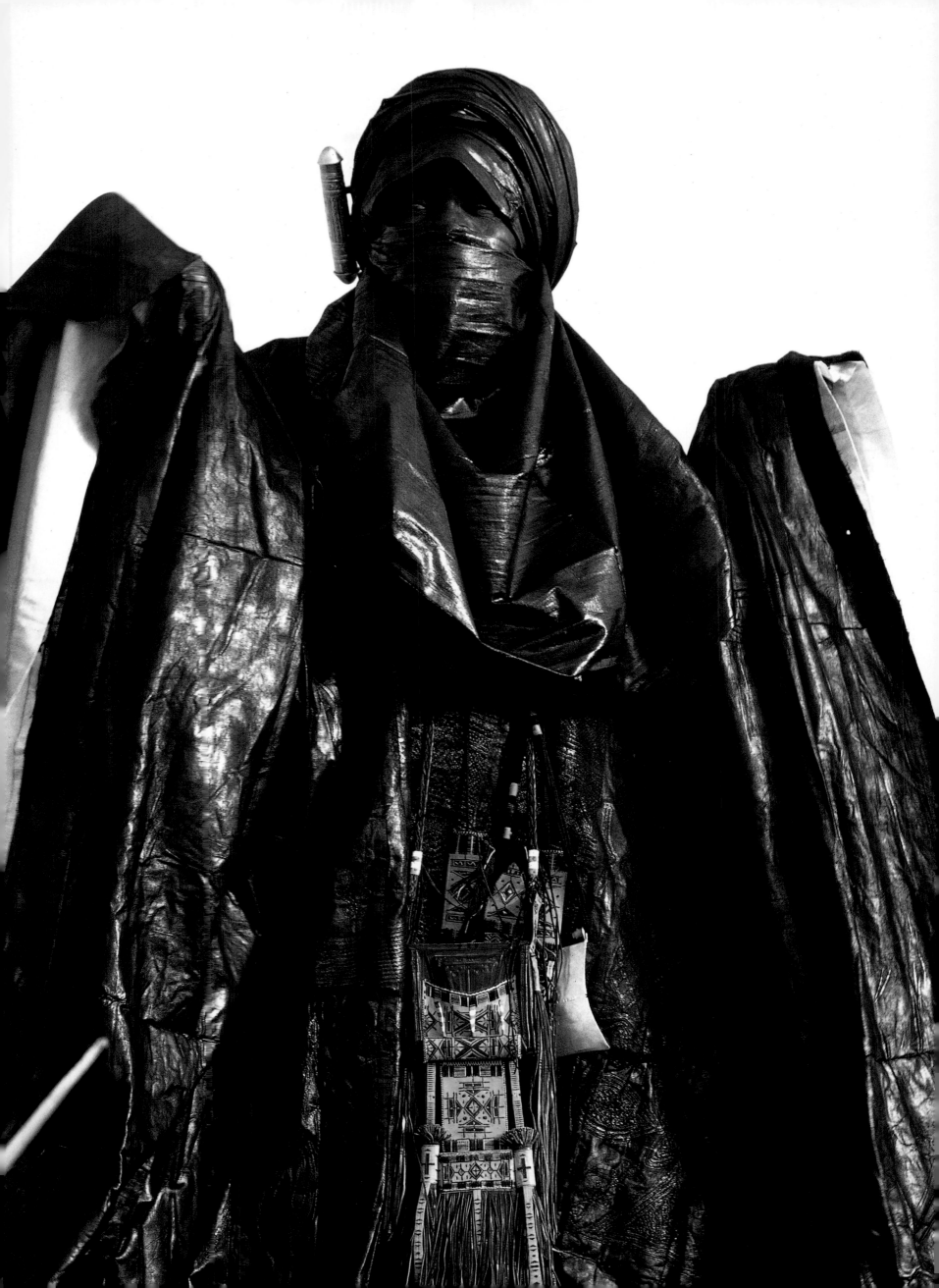

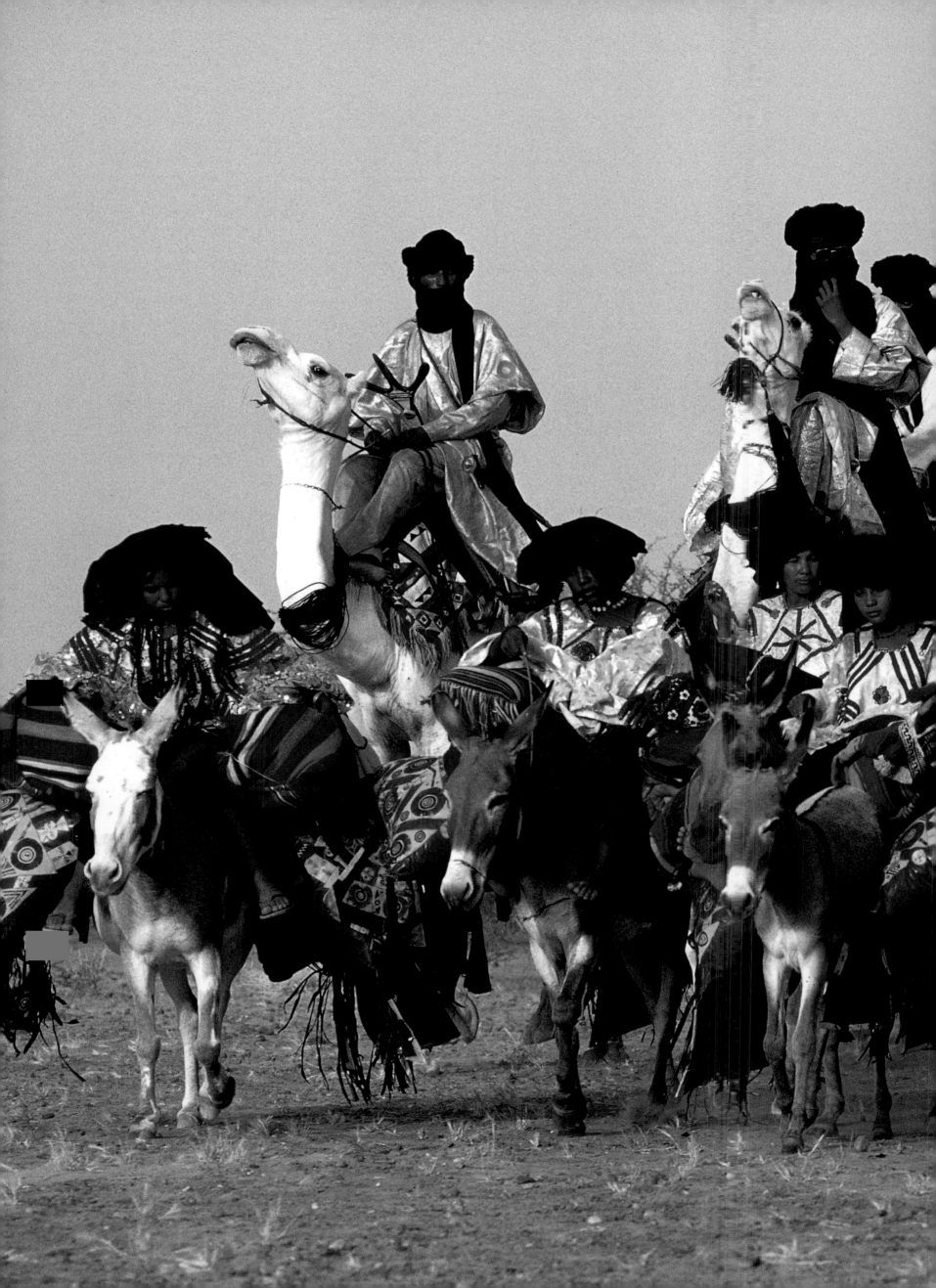

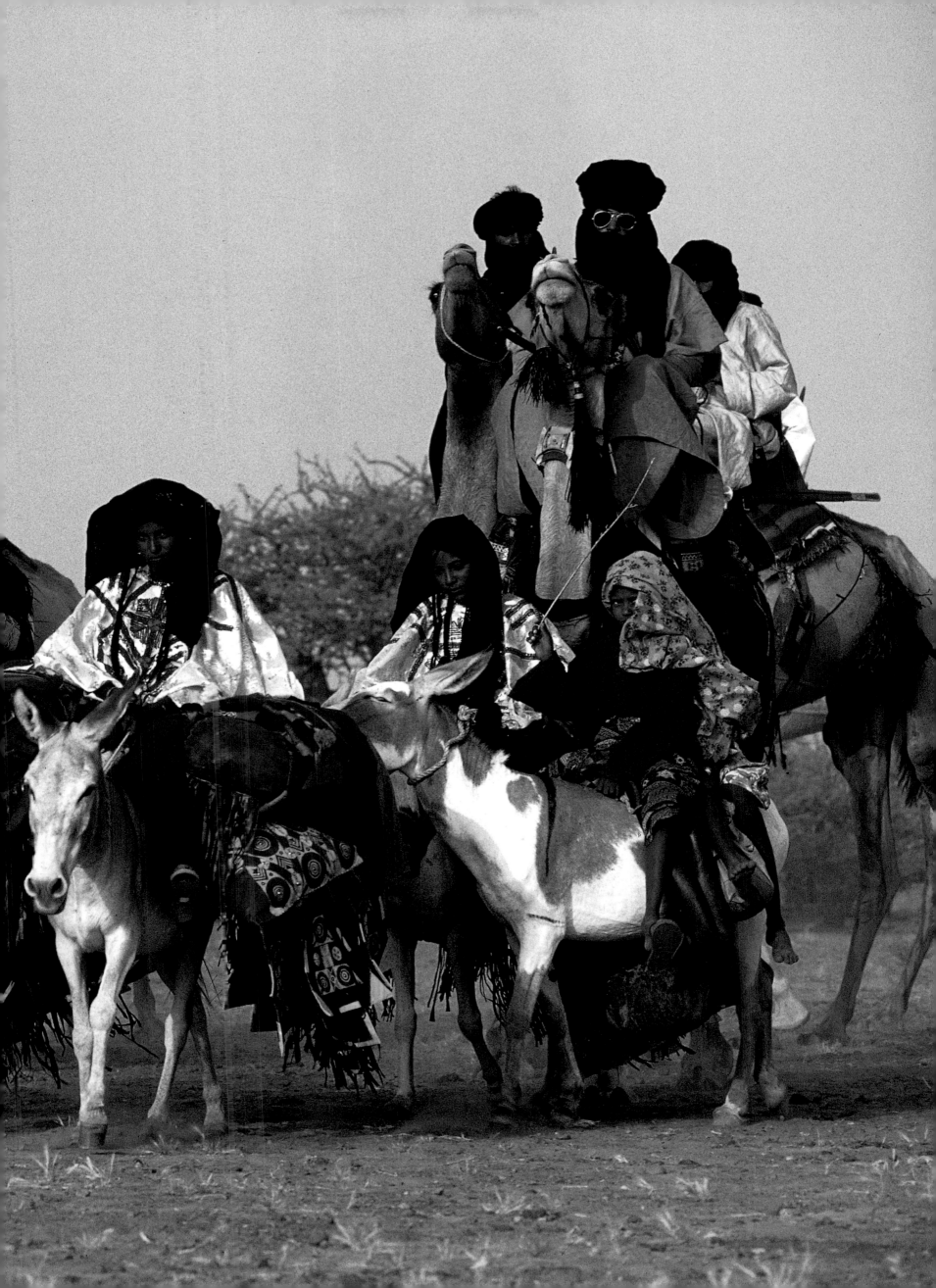

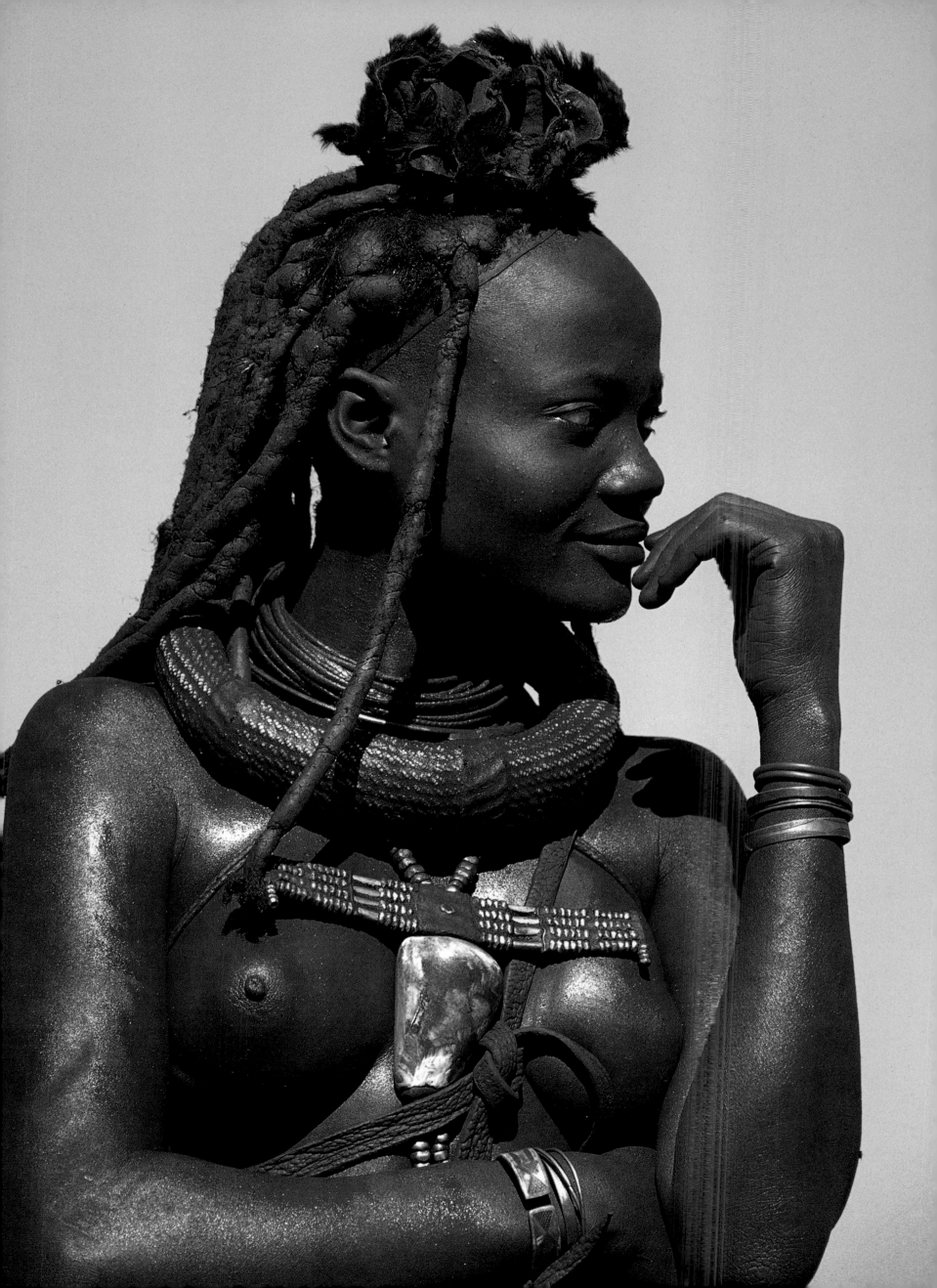

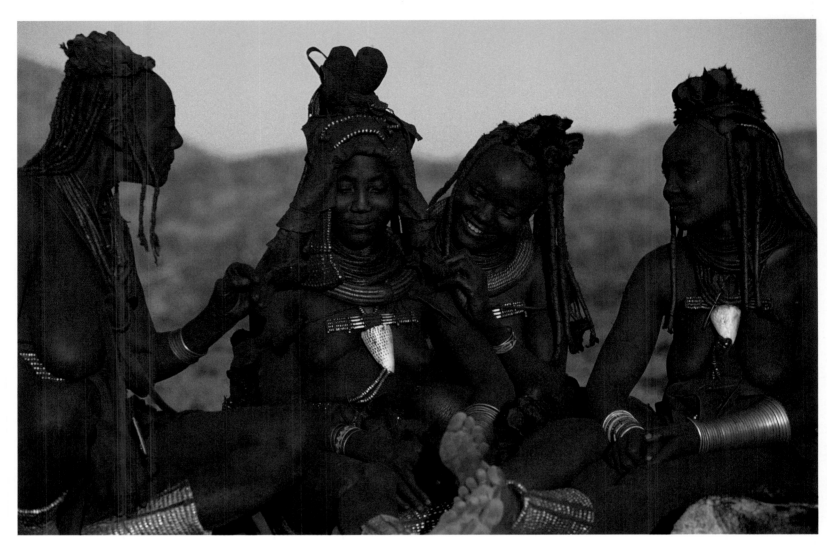

MARRIAGES OF THE HIMBA PEOPLE in the remote northwest corner of Namibia, are usually arranged by parents, as in many African cultures. Even in the case of a love match, the couple must have the agreement of their parents regarding the number of cattle to be given as dowry.

ABOVE:

On the morning of the marriage, female friends apply ocher and perfumed butterfat to the bride, who wears the traditional *ekori* headdress.

LEFT:

Beautified with ocher, a young Himba woman guest awaits the wedding festivities, which take place over several days.

>OVERLEAF:

In the tranquil darkness of her family hut, a mother prepares her daughter for marriage, giving her the ceremonial *ekori* headdress. With the front coil of her *ekori* rolled forward as she leaves her parental home, the bride can only focus ahead, and is thus shielded from the emotions of leaving her family.

>>NEXT FOLLOWING PAGES:

A Himba family gather at their semi-permanent dwelling among their animals.

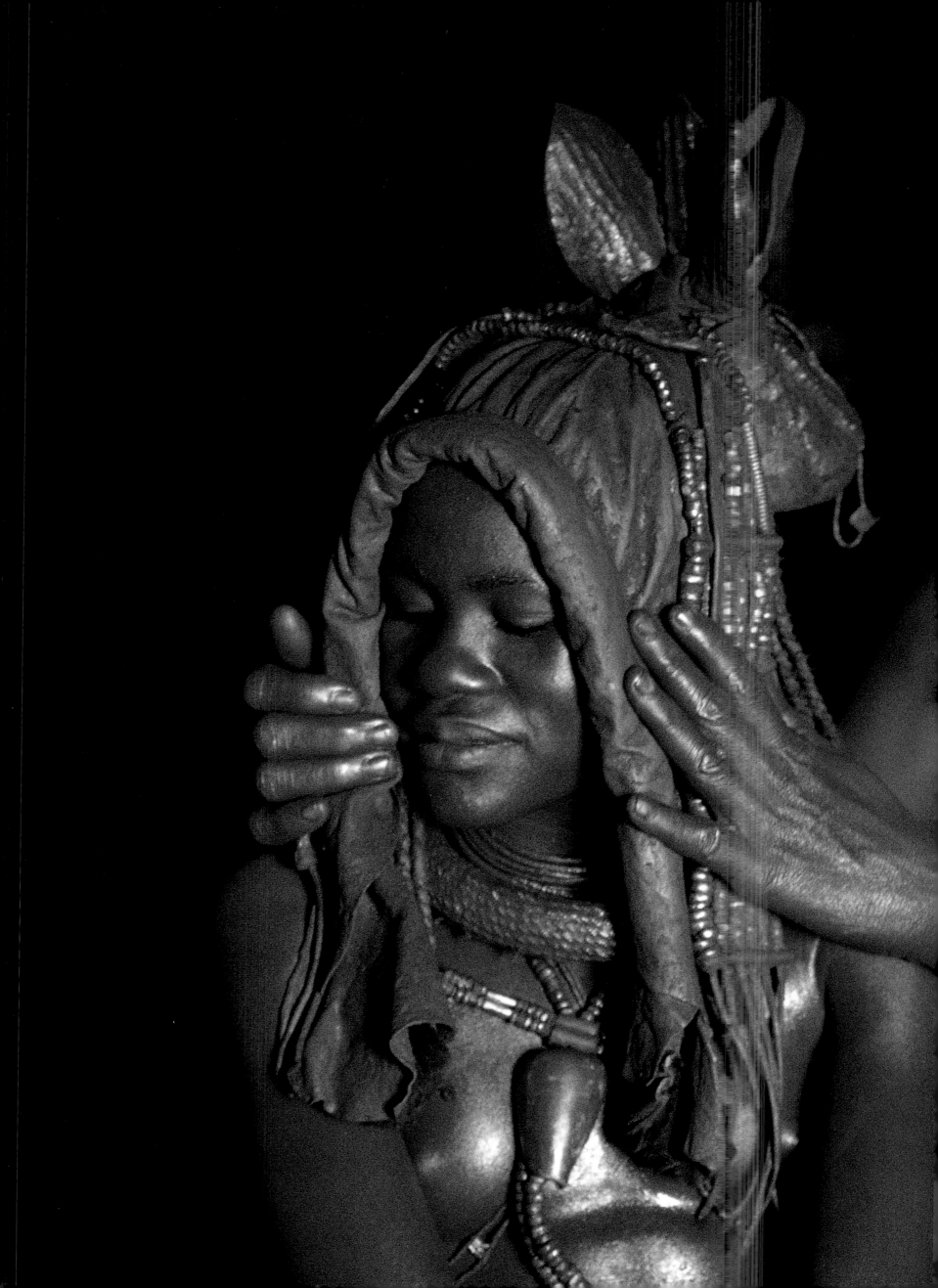

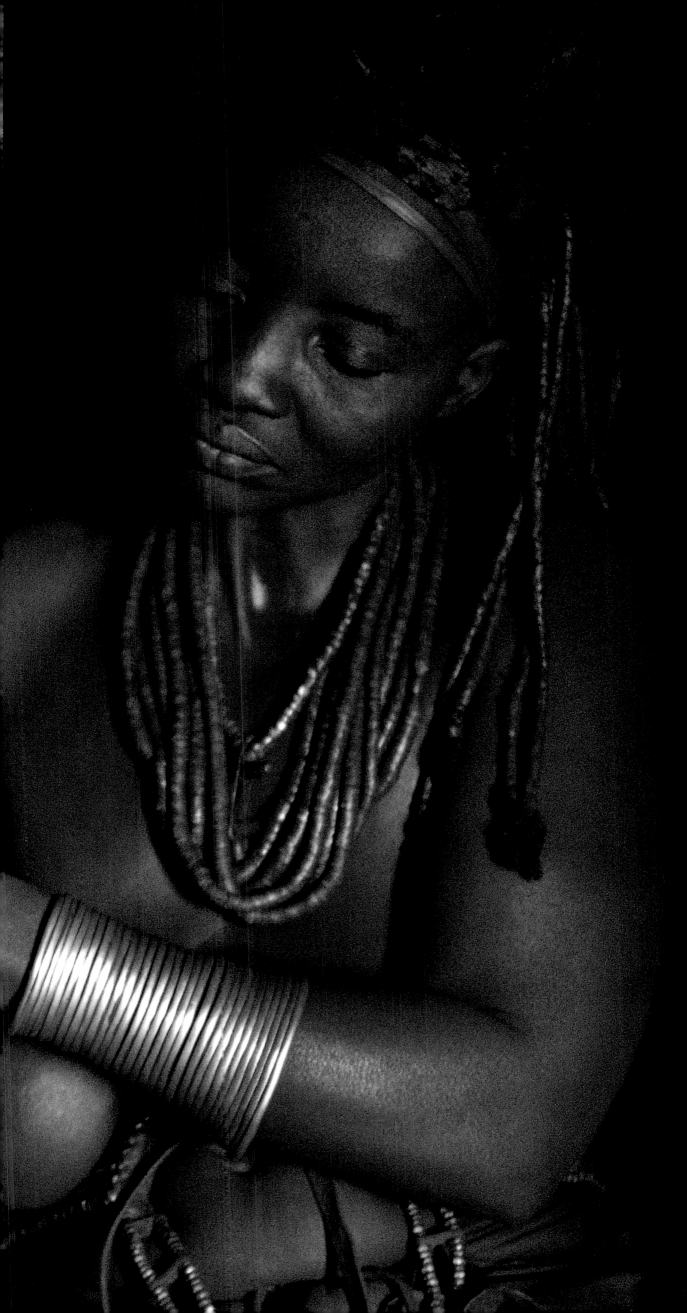

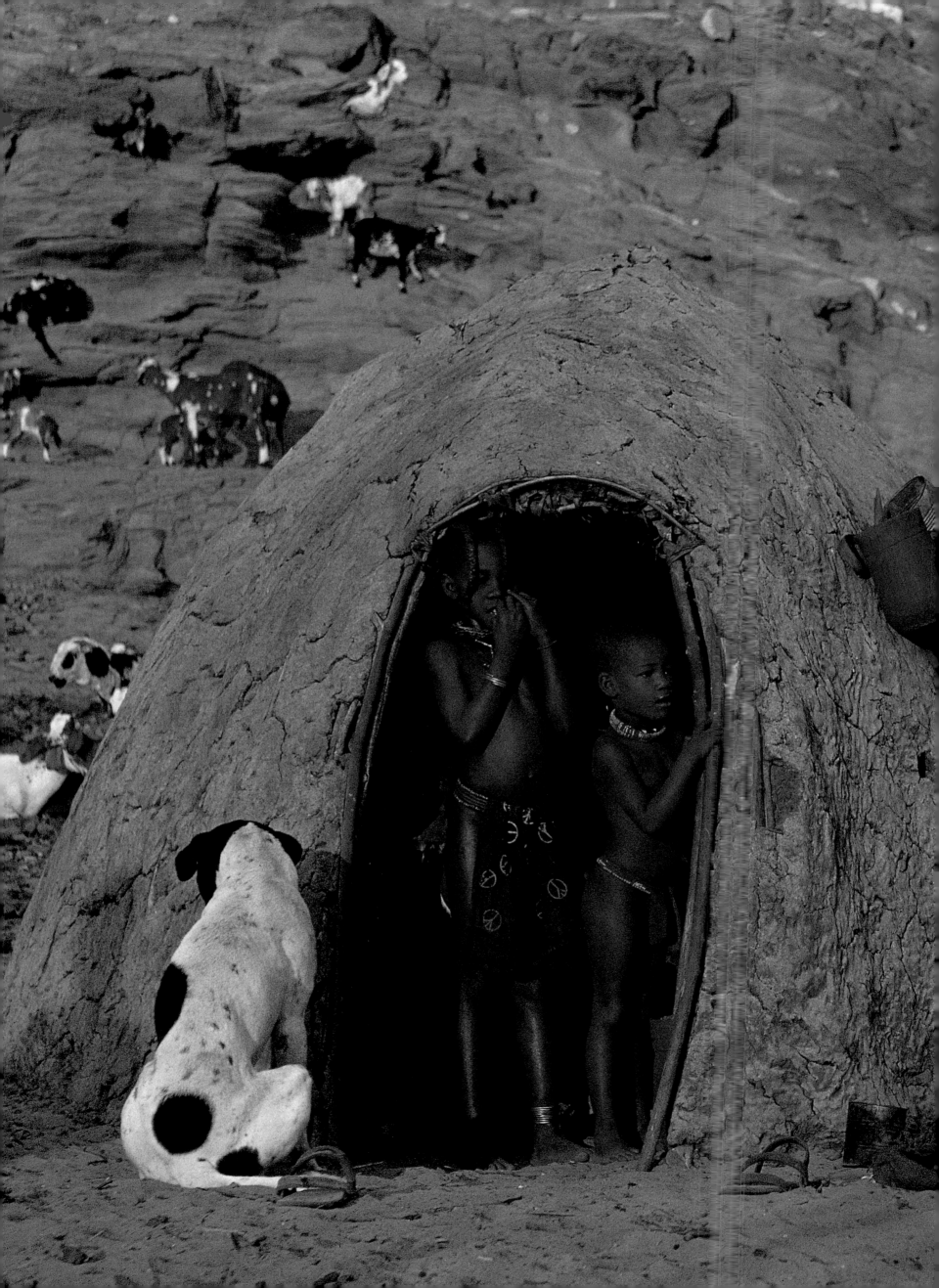

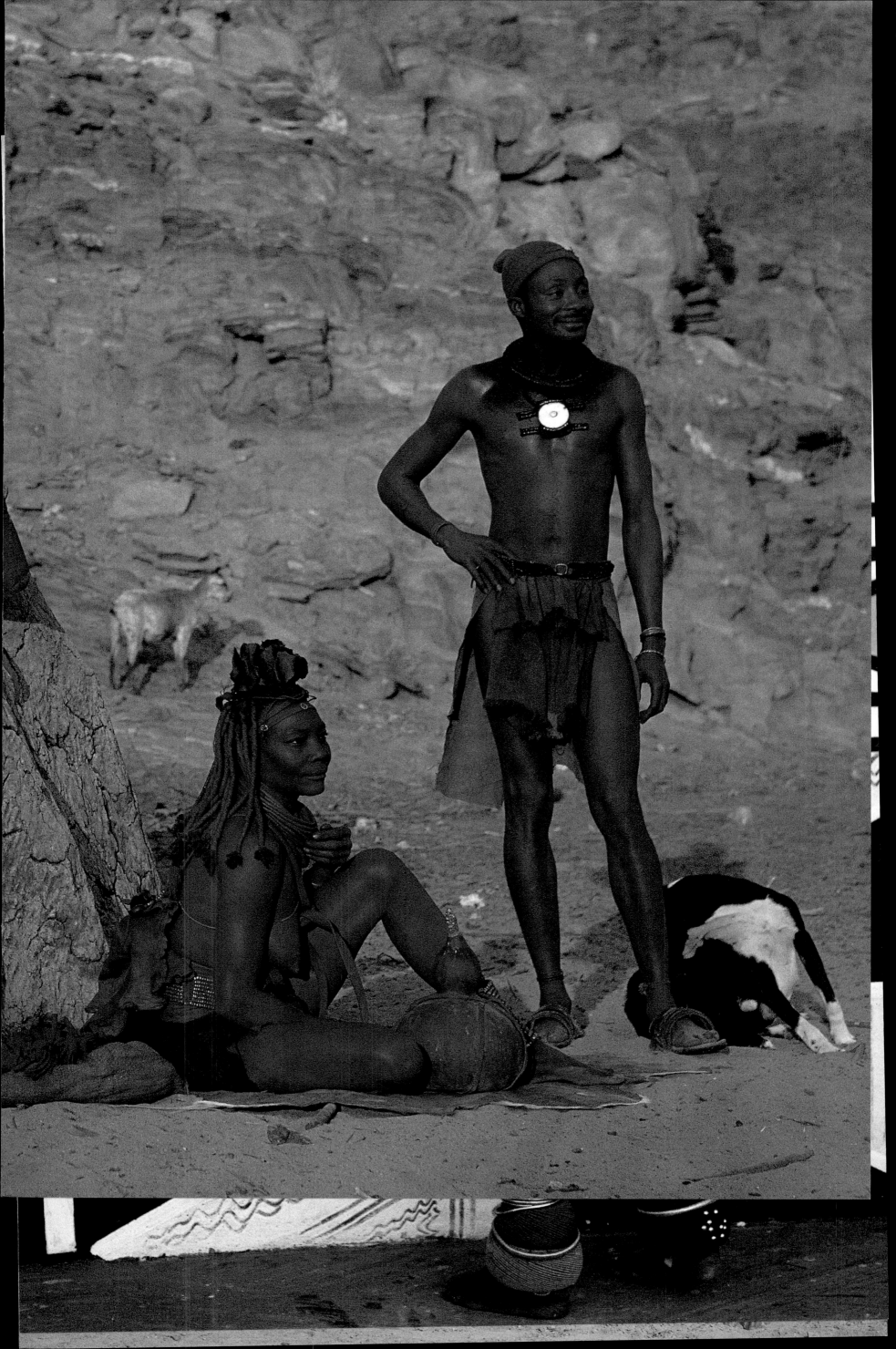

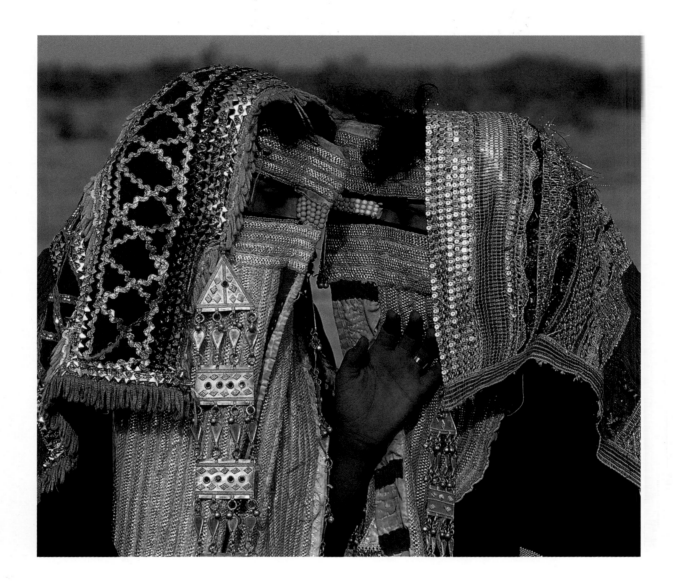

VEILED SINCE THE AGE OF FIVE, Muslim women are required by the law of purdah to cover their faces throughout their lives when they are in public. When they eat, they pass food beneath the mask, and when they sleep they must still remain lightly covered. The mask may be removed only when they are alone with their husbands. The Rashaida believe that showing a smile, a sign of happiness, would be disrespectful to the Prophet Mohammed. They also view the mask as an expression of female beauty, and its elaborate style has remained unchanged for more than 150 years.

At a Rashaida wedding, the two women above exchange confidences and the young woman at right dances in celebration of her friend's marriage. The many layers of colorful fabrics she wears, including her richly appliquéd skirt, enhance her movements.

>OVERLEAF:

A Rashaida bride never appears in public during her wedding celebrations but visits her husband after dark. For six nights, she sleeps with him, rising before dawn to return to her tent. On the seventh day the couple begins to live openly as man and wife.

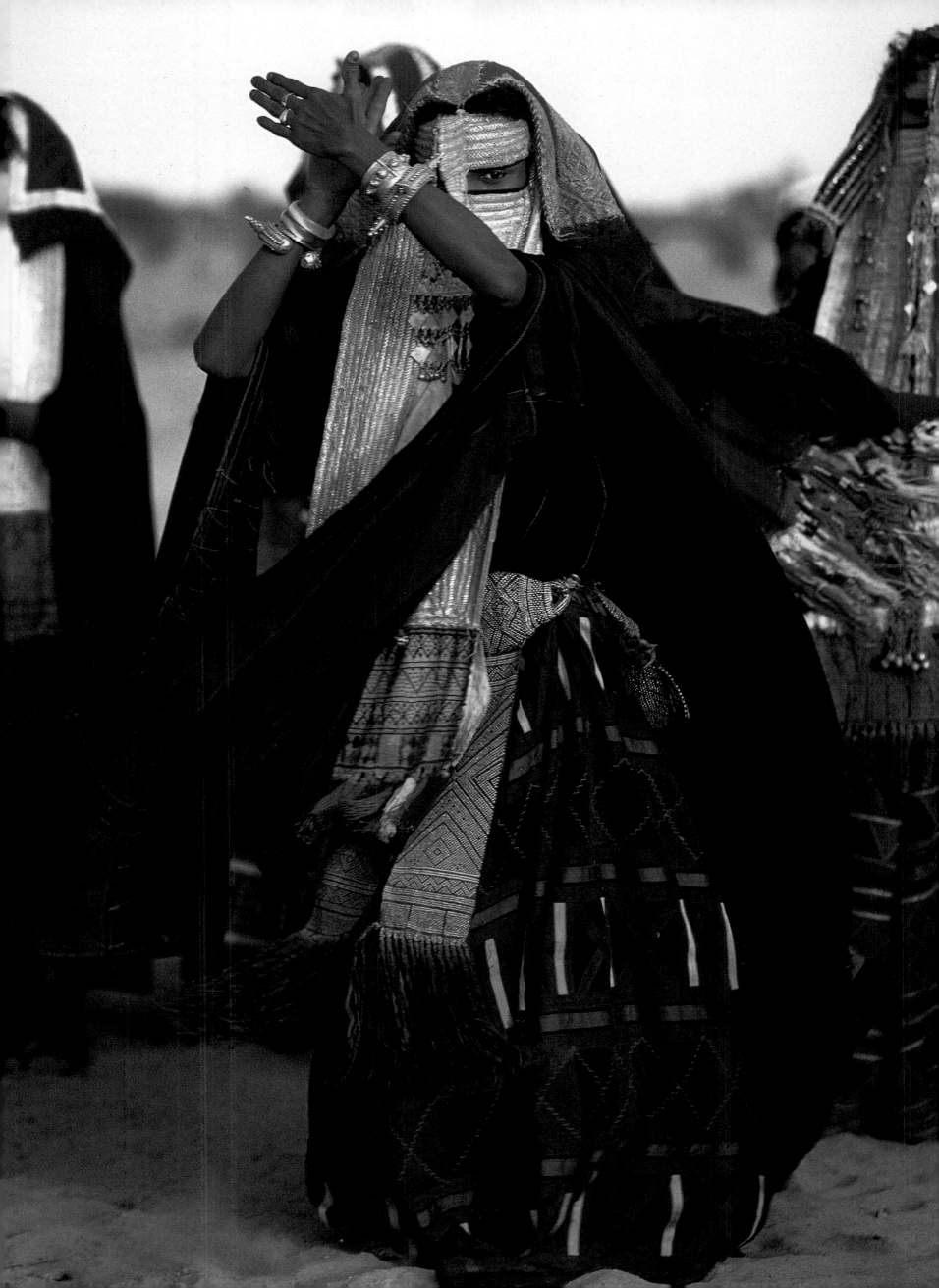

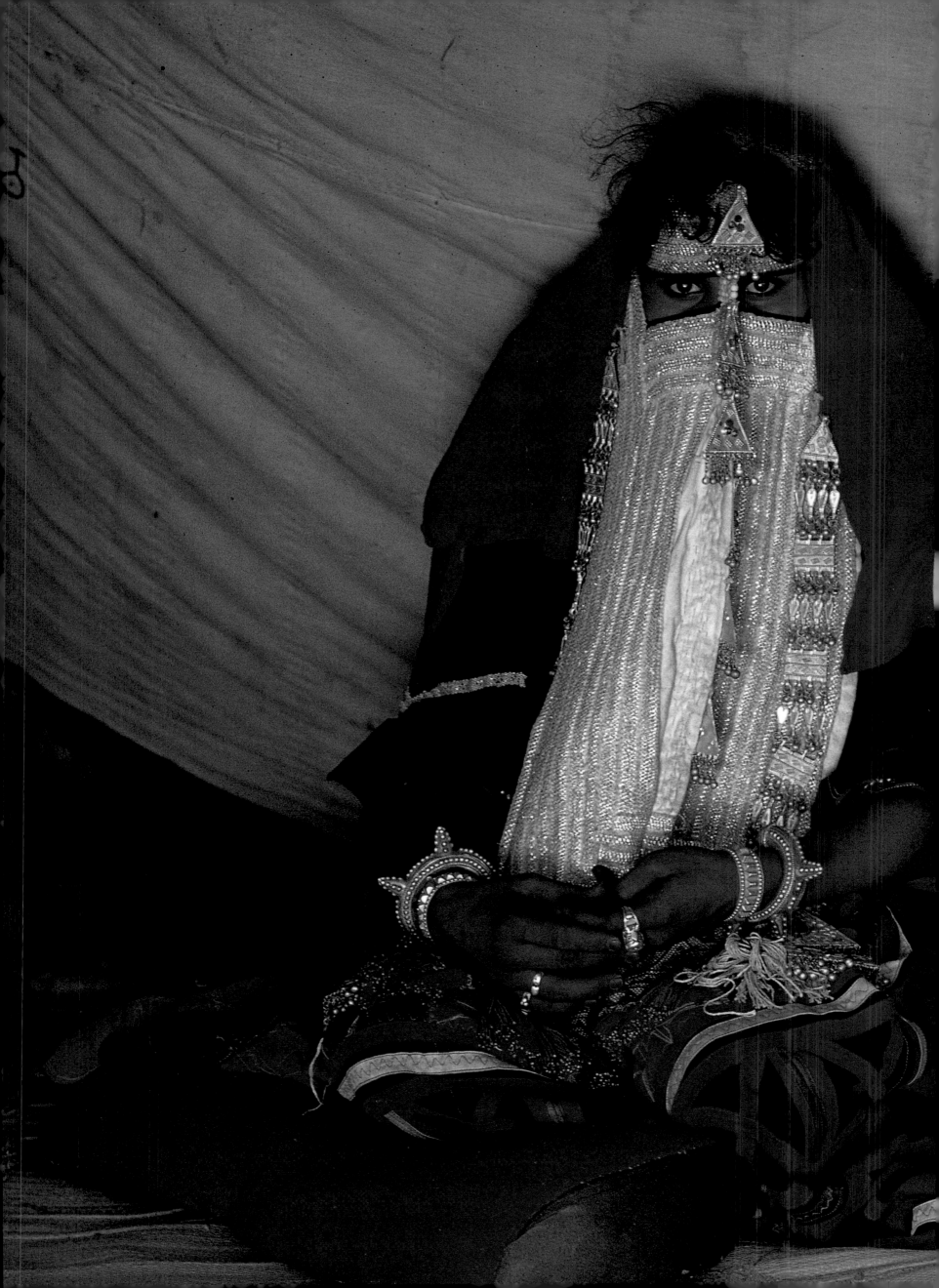

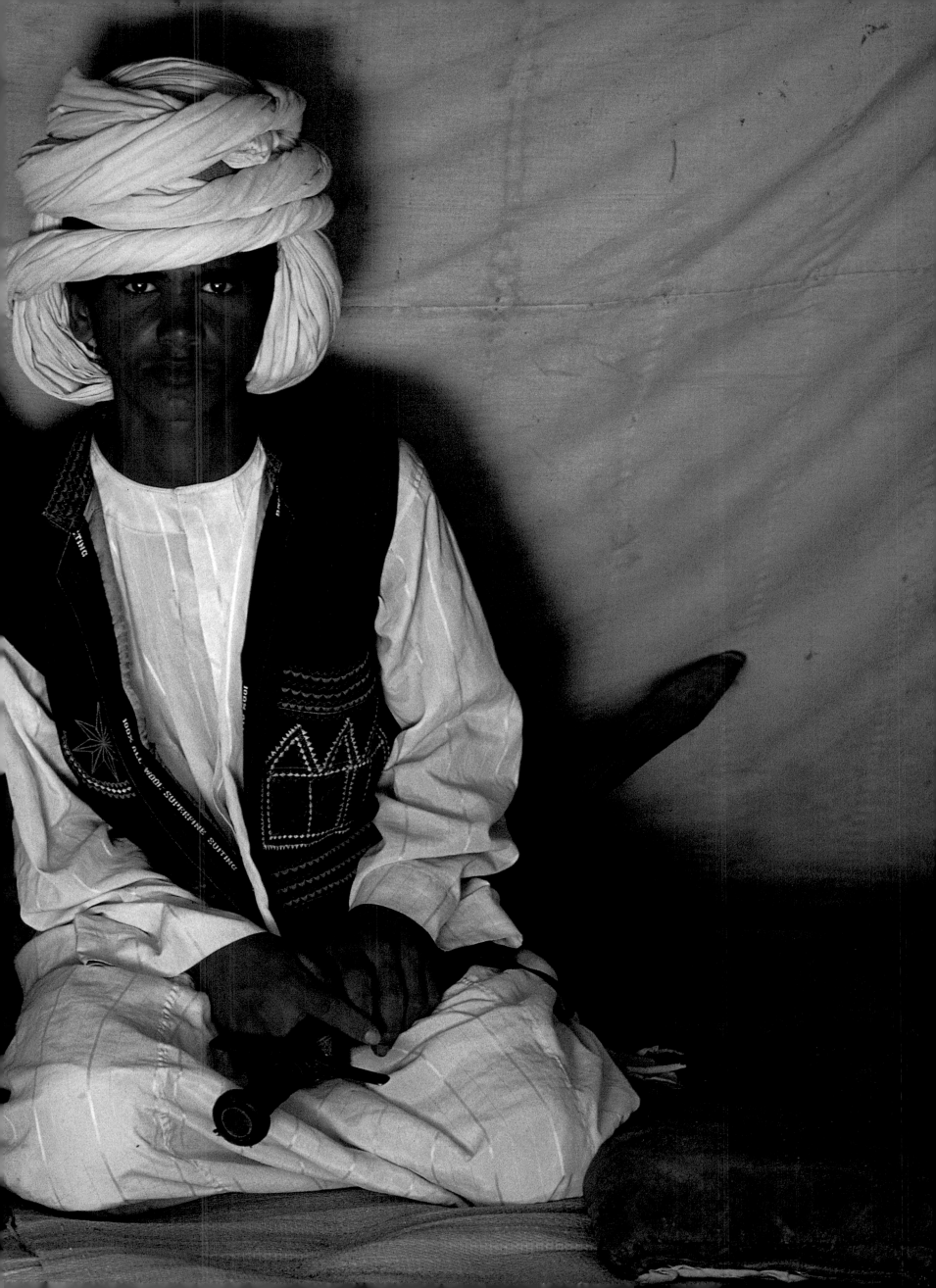

Bridal Portraits

ACROSS AFRICA, marriage is one of the most important events in a woman's life, and her elaborate adornment for her wedding enhances the occasion. The following portraits reflect the diverse and exquisite adornment worn by traditional African brides.

ZULU- A Zulu bride from South Africa wears a flaring red headdress reminiscent of the hair style of her ancestors.

TURKANA- Turkana men of northern Kenya say of a bride, "It's the things a woman wears that make her beautiful." The beaded necklace this girl wears indicates her availability for marriage.

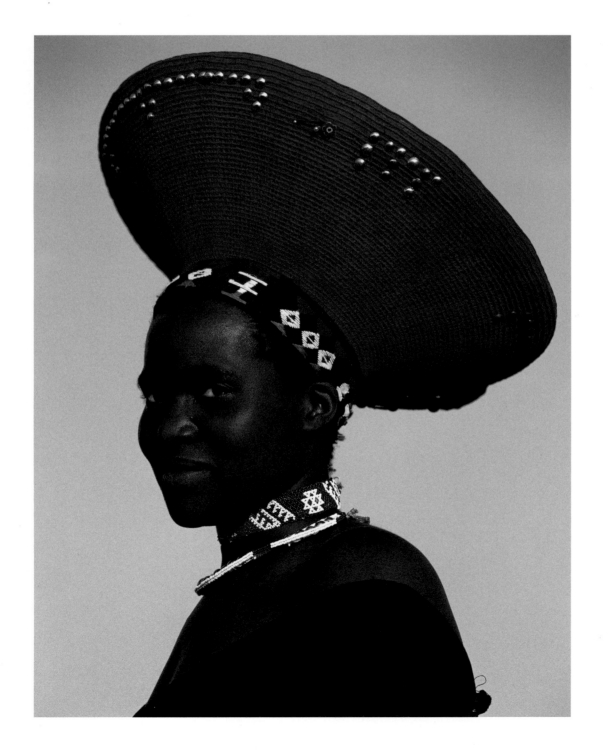

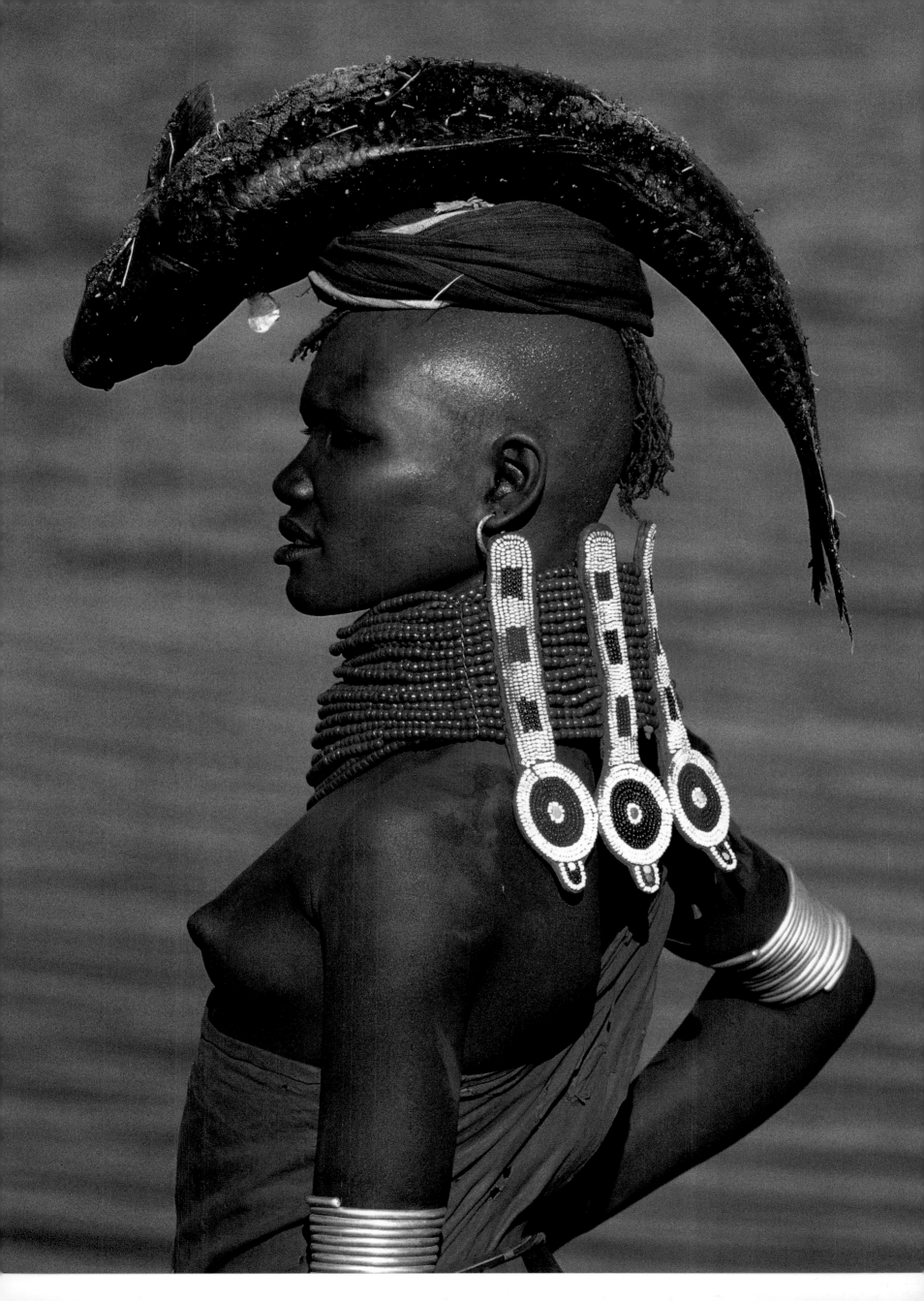

FULANI- A Fulani woman of Mali displays her bridal wealth in the form of large gold earrings and amber beads adorning her hair.

SURMA- A Surma bride from Ethiopia wears a clay lip plate, which is inserted six months before marriage. The size of the lip plate indicates the number of cattle that a young man must pay for her dowry. This bride wears a plate symbolizing the bride-price of seventy-five cattle.

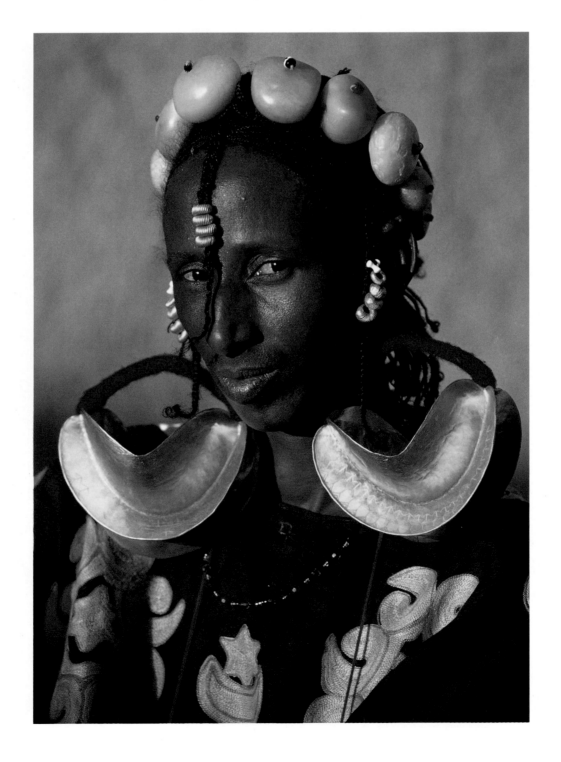

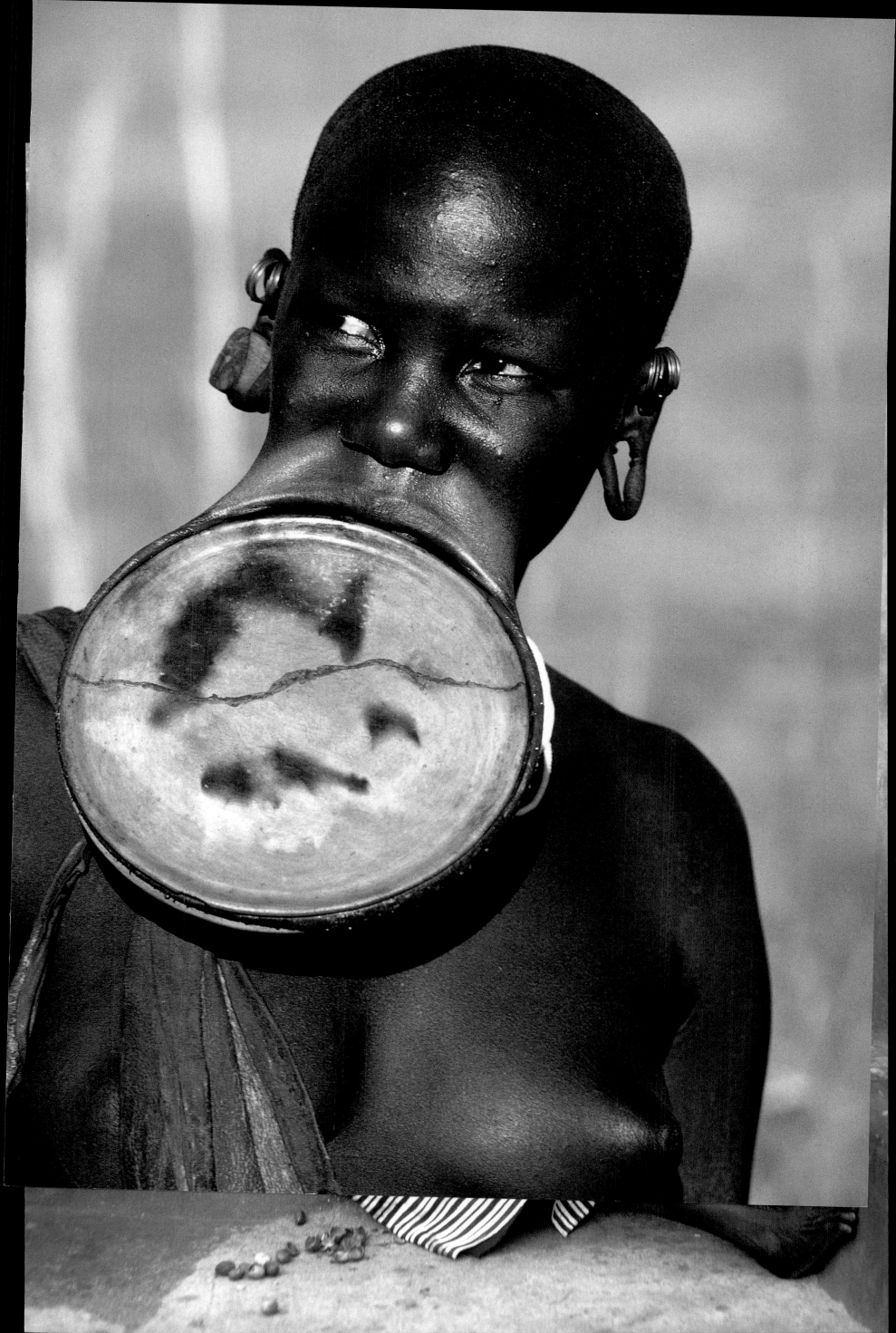

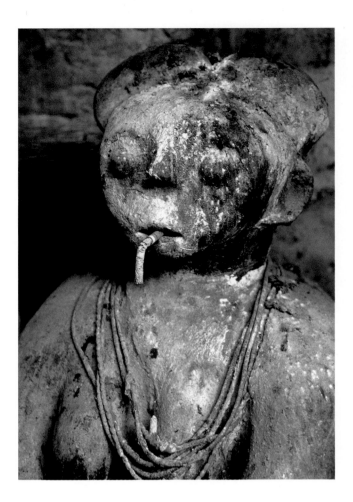

Beliefs and Worship

Voodoo, one of the oldest religions of West Africa, originated in Benin, Togo, and eastern Ghana, and is practiced by the Fon, Ewe, and Ga peoples. Voodoo has more than thirty million believers in West Africa alone, and is active today in Cuba, Haiti, and Brazil, where it was carried by the slave trade. Voodoo deities inhabit nature—animals, trees, and stones—and are embodied for human beings as "fetishes," which range in form from sculptural figures to amorphous mounds of earth. The highest state of being for a Voodoo believer involves complete abandonment to the spirit of a deity.

ABOVE:
One of the shrines of the Voodoo hospital in Togo houses a popular female deity, Gabara, who is frequently consulted by the lovesick, particularly women suffering from broken hearts. This deity figure receives offerings of cigarettes, gin, kola nuts, and perfume—substances believed to induce her to release her healing powers more quickly.

RIGHT:
At the Voodoo hospital, a priest acts as an intermediary between a deity and a patient.

>OVERLEAF:
Once every three years, on the border of Ghana and Togo, thousands of Voodoo followers gather together for a spectacular seven-day celebration honoring Flimani Koku, their ancient warrior god who provides defense against witchcraft and evil. The festival begins with pulsating Voodoo drum rhythms that stimulate dancers to spin themselves into intense trances.

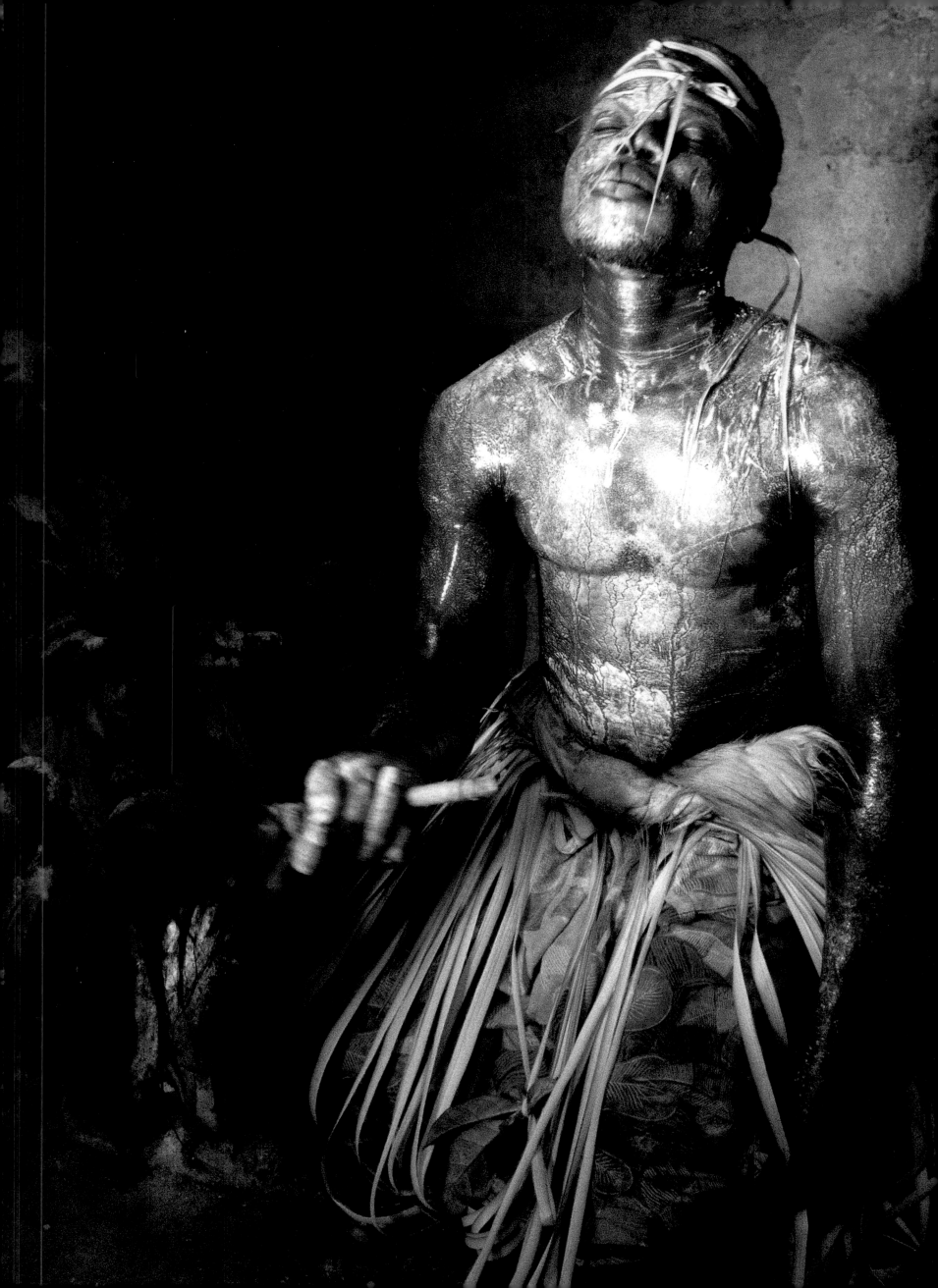

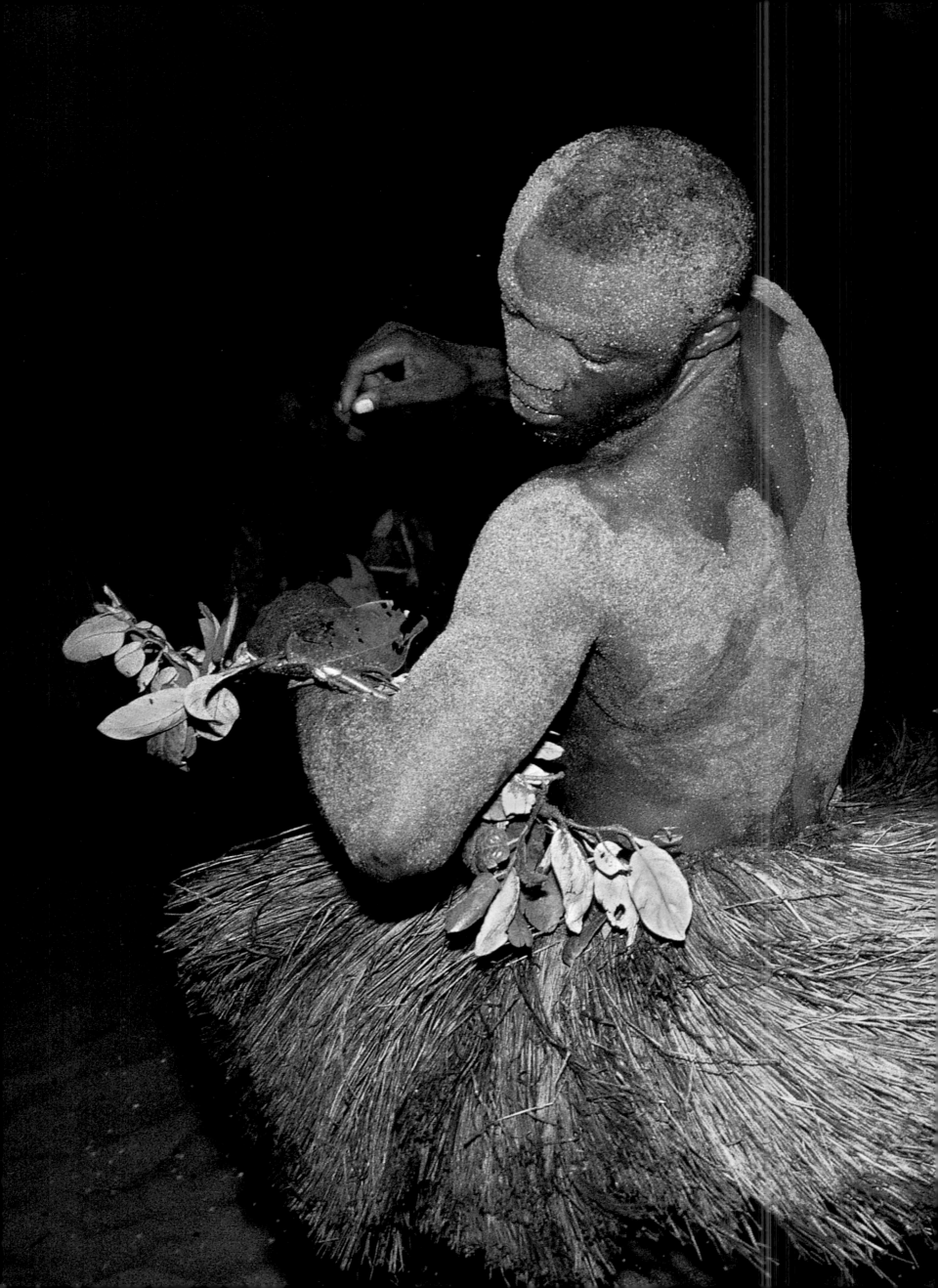

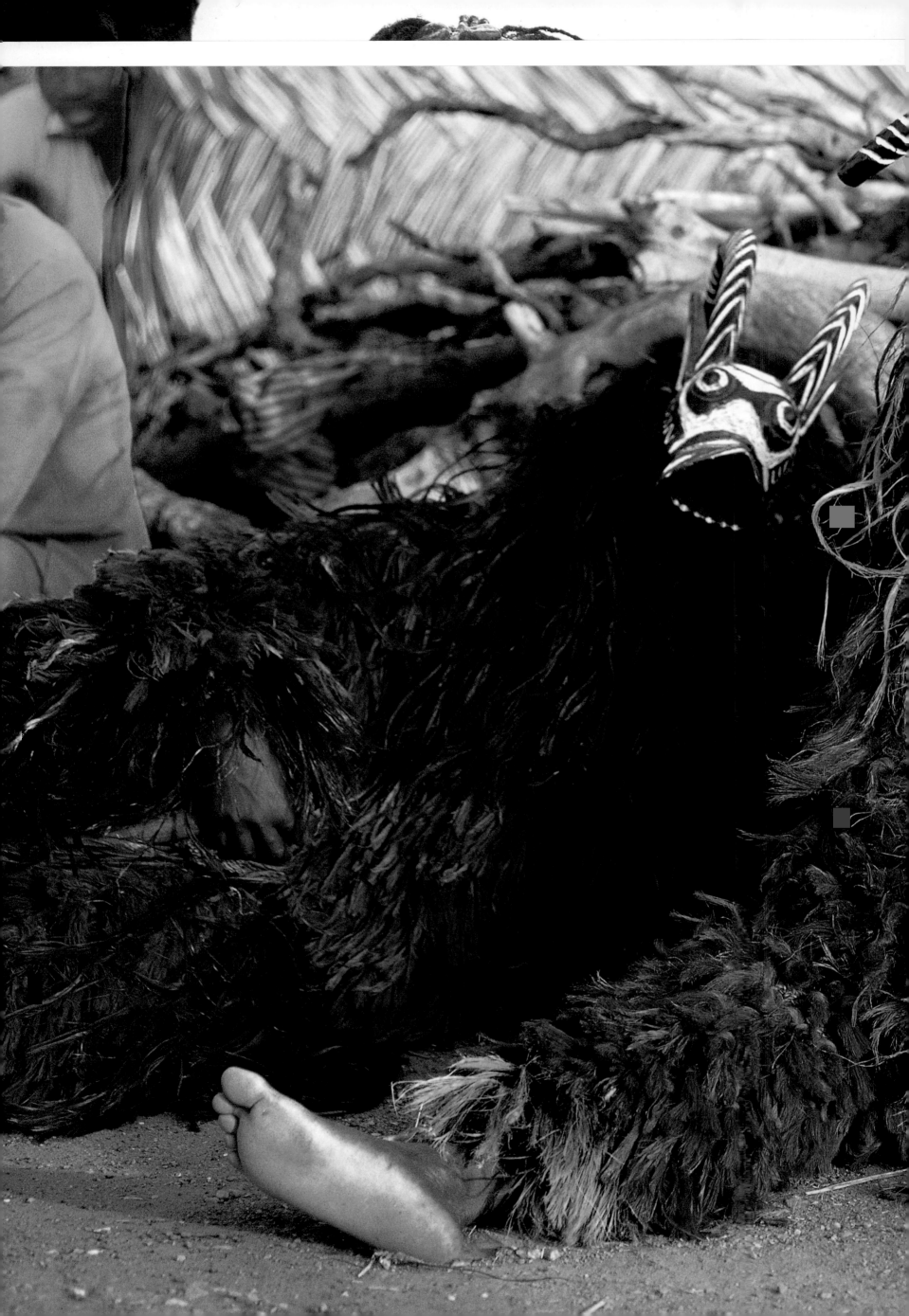

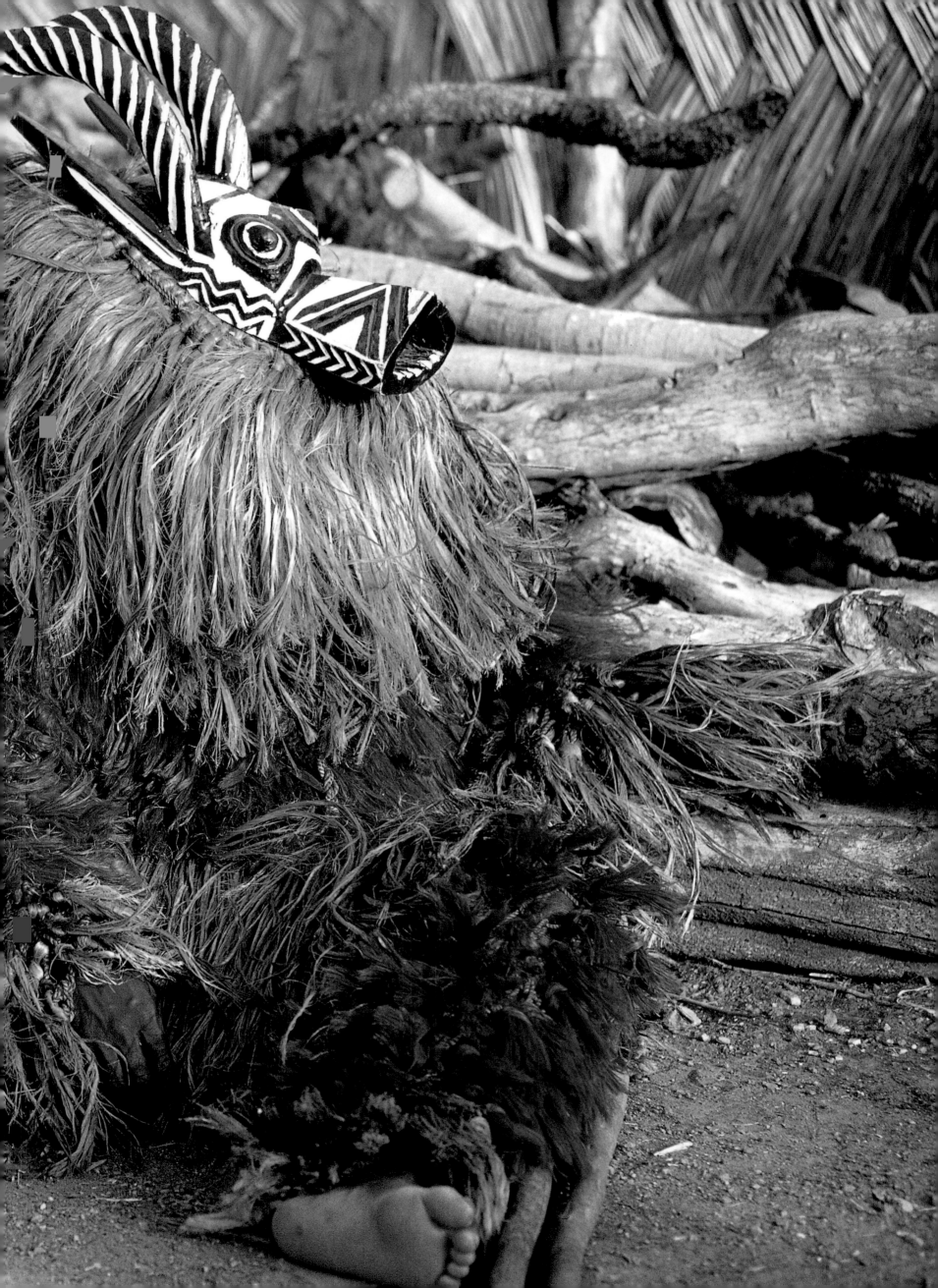

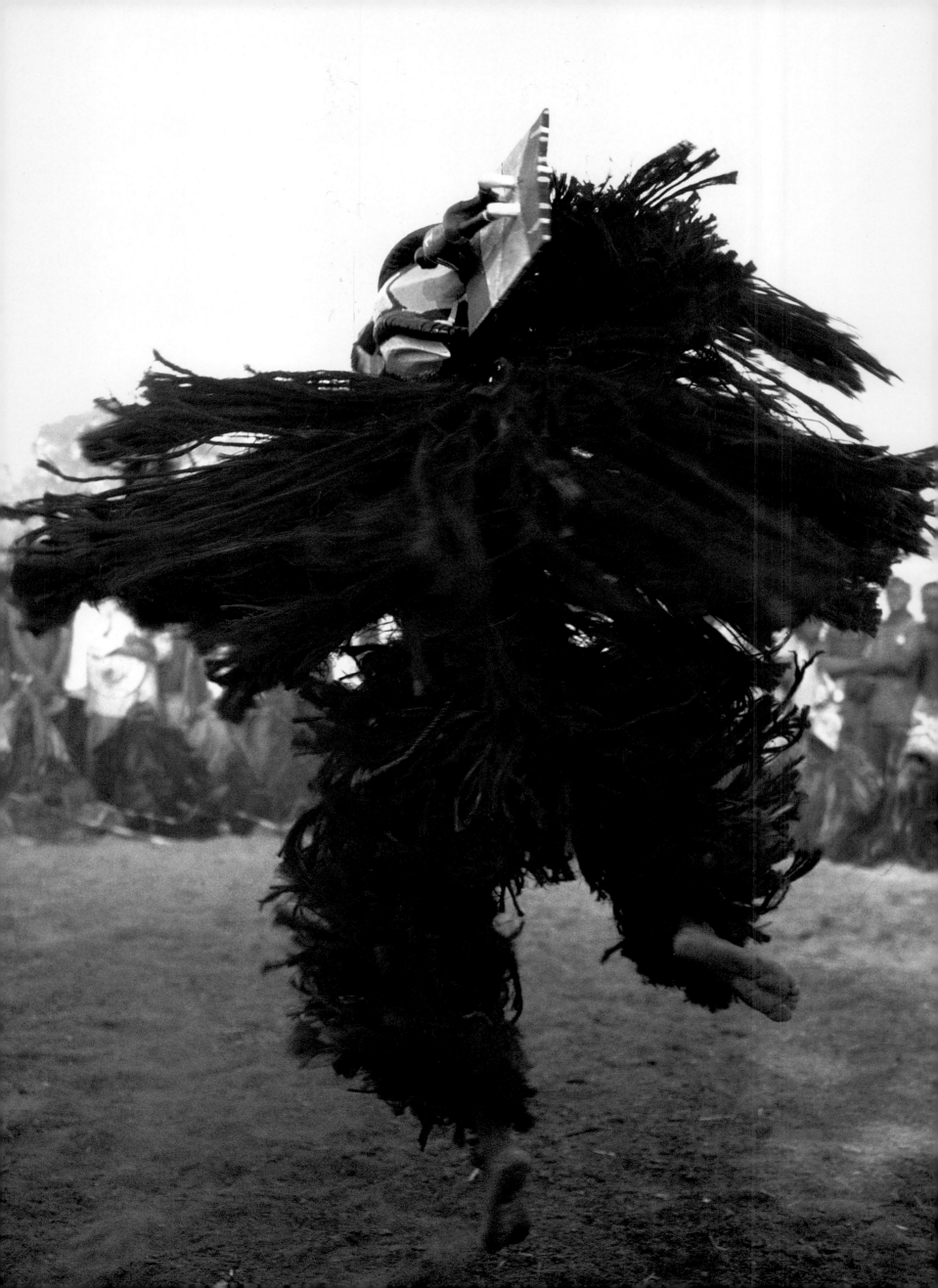

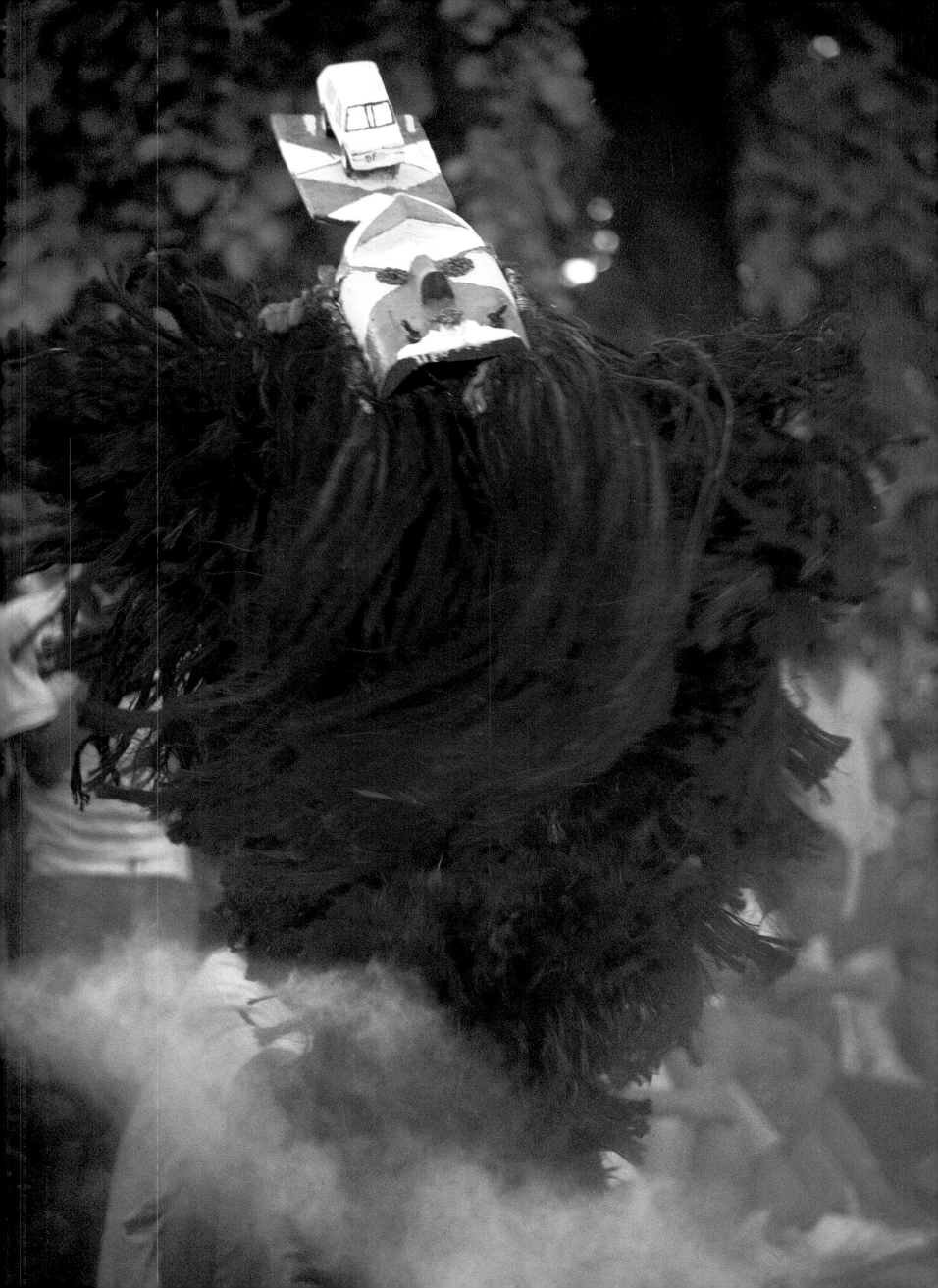

A RICH SPECTACLE OF DRAMA, masquerade, poetry, and drumming plays an important role for the Yoruba people of southwest Nigeria and Benin. Performed by male members of a ritual cult who have been trained in the arts of masking from the age of four or five, the Gelede masquerade offers a comedic, often farcical, spectacle that belies its more serious function of social and spiritual control. The dancers are concealed in puppet masks that lightheartedly represent traditional proverbs, and intricately carved animal masks that remind the audience of the dangers of ignoring social position and natural order in the world.

BELOW AND RIGHT:

The Daguno mask embodies female fertility in a ritual of maternity.

>OVERLEAF:

Oro Efe masks emerge from the sacred forest to sing traditional prayer songs that invoke divine blessings on the Gelede festival and tell of the hierarchical order of the world. The songs remind people through allegory and riddle to pay respect to those who are powerful, in particular the female elders in Yoruba society. The masks feature large, carved headpieces depicting various creatures of the bush.

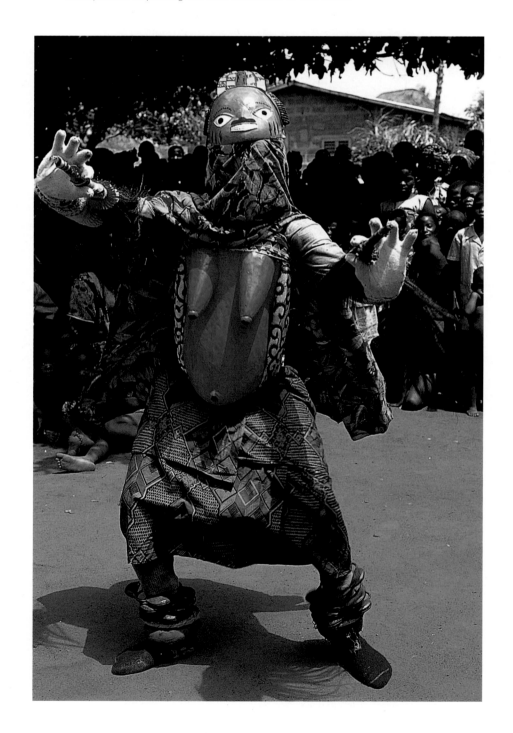

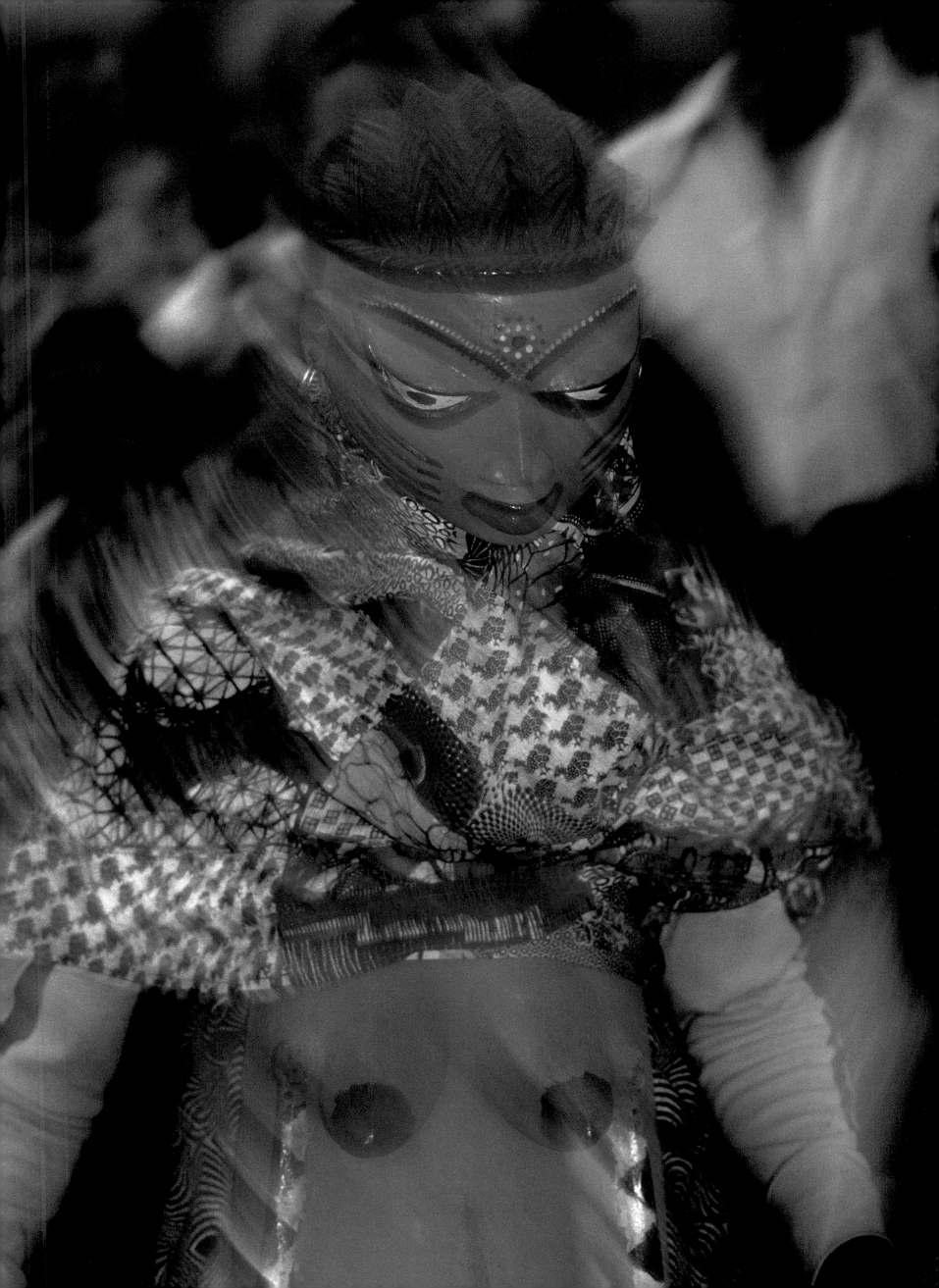

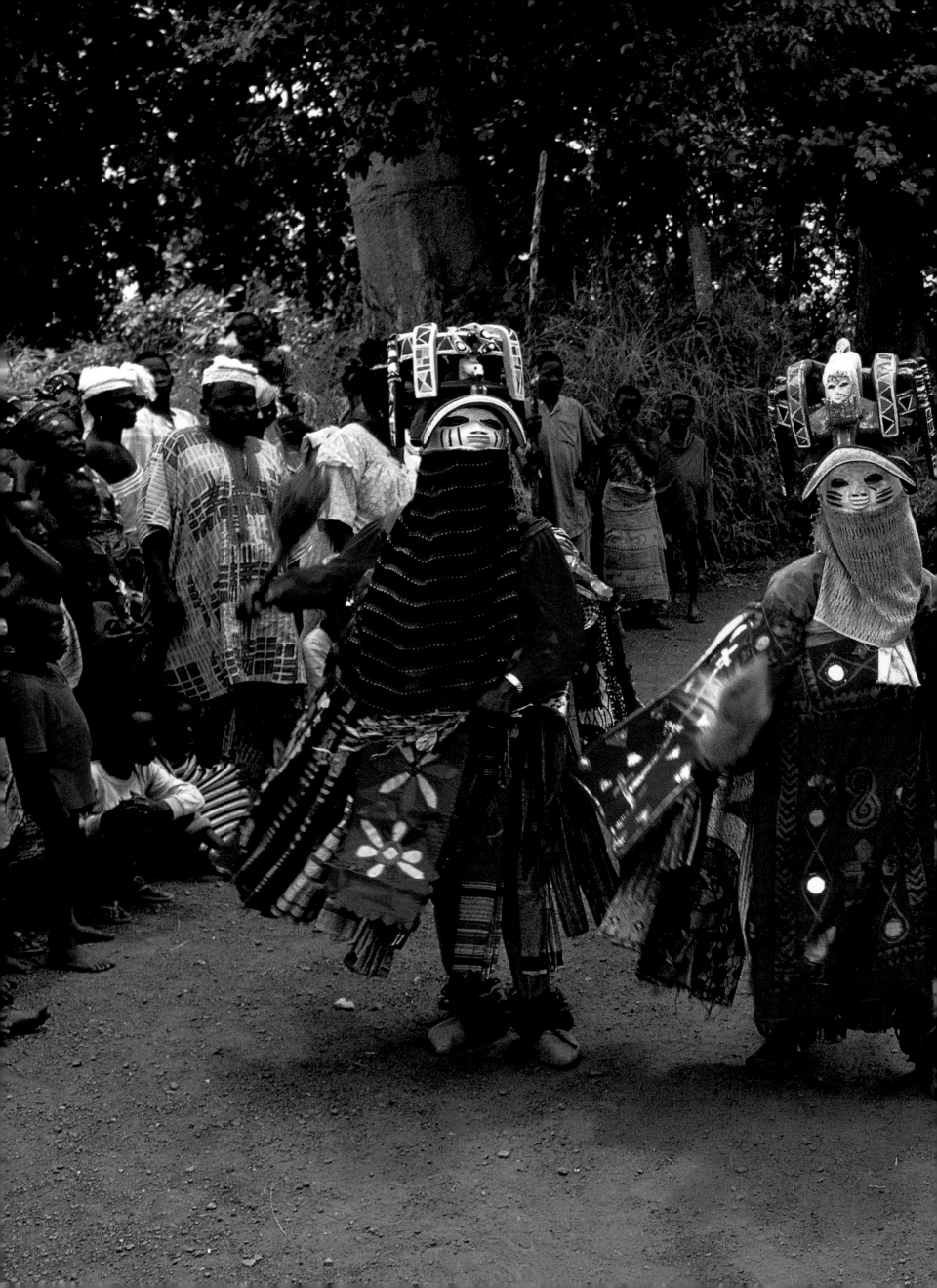

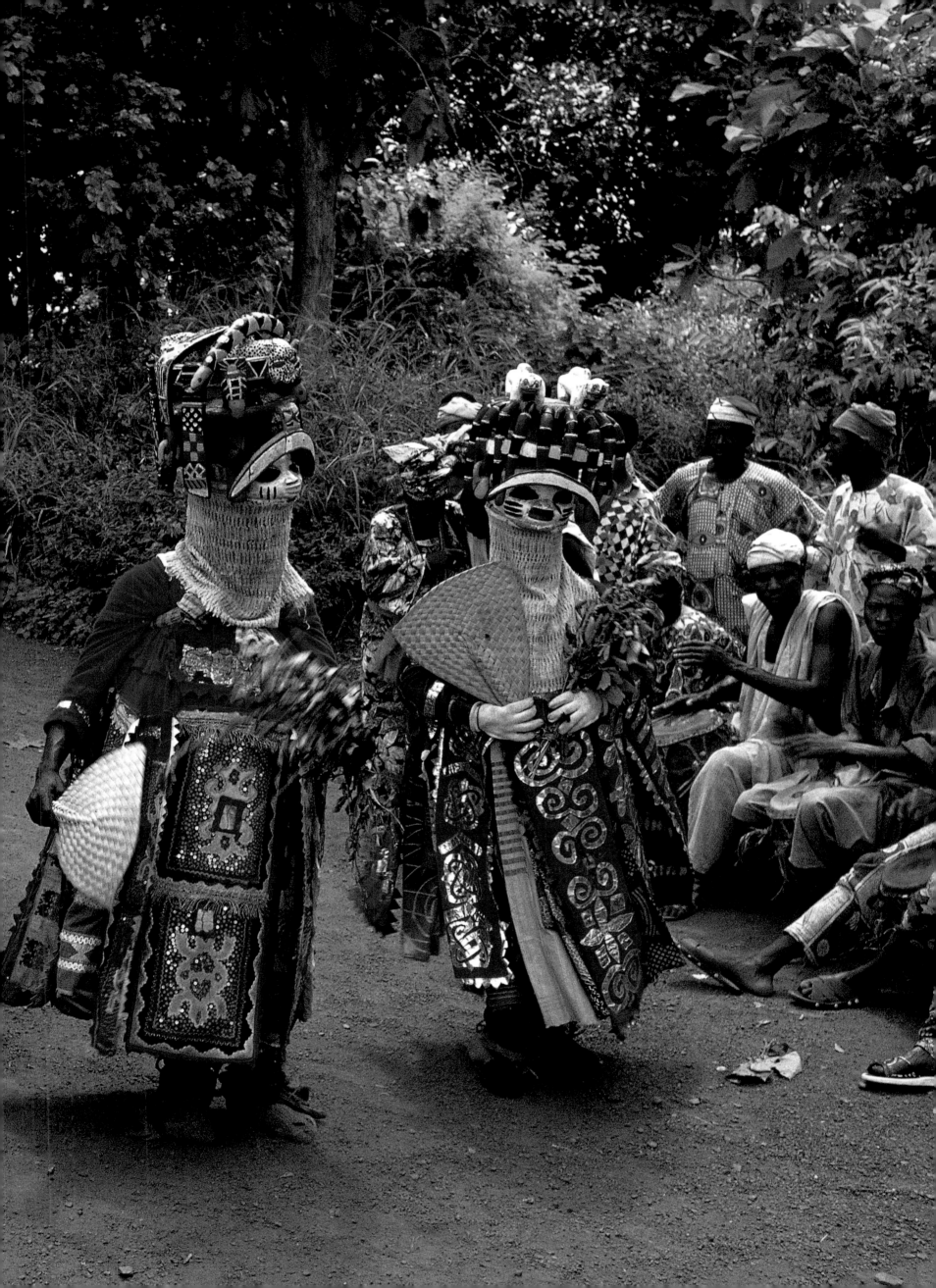

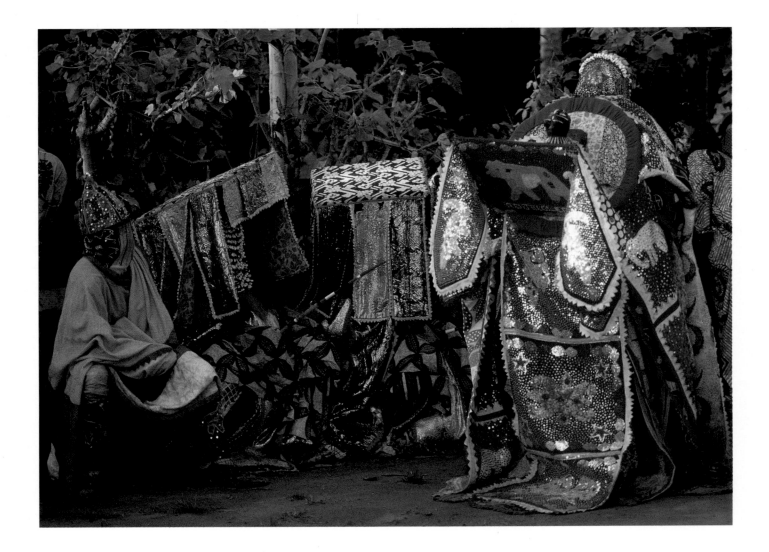

THE RITUAL OF EGUNGUN, a word literally meaning bone or skeleton, honors the ancestors of the Yoruba people of western Nigeria and Benin. The Yoruba believe that all spirits live in Kutome, the afterworld, and they must be summoned back to earth regularly to rebalance a cosmic order upset by human transgressions. The Egungun ritual takes place every year between June and November at a month-long festival, when the Yoruba spirits, who possess immense knowledge and power, are invoked to help and advise the living. The visiting spirits enter the bodies of members of the secret Egungun masking society, who wear masked heads and vibrant, lavish costumes fashioned from many yards of magnificent fabric. This reflects the Yoruba preoccupation with cloth: the more sumptuous and expensive the fabric of a costume, the more powerful and influential the wearer.

ABOVE:

Iridescent with rich, shimmering fabrics, these Egungun Paka masks display the wealth and social standing of their owners.

RIGHT:

The shell-encrusted Oblameji mask portrays a noisy, evil troublemaker.

>OVERLEAF:

As the dance of the Paka mask becomes more ecstatic, the vibrant fabric panels of its costume begin to fly around, turning the mask into a blur of color. The Yoruba believe that the breeze stirred up by the whirling dance of an Egungun mask brings security and the promise of good fortune to those close enough to feel it.

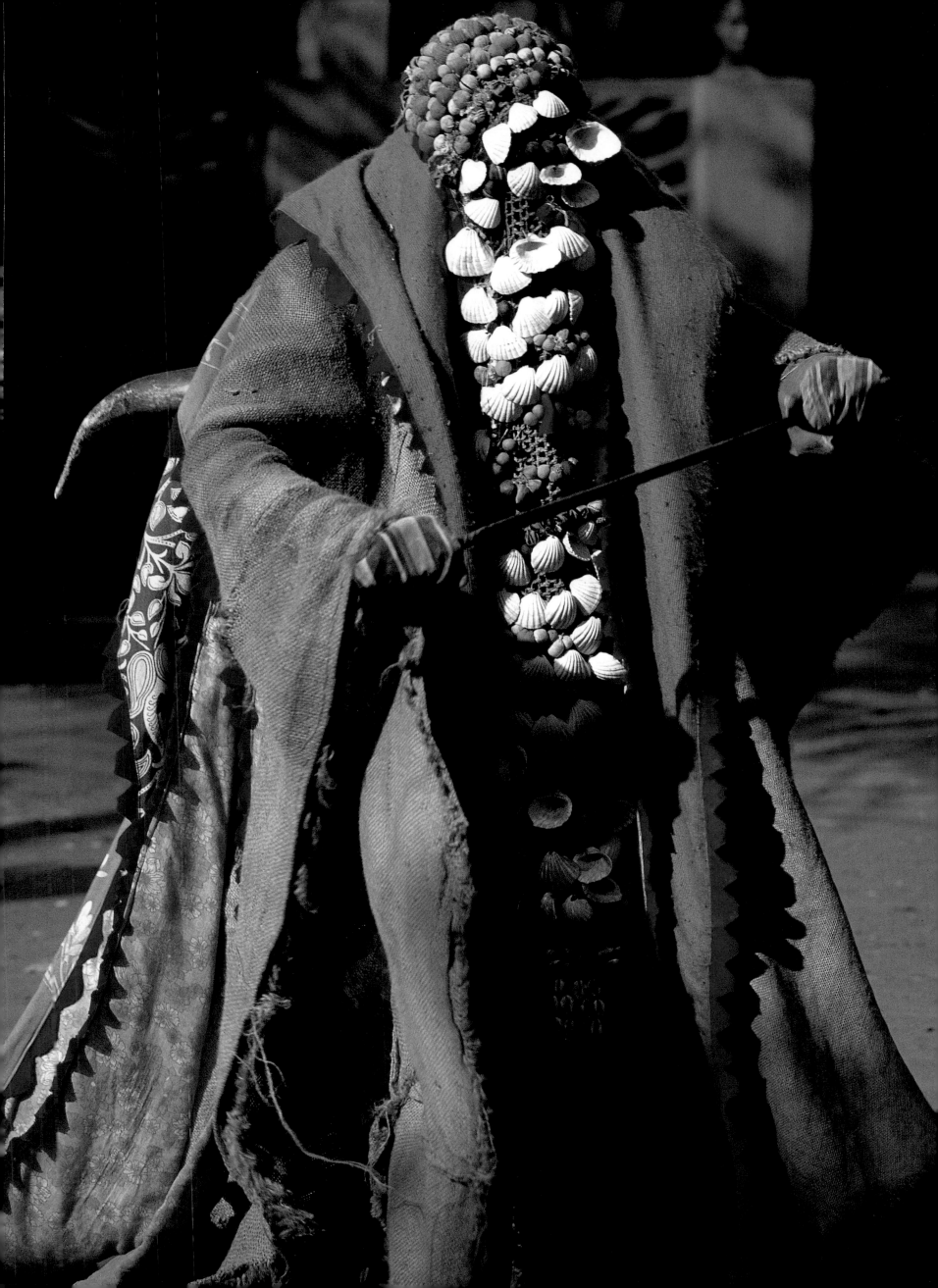

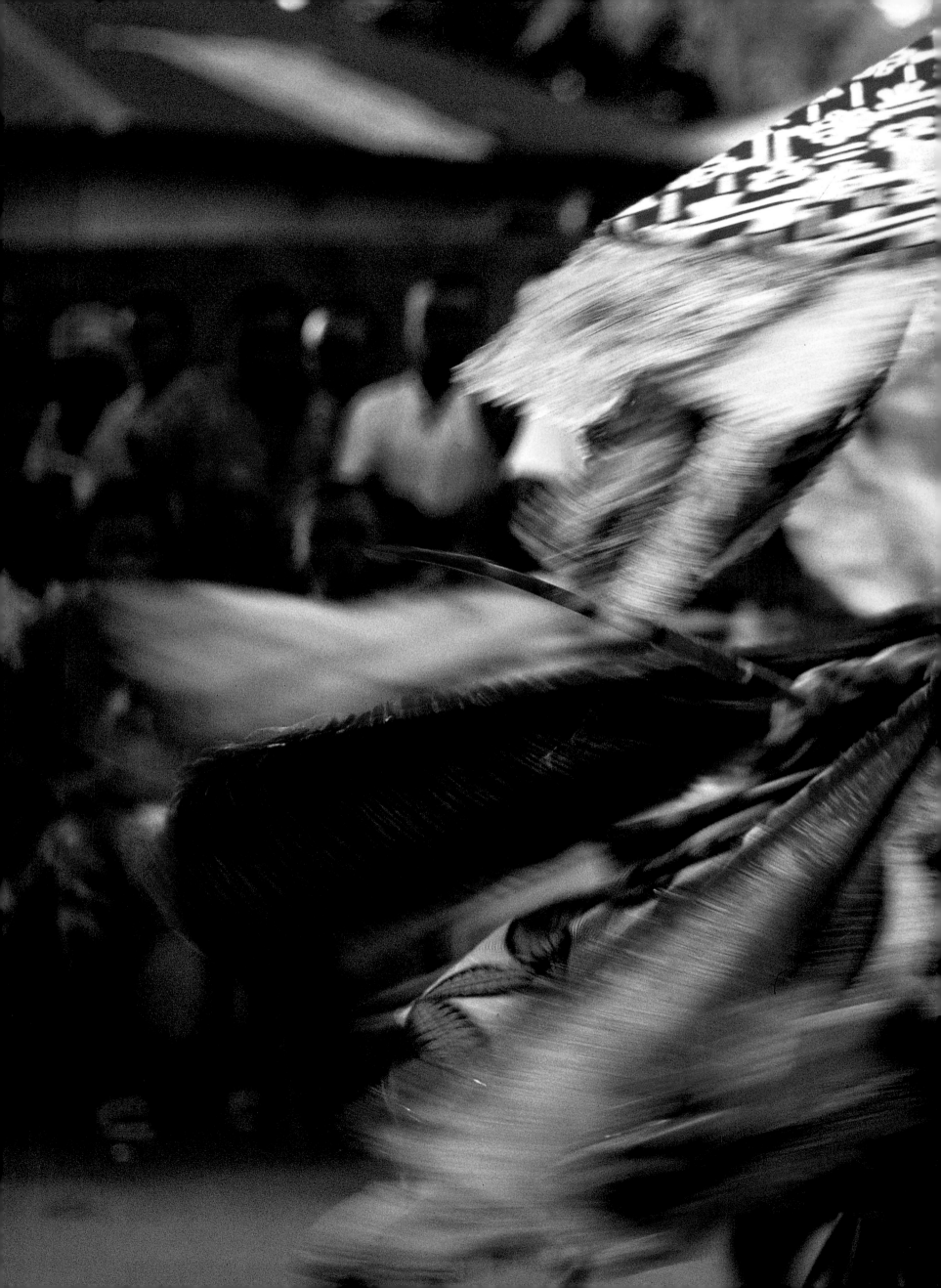

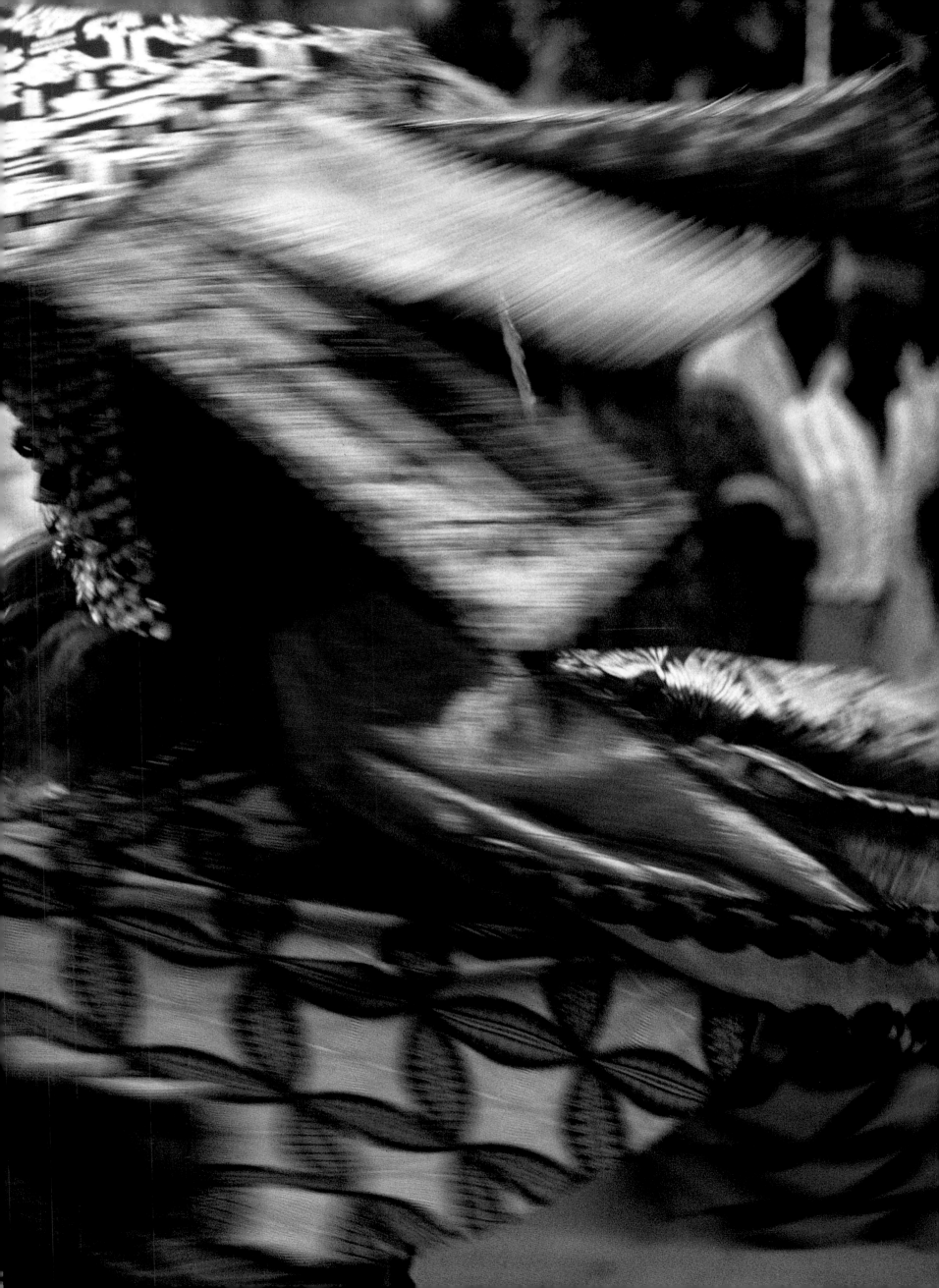

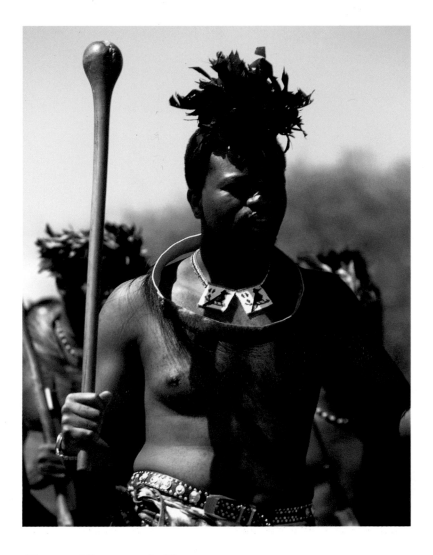

Royalty and Power

AFRICAN RULERS TRADITIONALLY SYMBOLIZE the welfare of the state, and are responsible for the security and prosperity of their people. In many societies, a king's role in maintaining social order is considered so important that when he dies it is believed that the realm temporarily falls into a state of anarchy.

RIGHT:
Wearing bark cloth and leopard skin robes, Ronald Mutebi II is installed as *kabaka*, or king of the ancient Baganda kingdom of Uganda. A mark of traditional Africa's connection with Europe and the modern world is that the king was educated in England and living in Britain just before his succession to the throne.

ABOVE:
King Mswati III of Swaziland, a small kingdom in South Africa, participates yearly in the ceremonial Reed Dance, when as many as twenty-five thousand girls of marriageable age parade and dance before him. Whenever the beauty or dancing ability of a girl catches his eye, he bends down and drops his shield in front of her to indicate his pleasure. In this way, the king surveys potential new wives from among the maidens who attend the ceremony each year.

>OVERLEAF:
All Swazi girls from the ages of ten to eighteen throughout the kingdom are expected to attend the Road Dance ceremony, which is also traditionally regarded as a female rite of passage into womanhood.

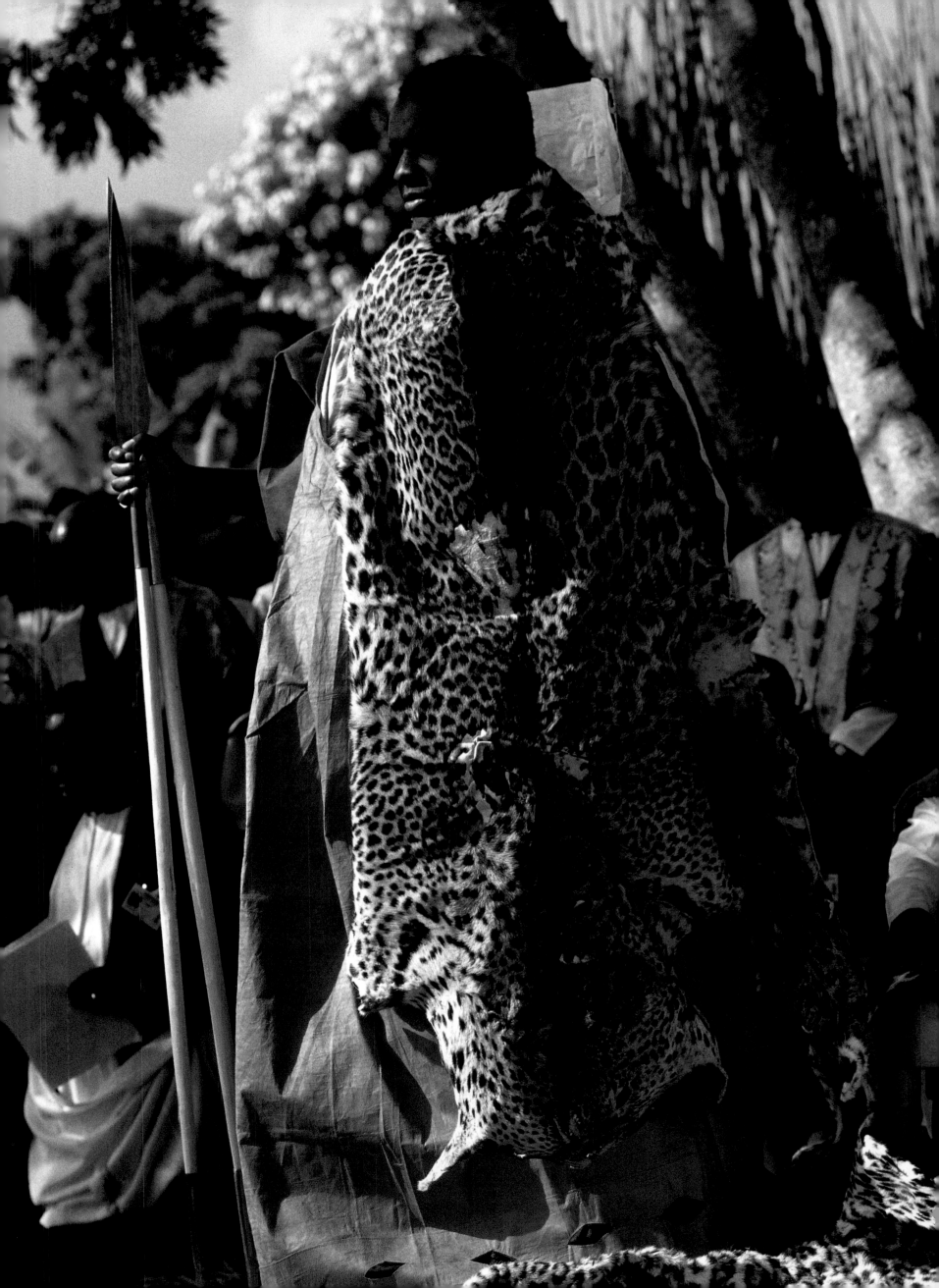

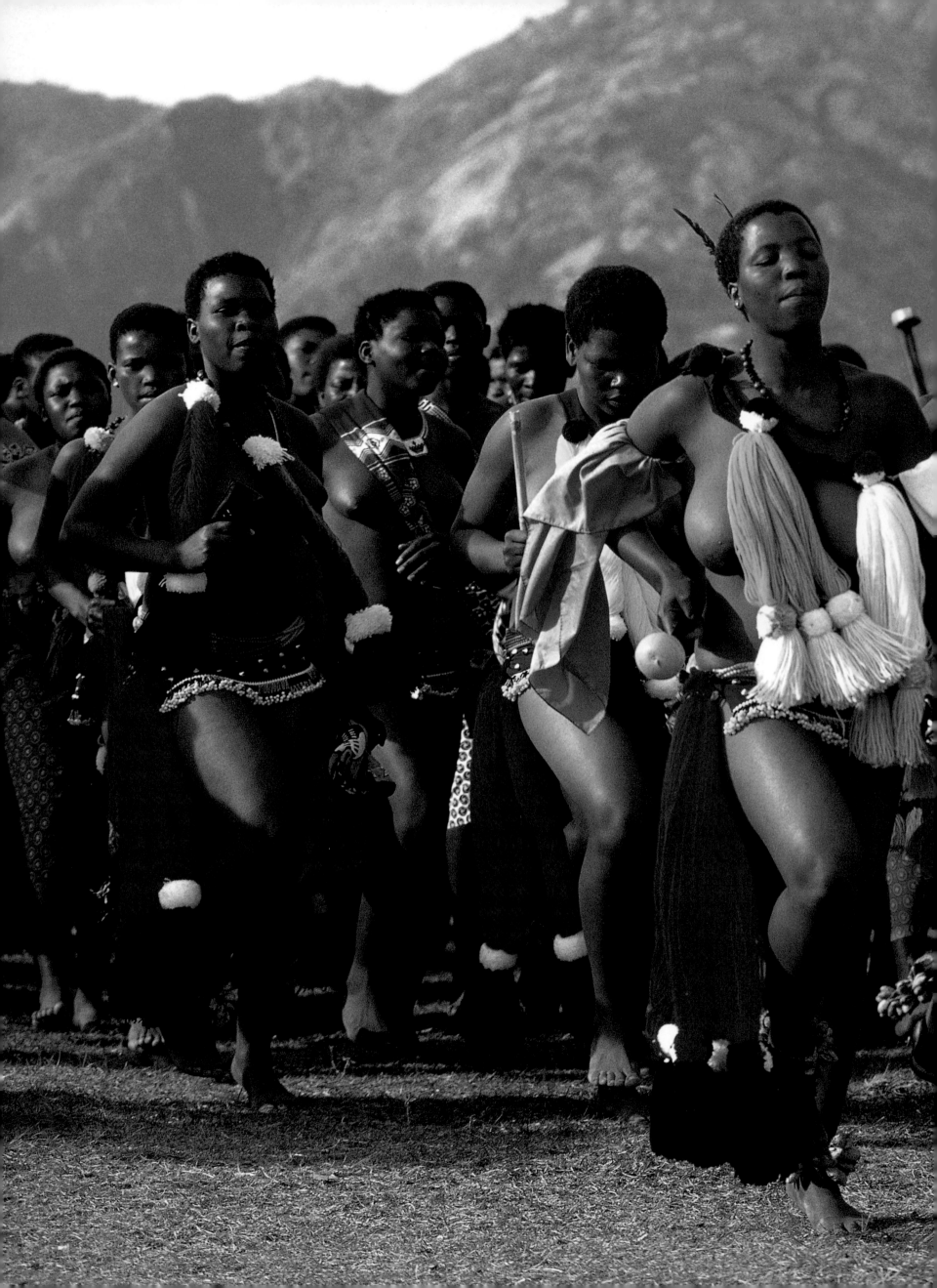

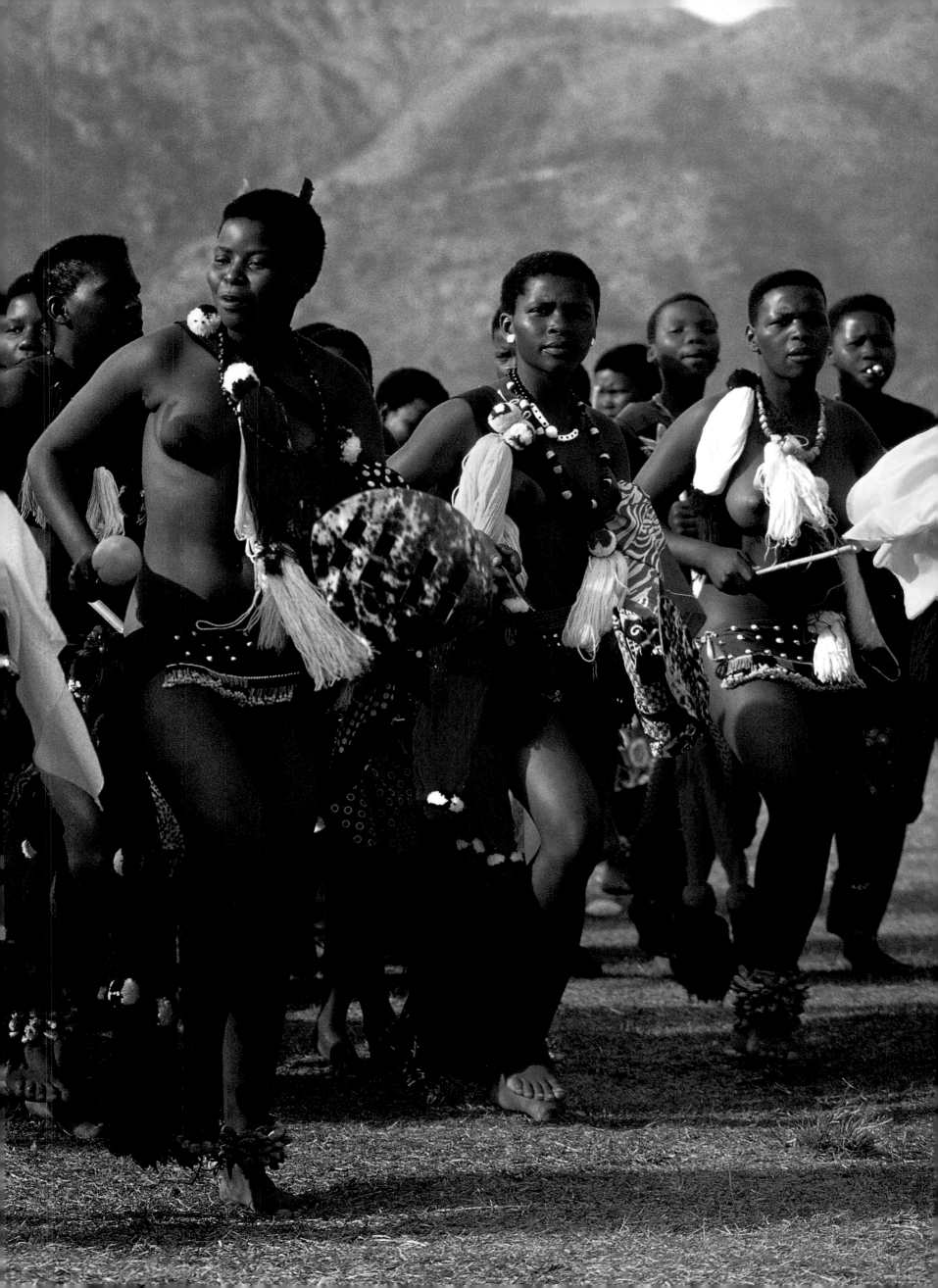

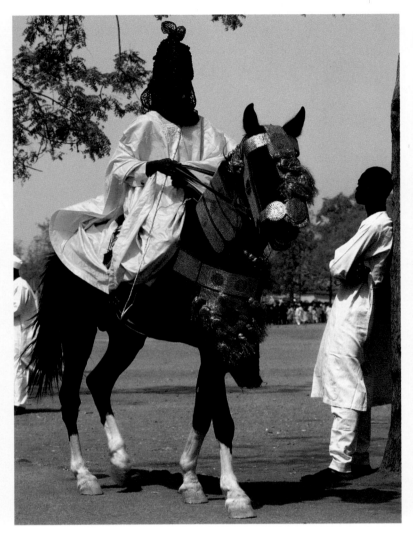 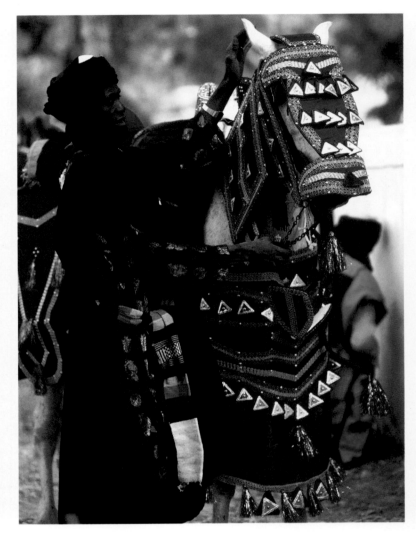

A RITUAL SHOW OF LEADERSHIP AND AUTHORITY characterizes the Sallah Festival at Katsina in central Nigeria. There, the Fulani chieftain, known as an Emir in the religion of Islam, appears with his retinue of mounted noblemen before the town's Hausa and Fulani inhabitants. Dressed in their most extravagant robes, and riding richly caparisoned horses, they proceed along a historic route in Katsina that links the sacred space of the mosque's communal prayer ground and the secular space of the palace, reflecting the Emir's dual role as the religious and political leader of the region.

LEFT AND RIGHT ABOVE:
Two Fulani noblemen display their mounts' impressive livery.

RIGHT:
Wearing a gold cloak over a white robe and turban that signal religious piety, the Emir, His Royal Highness Alhadji Muhummadu Kabir Usman, proceeds to his palace behind members of the aristocracy, and surrounded by palace attendants in red turbans.

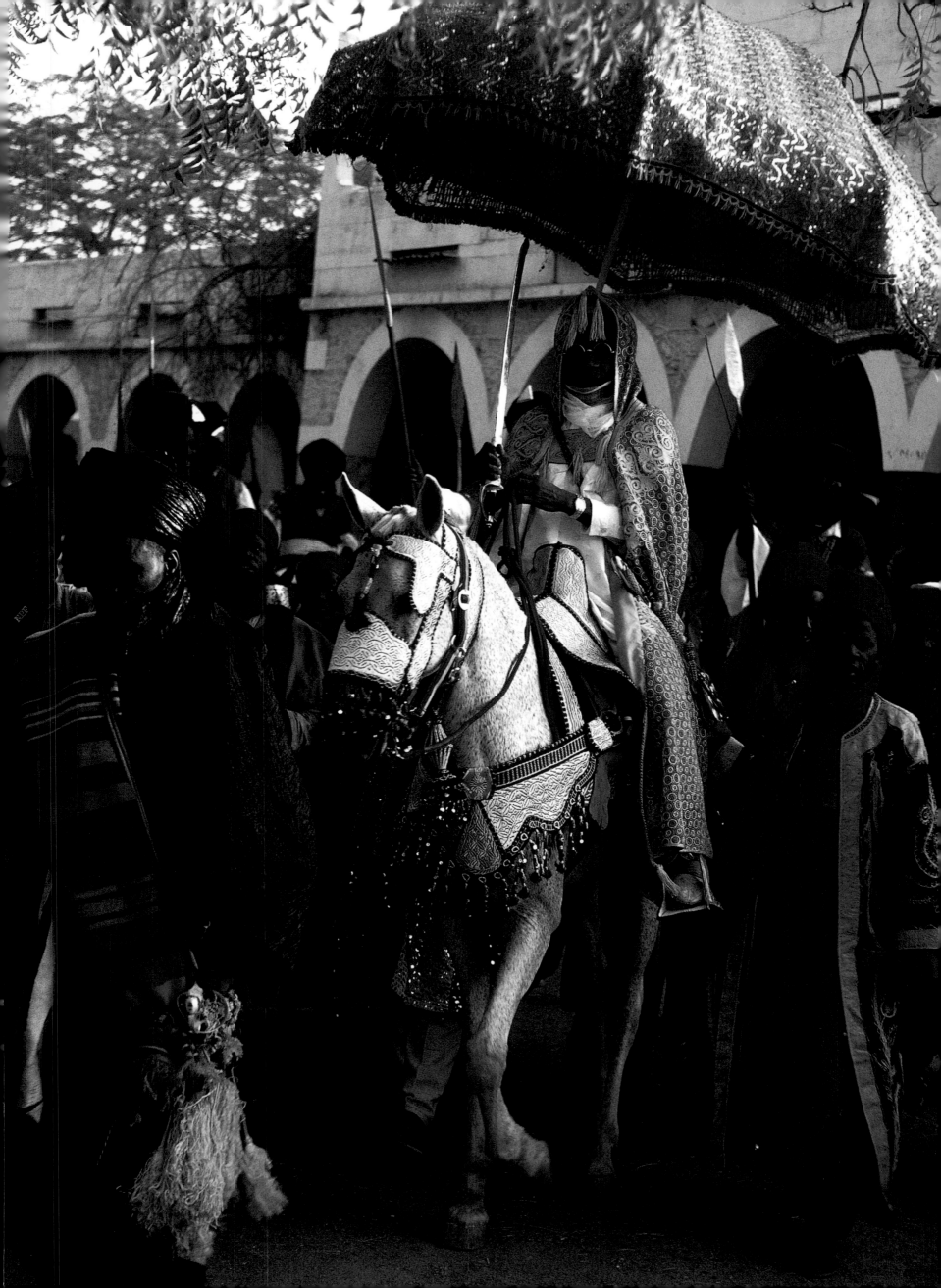

THE GOLDEN HERITAGE of the Ashanti kingdom was never more magnificently displayed than at the Silver Jubilee of the late King Otumfuo Opoku Ware II, in August, 1995, in Kumasi, Ghana. In the presence of some 75,000 loyal subjects and international guests, the king of kings, known as Asantehene, his royal court—including his Chief Soul Bearer (right), and numerous paramount chiefs of Ghana—showed the most extravagant collection of golden regalia to be seen anywhere in the world. Culminating a year-long celebration in honor of the monarch's twenty-five-year reign, the royal procession lasted for more than six hours, during which hundreds of dignitaries, chiefs, and royal bearers filed into a huge arena, symbolically reaffirming the wealth, power, and solidarity of the Ashanti nation.

BELOW:

Most important of all the royal treasures is the Golden Stool, embodying the spirit of the Ashanti nation and seen in public for the first time in twenty-five years. Originally "brought from the sky" by the legendary priest Anokye, the stool was given to the Ashanti people as a symbol of their strength.

>OVERLEAF AND FOLLOWING PAGES:

The Asantehene arrives at his jubilee celebration in a sumptuous palanquin surrounded by twirling umbrellas, and with his retinue of 150 chiefs and bearers. Resplendent in *kente* cloth robes, the king wears many heavy gold bracelets and intricately worked gold rings, seen in detail on the following pages. Carried before him are the swords of state, with handles covered with gold leaf.

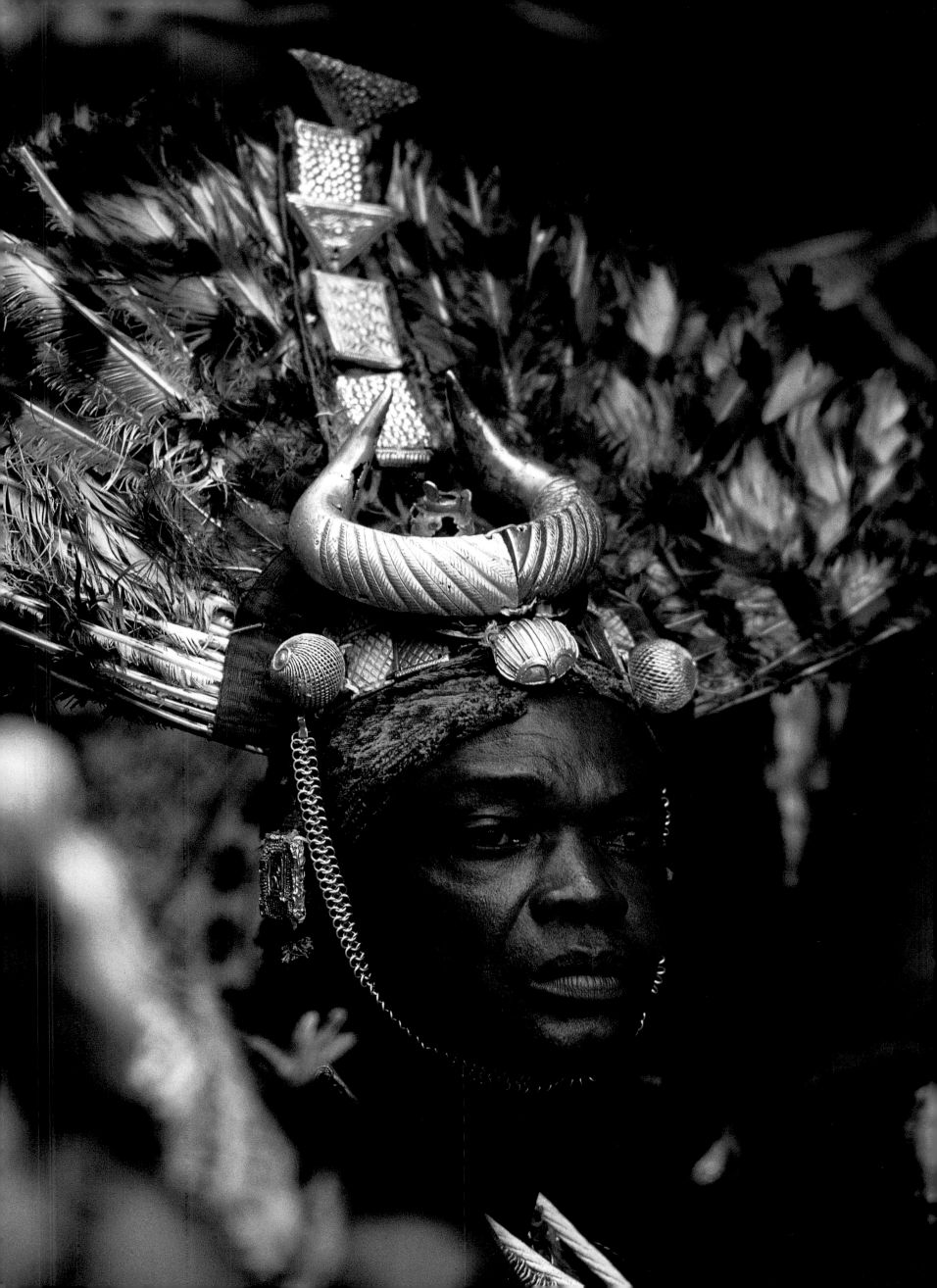

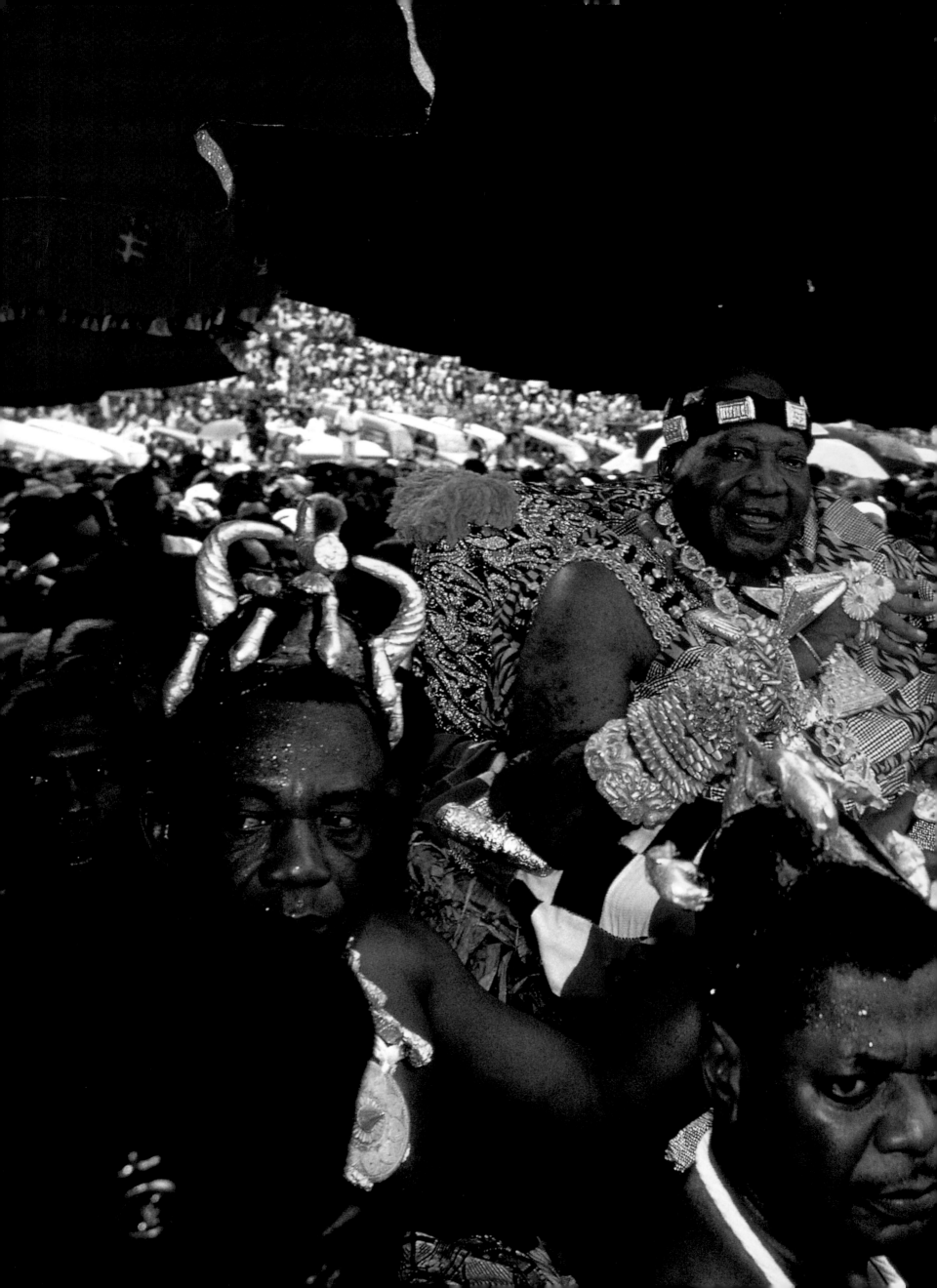

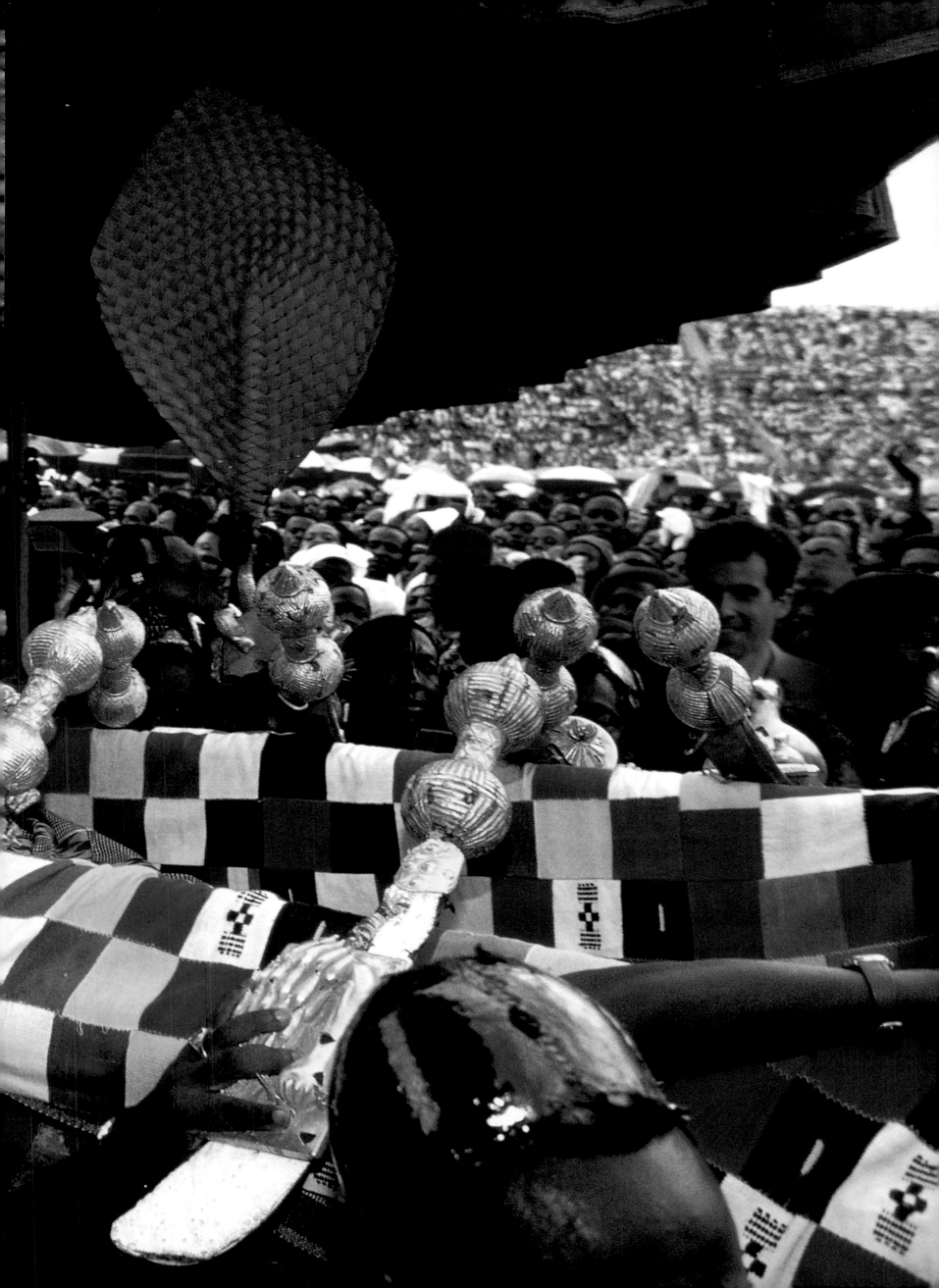

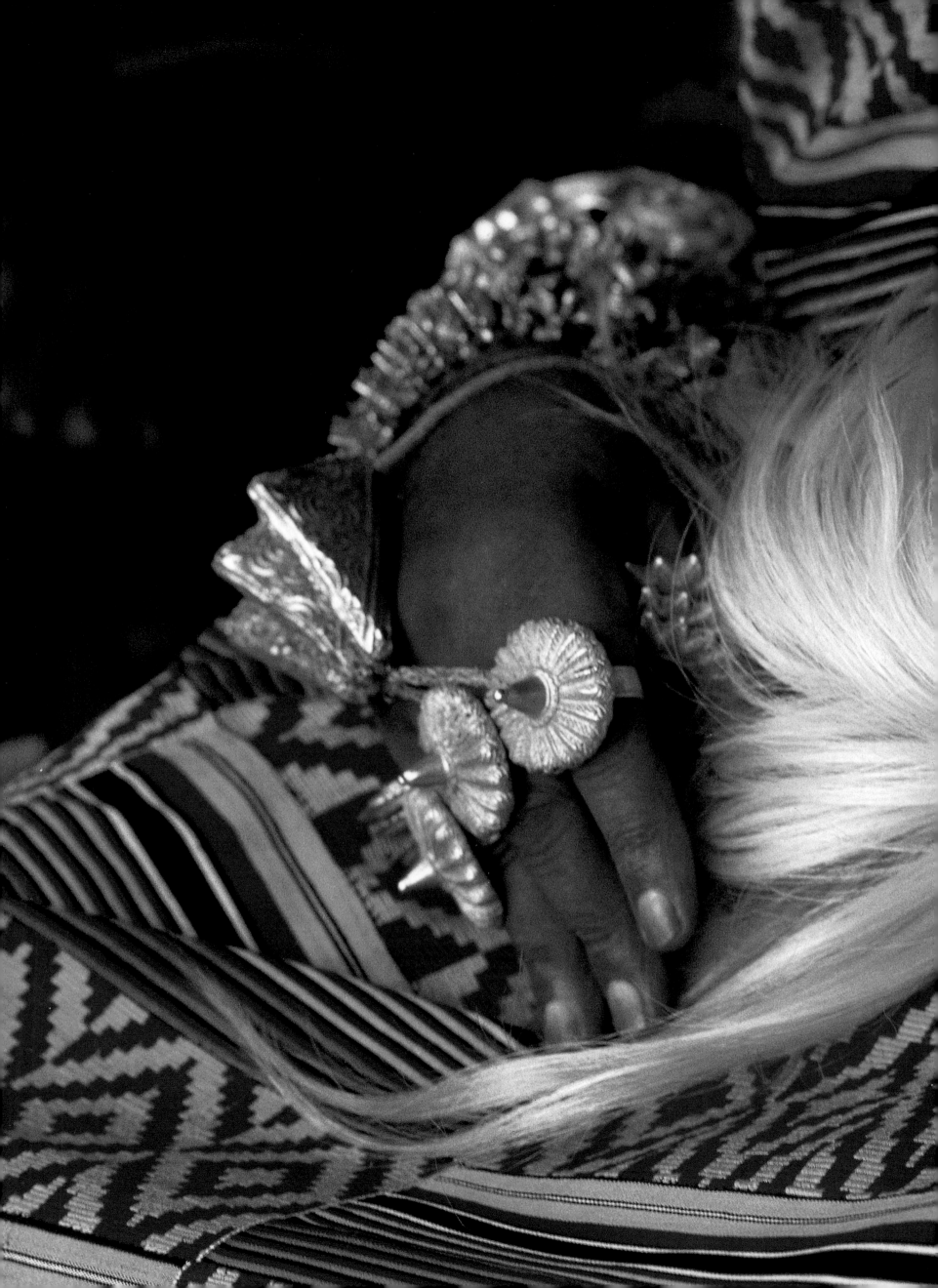

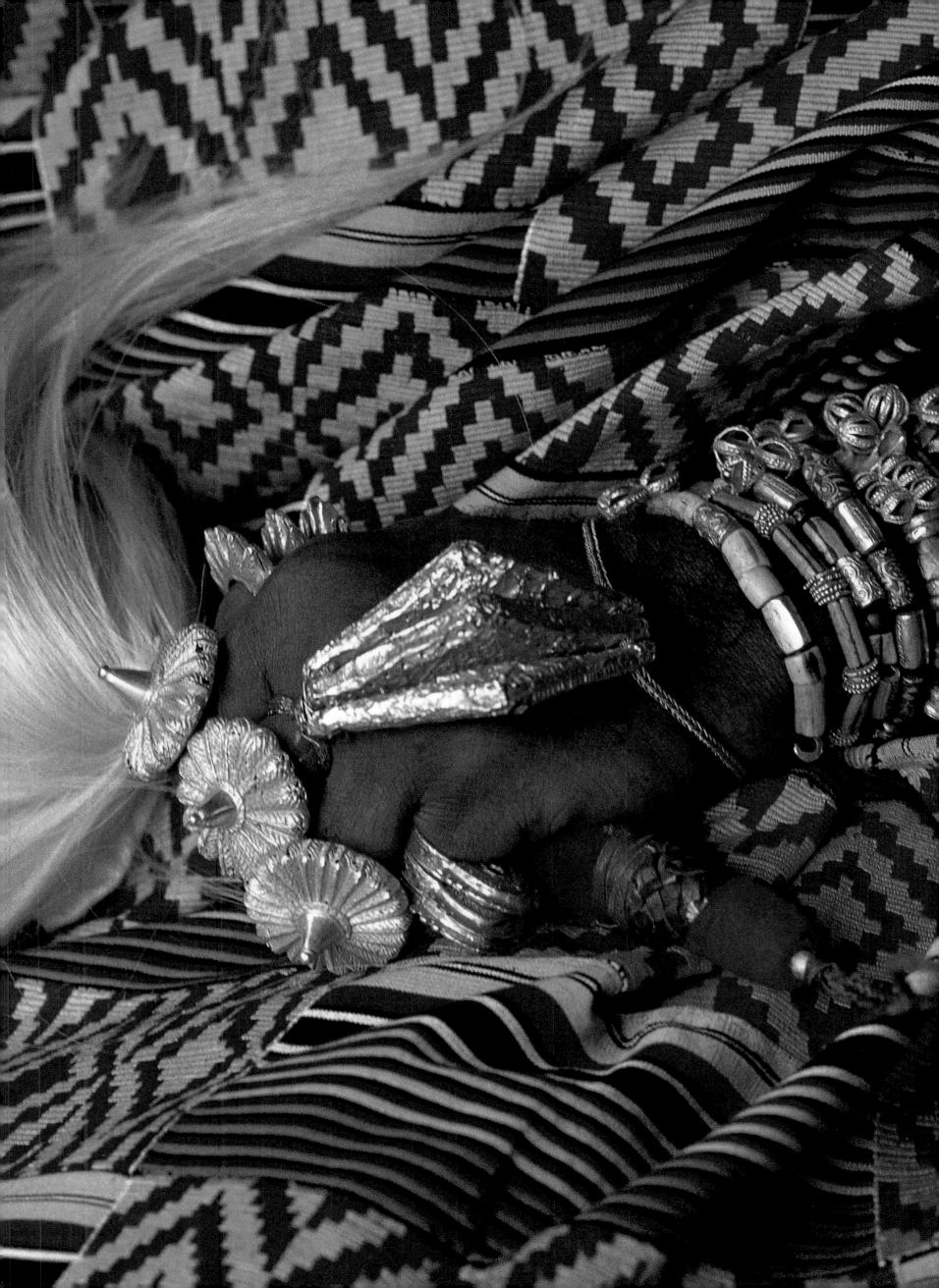

Spirits and Ancestors

BELIEVING THAT ALL LIVING BEINGS AND MATTER HAVE SPIRITS, the Dogon people of Mali hold that when a person dies, the spirit becomes detached from the body and has the power to disrupt the order of the world. Ritual acts must, therefore, be performed to restore balance. Once every twelve years, the Dogon hold a collective funeral called the Dama honoring all those who have died during that time.

BELOW:

A guardian surveys a burial cave in the cliff face of the Bandiagara escarpment that rises above the Dogon villages.

RIGHT:

The Toguna house, decorated with relief carvings of ritual dance masks, is the meeting place for elders.

>OVERLEAF:

Both chief and priest of his village, the Hogon officiates at all religious and judiciary ceremonies. Halfway up the escarpment, the Hogon's spirit house focuses the ritual activity for the Dama. Built into a large cave and surrounded by tall granaries, its façade bears the skins and skulls of countless sacrificed animals, many of which have been offered during the six-week period before the Dama begins.

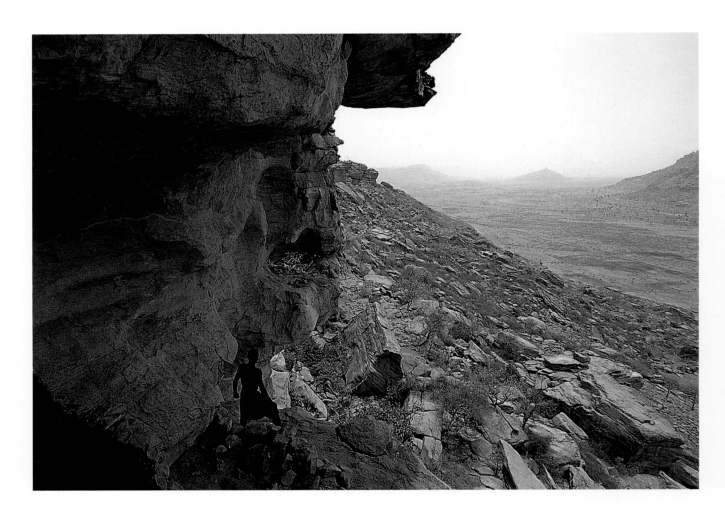

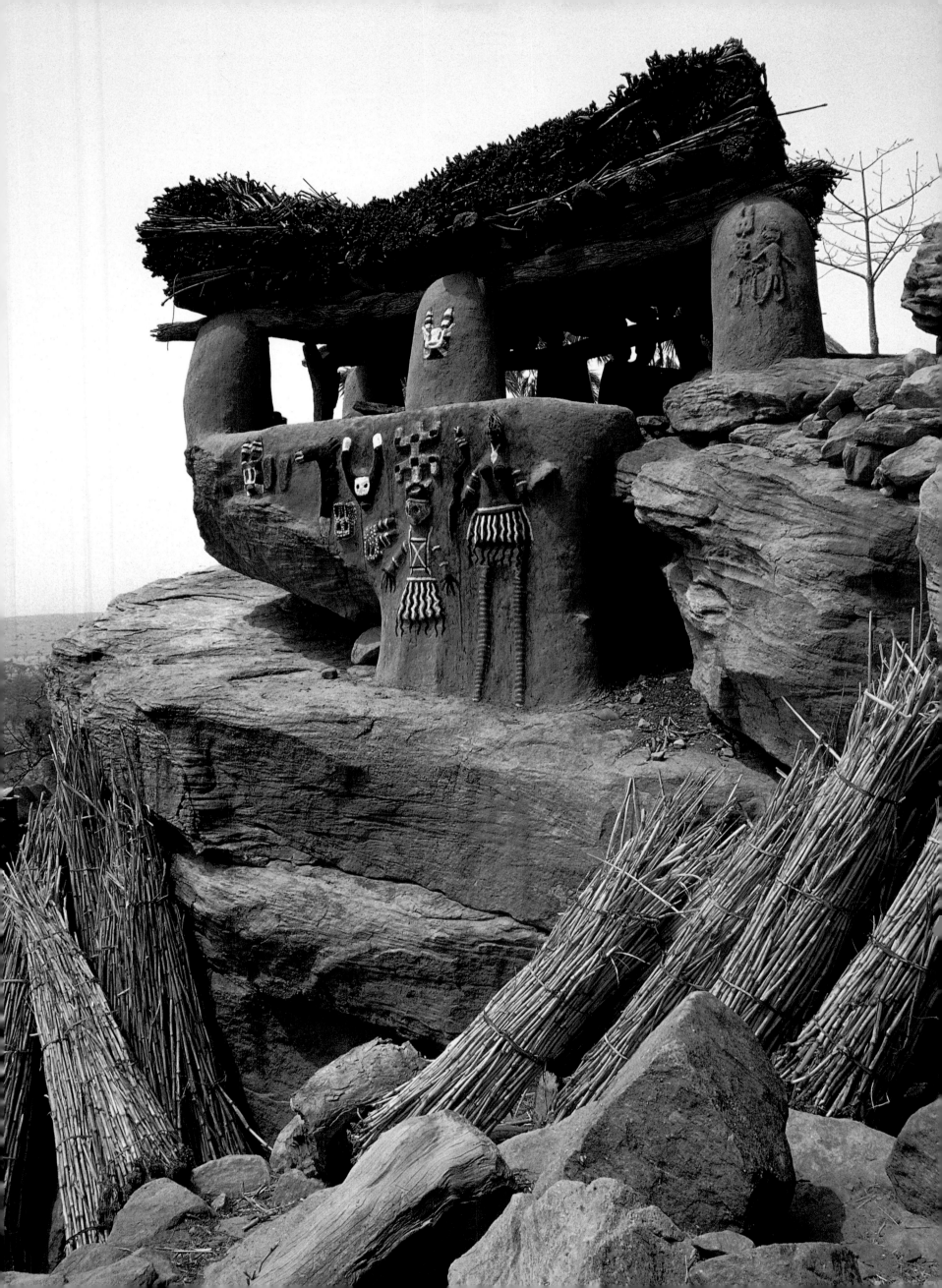

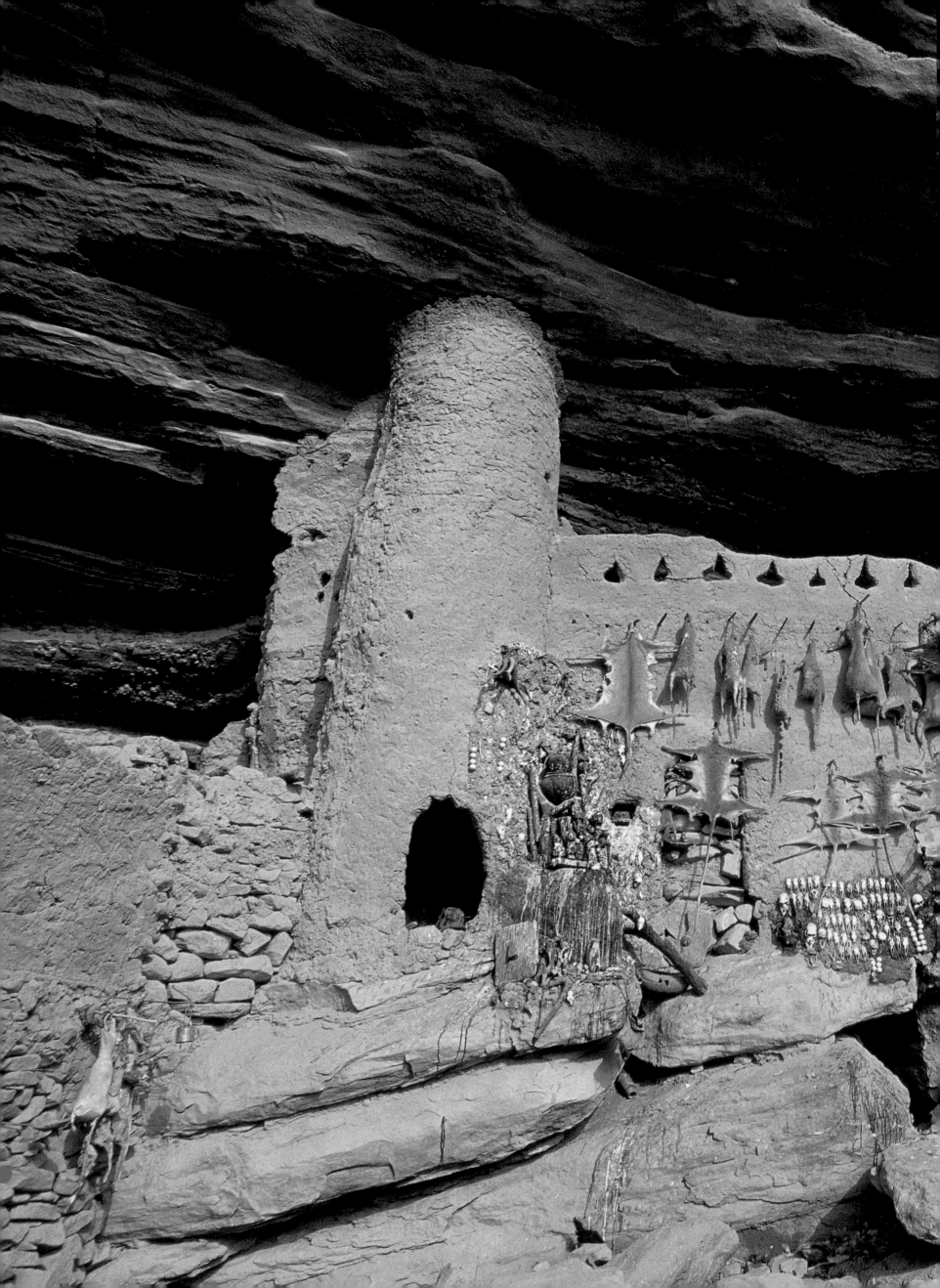

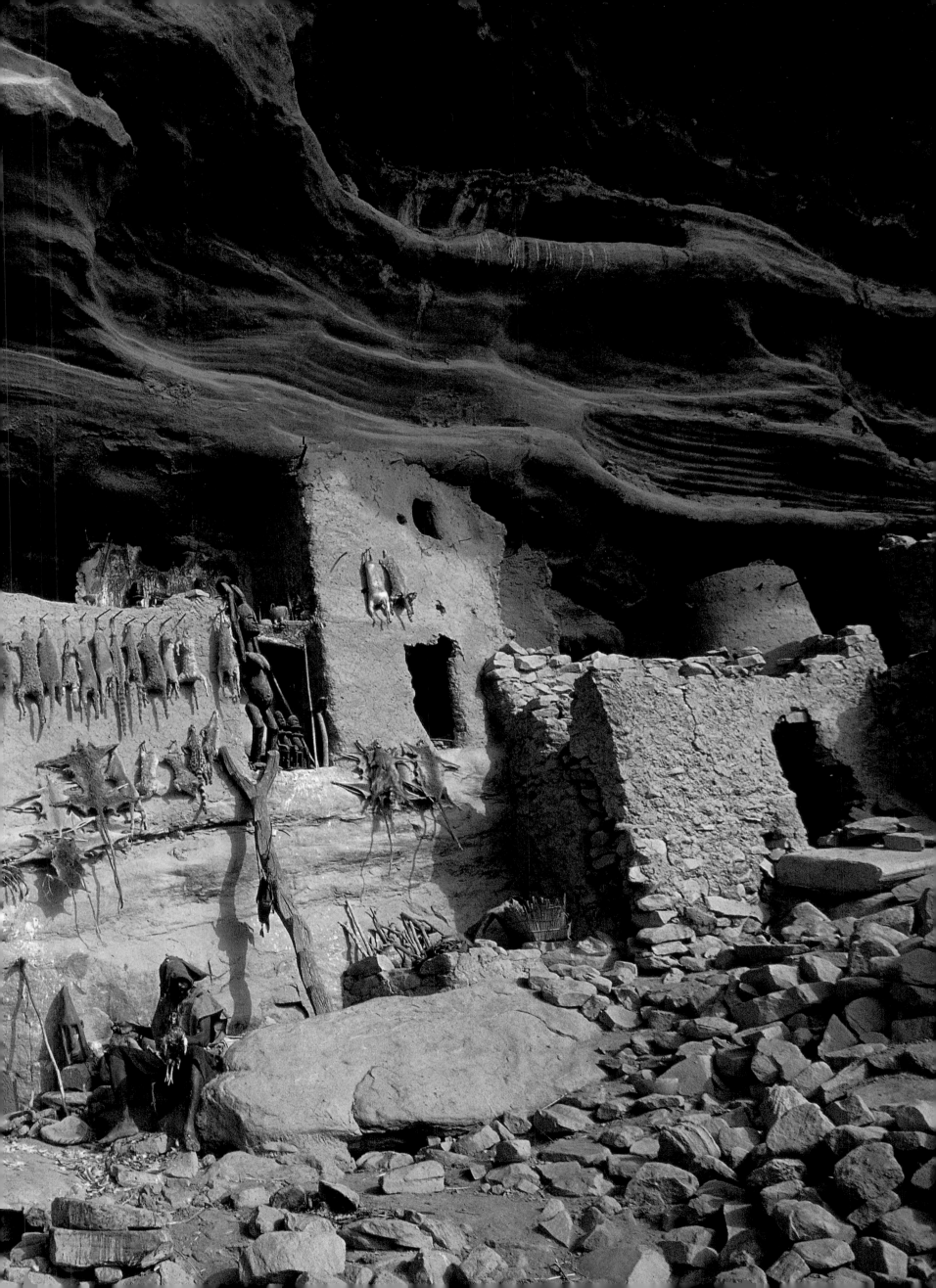

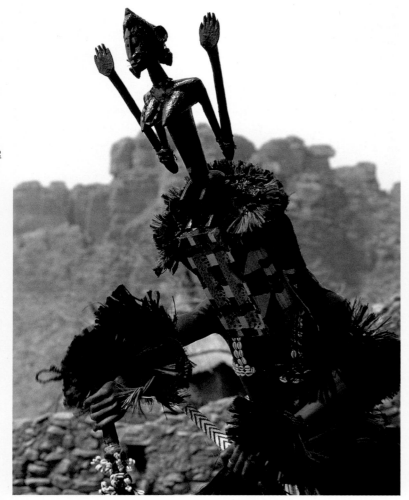

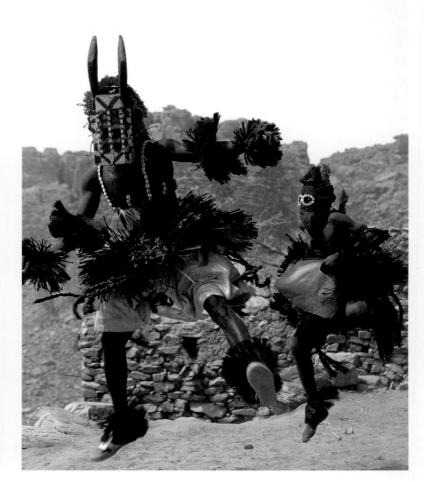

FIVE DAYS OF MASKED DANCING mark the climax of the Dama. As the masks wind their way down the narrow footpaths of the escarpment, they create an otherworldly spectacle for the crowds in the village below. Reaching the village center, they burst into an explosive display of dance and drama.

ABOVE LEFT:

The Satimbe mask represents the first ancestors of the Dogon, who were limbless watery beings living in an ethereal realm before the world existed.

ABOVE RIGHT:

Mimicking the gait of the antelope, the Walu mask leaps about, followed by Adyagi, a stinging insect. Dogon animal masks are regarded as "beings of the bush," representing the world outside the village and symbolizing everything that is wild and beyond the control of man.

FAR RIGHT:

The Sirige is the most impressive of all Dogon masks, standing some fifteen feet high and drawing its name from the multistoried house of the Hogon. The mask is believed to portray events that took place at the beginning of creation.

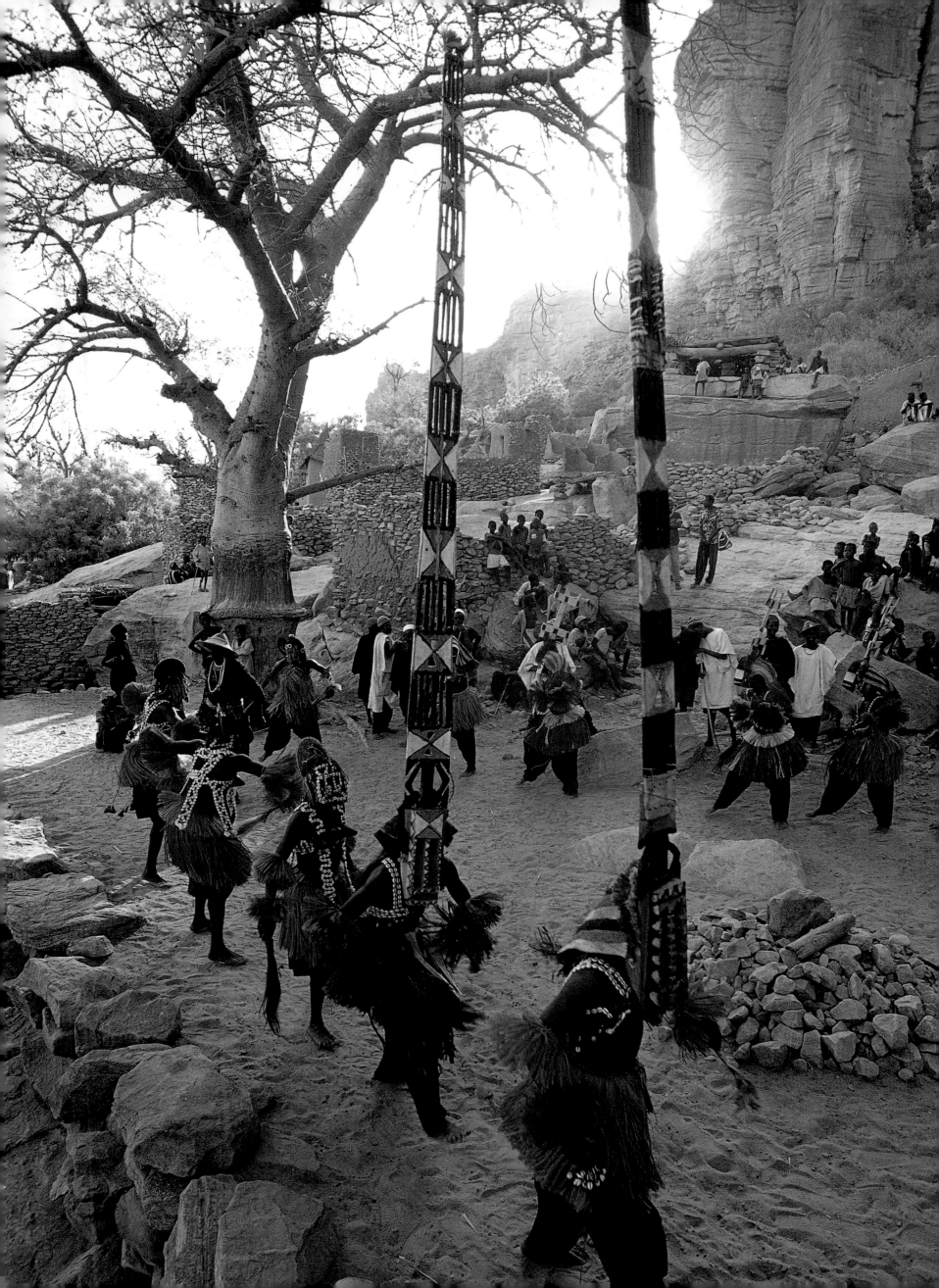

SPECIALLY CARVED COFFINS that relate to the lifetime professions of deceased persons are a recent feature of funerals among the Ga people of Ghana. The originator of this tradition was a carpenter, Kane Kwei, who created the first fantasy coffin in the early 1960s to honor the death of his uncle, a fisherman, who wished to be buried in a coffin symbolic of his trade so he could arrive in the afterworld ready to fish.

BELOW AND RIGHT:
Kane Kwei's nephew Paa Joe carries on the tradition. Below, he puts the finishing touches on a pink tuna fish commissioned by the family of the Chief of Fishermen. The coffin is later paraded through his village (right) for all to pay their respects.

>OVERLEAF AND FOLLOWING PAGES:
In the iconography of Ga coffins, powerful birds are specifically reserved for the burial of royalty, prominent chiefs, and leaders. The eagle coffin of a paramount Ga chief, seen lying in state on the following pages, was carried through the streets of Accra, where ritual libations were periodically poured over the head of the eagle and thousands of mourners paid their respects.

>> NEXT FOLLOWING PAGES:
Masked Dogon stilt dancers from Mali help bring the Dama funeral ceremony to a close. The spirits of the dead who were reluctant to return to their own domain are finally successfully driven away to their resting places in the afterworld, restoring the natural balance of society and leaving the village free from their disruptive influence.

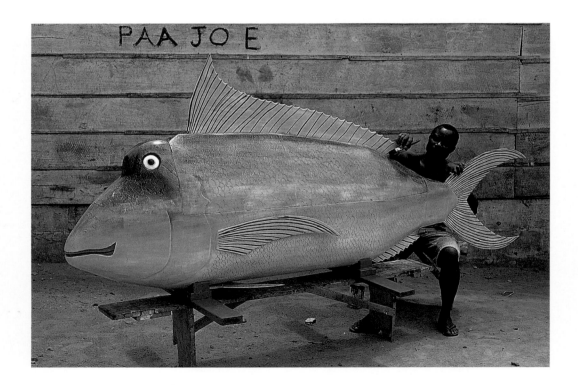

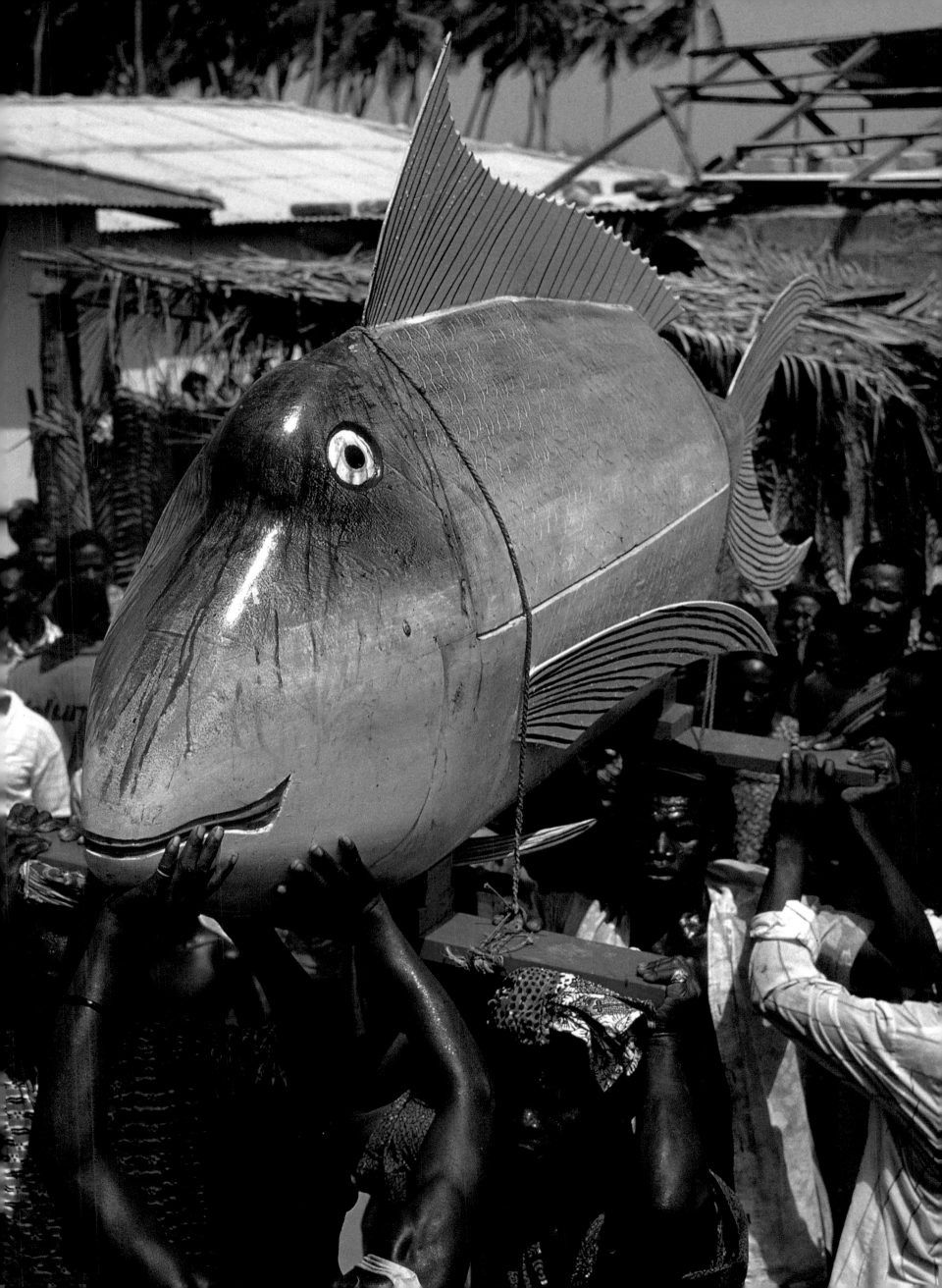

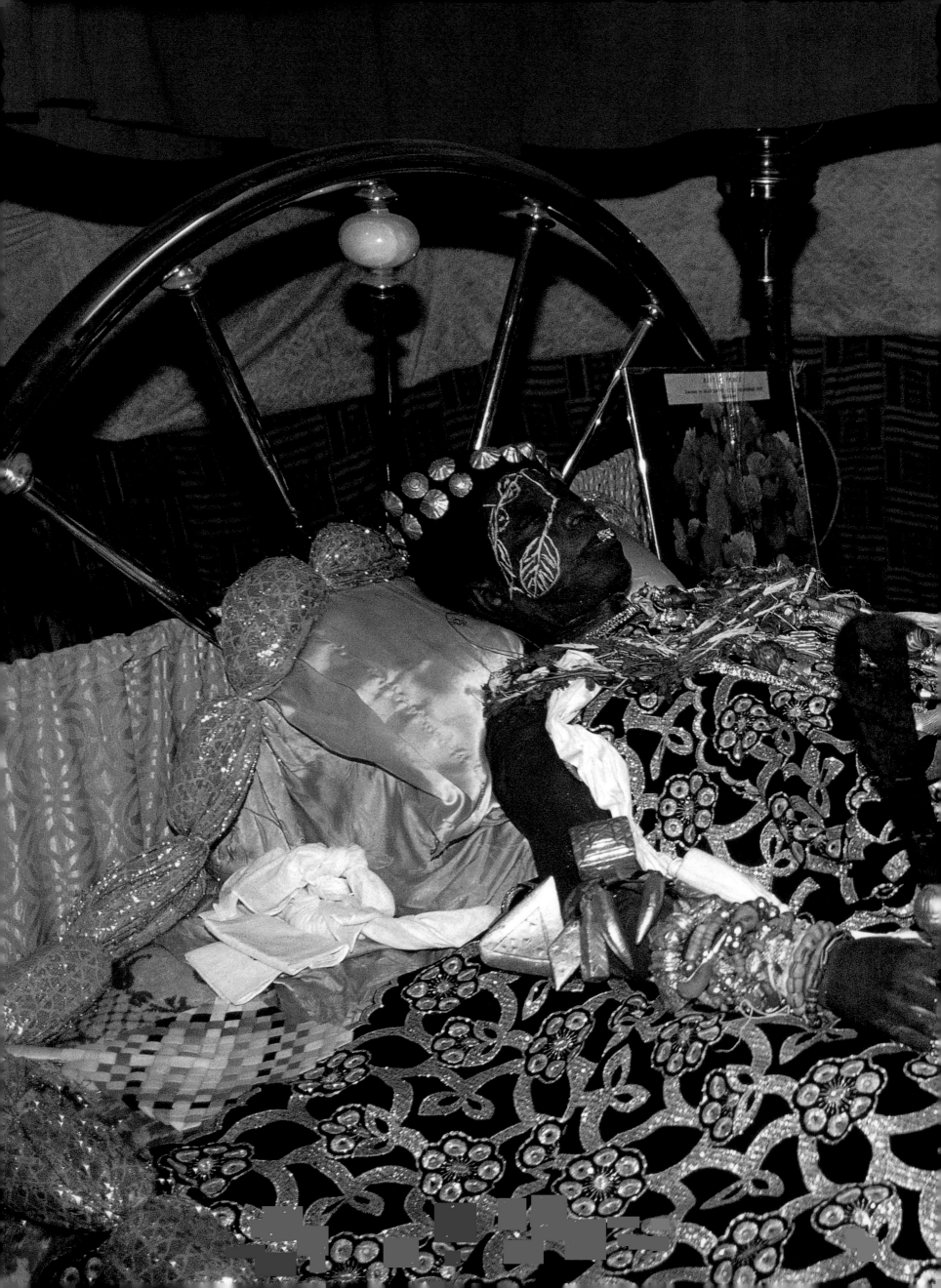

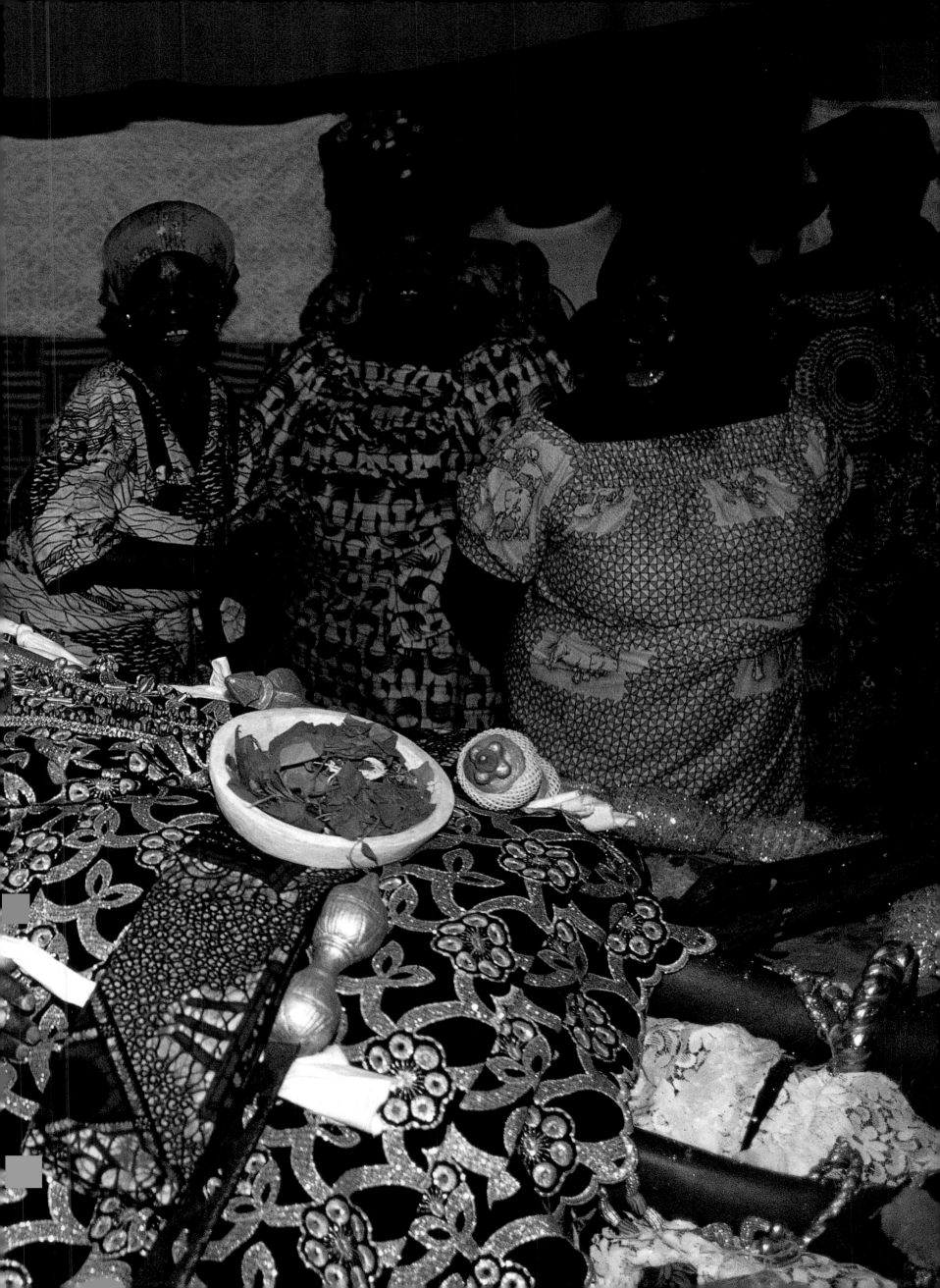

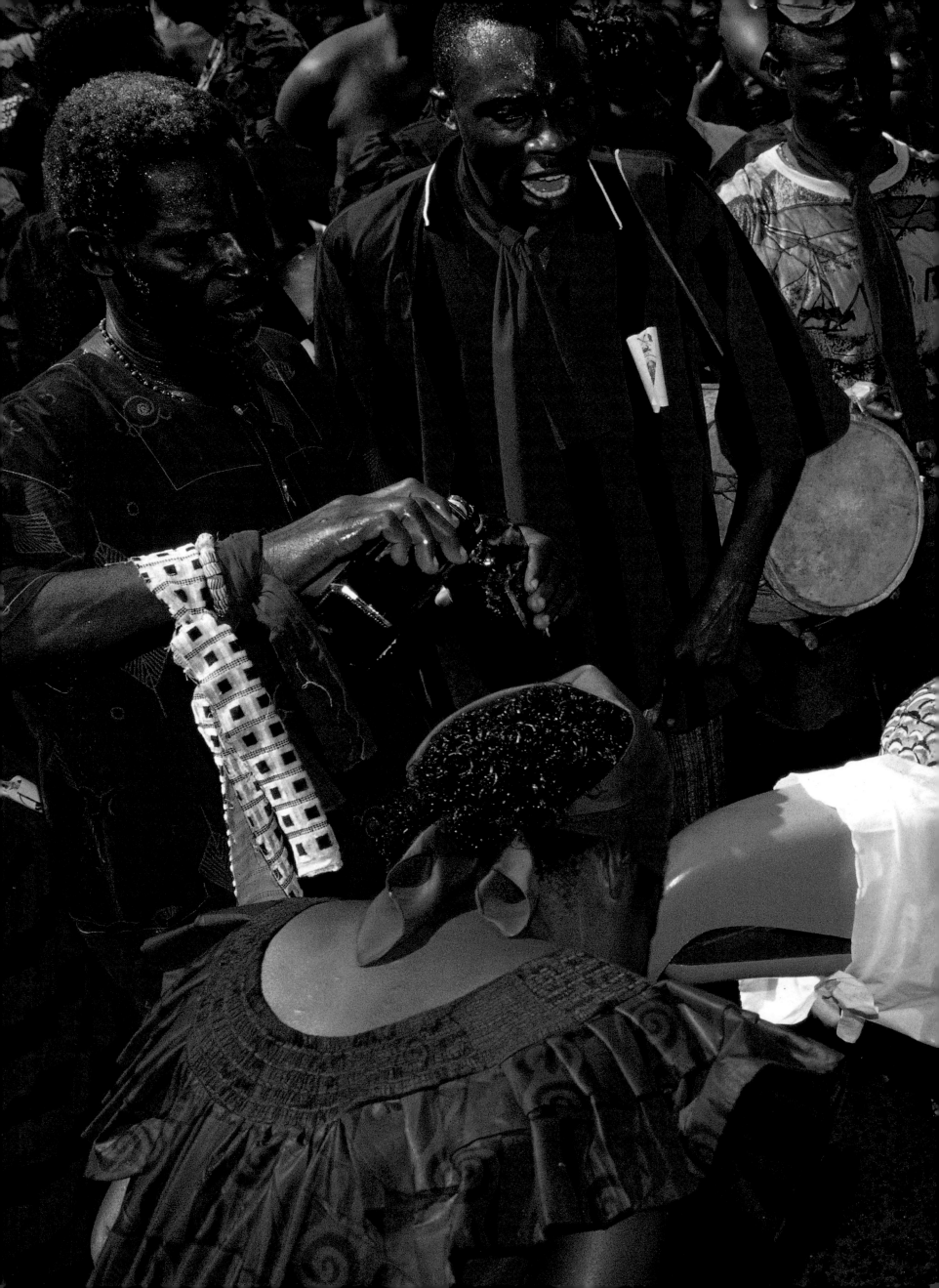

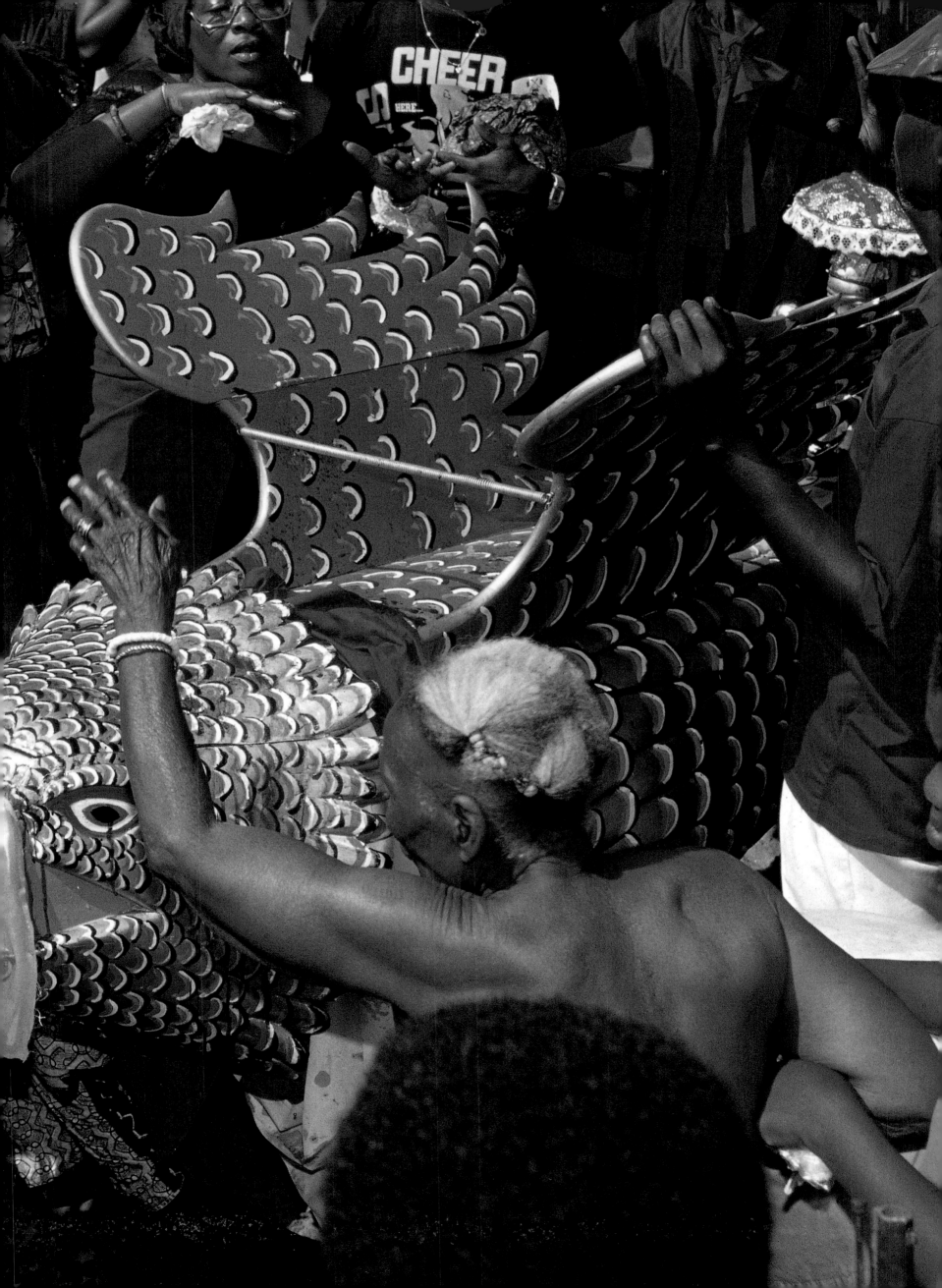

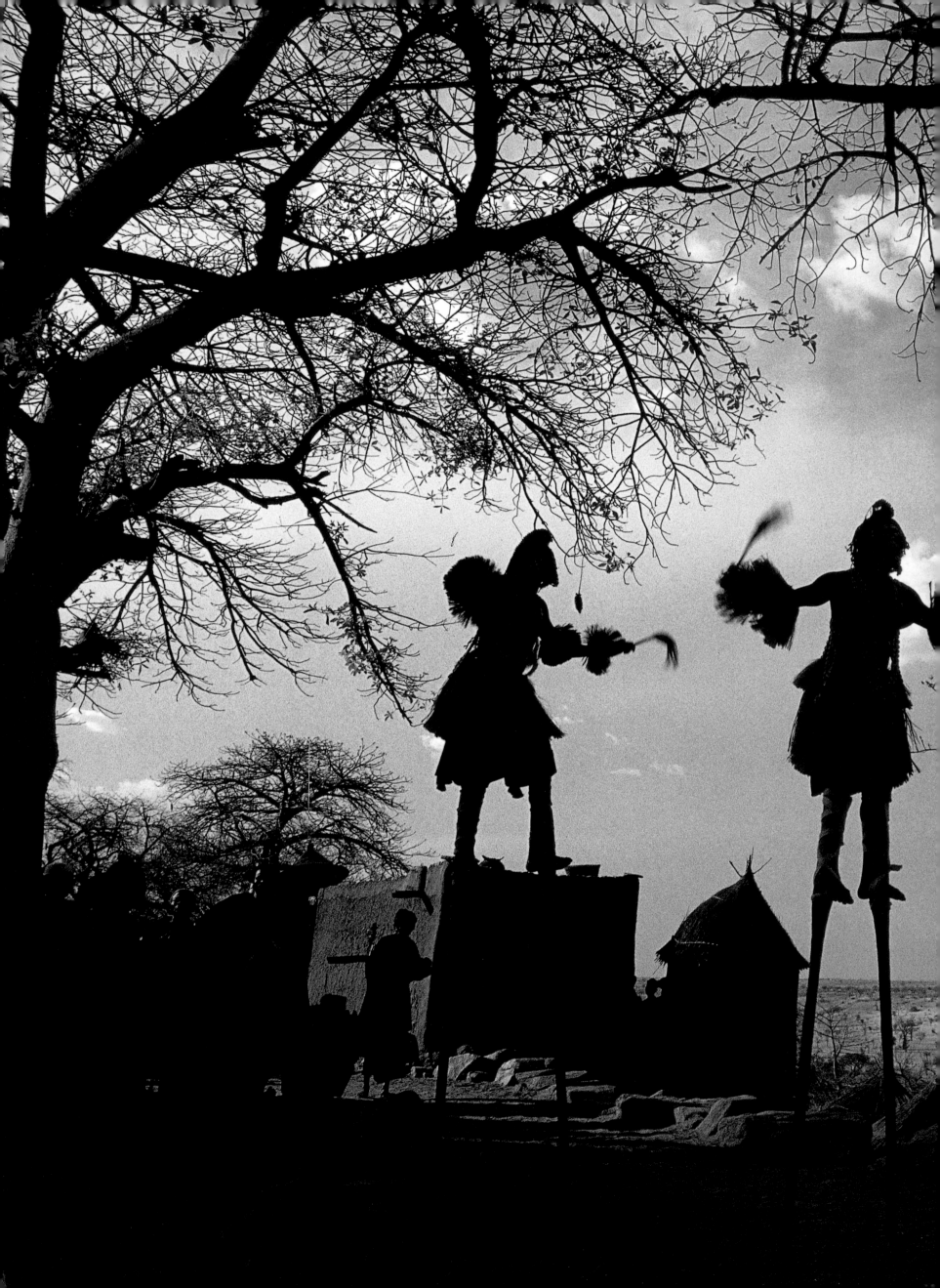

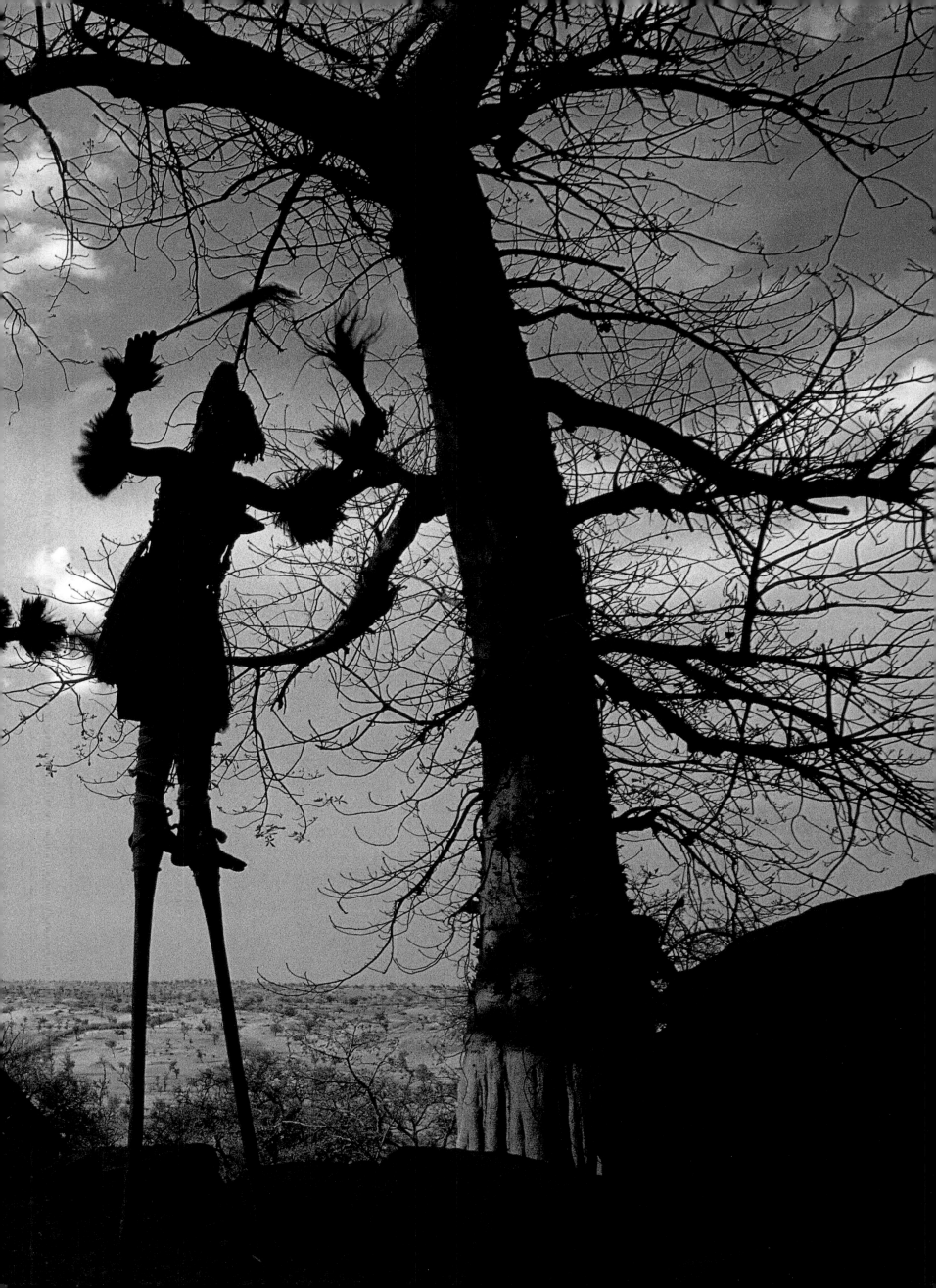

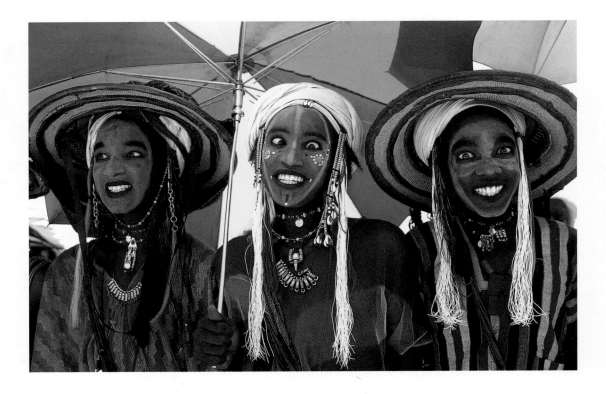

ABOVE:

In preparation for the Yaake charm dance, each Wodaabe dancer applies pale yellow powder to lighten his face; borders of black kohl highlight the whiteness of teeth and eyes; a painted line from forehead to chin elongates the nose; a shaved hairline heightens the forehead. These are among the most admired physical features for the Wodaabe. The man in the center held one eye still and rolled the other, a feat that confirmed his choice as winner of the dance.

EDITOR: ROBERT MORTON
ART DIRECTOR: MICHAEL WALSH
COVER CONCEPT: HADY SY
ASSISTANT WRITER/RESEARCHER: SHAUN FORD

Copyright © 2000 Carol Beckwith & Angela Fisher
www.africanceremonies.com

Front and back cover: Karo man from Ethiopia

Page 1: A gold-encrusted queen mother from Ivory Coast

Page 2: A Karo man preparing for a courtship dance

A portion of the royalties from the sale of this book will be used to assist the peoples of Africa during times of need.

Library of Congress Cataloging-in-Publication Data
Beckwith, Carol, 1945-
 Passages / photographs in Africa by Carol Beckwith & Angela Fisher.
 p. cm.
 ISBN 0-8109-2948-1(pbk.)
 1. Rites and ceremonies–Africa, Sub-Saharan–Pictorial works. 2. Initiation
rites–Africa, Sub-Saharan–Pictorial works. 3. Marriage customs and rites–Africa,
Sub-Saharan–Pictorial works. 4. Africa, Sub-Saharan–Social life and customs–Pictorial
works. I. Fisher, Angela. II. Title.

GN645 .B43 2000
390'.967'0222–dc21 00-31317

PRINTED AND BOUND IN JAPAN

Harry N. Abrams, Inc.
100 Fifth Avenue
New York, N.Y. 10011
www.abramsbooks.com